THE BEST FROM AROUND THE WORLD

THE ILLUSTRATOR

THE BEST FROM AROUND THE WORLD

Edited by Steven Heller & Julius Wiedemann

TASCHEN

CONTENTS

LONG LIVE THE ILLUSTRATION BOOKS!

by Julius Wiedemann

It was not long ago—meaning about 20 years—that the propagation of the art and craft of illustration was mostly confined to editorial and advertising. That has now changed dramatically. When I asked Christoph Niemann, commissioned to produce the cover of this book, to say something about today's state of affairs, he wrote back to me: "One of the side effects of the digital age is that it has shown how visually literate our audience is, and no medium can celebrate this literacy quite as well as illustration." It still surprises me that we, in the fields of publishing, curating, buying, and judging illustration, hadn't realized we could appeal to a much bigger audience. And so we started to understand books about illustration in a completely different way.

Illustrators are now more than creators of images designed to sell a product or convey the main idea of an article. They are now the purveyors of much deeper and more diverse experiences. The murals and the gallery exhibitions were not the only changes in a landscape that encompassed bigger and more complex drawings, paintings, installations, toys, and so many other media. The biggest change lay in the shift in understanding what illustration means to a wider audience.

As in every technological revolution that democratizes tools and empowers users, it is not hard to understand why most people instinctively thought that anyone could illustrate (or photograph, for that matter) at any level. As a simple tool, illustration is a potent vehicle for self-expression and for transmitting ideas, and should be learned by all. But what is interesting is the learning curve we had to go through to appreciate the hard work that is done by thousands of professionals every day, and to realize that together we are creating a new collective visual culture.

For about ten years now we have teamed up with Steve Heller to follow new developments in the field. Just as illustration and illustrators changed, so did the publications about their work. The wide variety of monographs available on the market is a sign that these illustrators have a lot to show. They should also be collected. This book, a compilation of works of nearly 100 artists, is not comprehensive of the entire field, of course. But it manages quite well to display the current state of affairs, with a reasonable—and perfection here is a very abstract concept—distribution of styles, techniques, and use of color, by illustrators of different genders from many different countries. The publication does not aim to be the only standard reference book, but is still a compelling snapshot of what is happening right now. Many of the artists included already show their work in contemporary art collections, and the others might follow soon. This book allows you to appreciate the images, the profiles of the artists, and the reach of their work. I dare you to pick your favorites, and seek more information until you become an illustration connoisseur.

THE ILLUSTRATOR: ALIVE, WELL AND ILLUSTRIOUS

by Steven Heller

In the past two introductions written within the last five years for TASCHEN's *Illustration Now!* series, I predicted that the art of illustration was on the verge of extinction as we know it. It seemed like a logical assumption at the time. The pen (and brush), no longer mightier than the sword, have succumbed to Adobe Photoshop and Illustrator programs, which I implied in my texts made illustration now less an art than a digital technique. My apologies: I was wrong on both counts. Illustration is alive and the new digital tools have given the art renewed vigor and the illustrator greater stamina.

Nonetheless it would probably be just as foolish to bloviate that we are currently experiencing the most fertile period of illustration in its long "illustrious" history as to say it is nearing the end. Constantly, I hear complaints from illustrators and art directors that the business of editorial and advertising illustration has declined since the rise of digital media (especially owing to the availability of stock online images) and the flood of tightened budgets throughout the 2000s.

However, while this may be true for some kinds of illustrators, equally important is the fact that the digital world has opened alternative platforms for illustration for the surge of newcomers and old-timers alike. So to put my the-sky-is-falling-crying-wolf pronouncement into perspective: There were extraordinary eras before contemporary mass visual media changed our perceptual habits, back in the day when illustration was the most effective—and the primary—means of illuminating the word on paper, to today when we get our words and images on screens as small as a watch face. And in this environment today's tableau and sequential illustrations (along with pictograms, icons, symbols) are holding their own brilliantly. The evidence of the creative explosion—the illustrators' work that is presented in this book—is so utterly persuasive that when I saw the layouts for the first time I was in heaven.

So being one who is given to extremes, I shall now unequivocally proclaim that we have definitely entered a new golden—if not a platinum and titanium—age of illustration.

Please note, however, that there have been many "golden ages" over the past two centuries comprised of legendary artists whose works are treasured today. In the United States, the titan of early- to mid-20th-century magazine illustration, Norman Rockwell, insisted in his autobiography that the Brandywine School generation, founded during the late 19th century by Howard Pyle (1853–1911),

which preceded Rockwell's own prominence, was the last of a golden breed. Yet another generation predictably believed that Rockwell's own golden age, and the creative circle that he inspired, was the highest peak of illustration. Frankly, being of an even later subsequent generation, I have long held that the late 1960s, 70s and 80s, which, among other things, introduced Push Pin Studios and many expressive, satiric, representational, and conceptual illustrators to the public's eyes was the most incredible of all periods (and everything has been downhill since).

But enough of this shortsighted doomsday blather. I've been wrong about the recent past future of illustration. The cataclysm that promised to wipe illustration, like dinosaurs, off the planet never arrived. And, even if there were some professional valleys among the hills, about this joyful book I can say: It marks a stronger life for a venerable art; illustration is exciting—more free and varied than ever—and it is ubiquitous in all kinds of media from paper to screen, from small to large screen, and let's not forget books, packages, and clothing. There are more illustrators contributing to the overall popular culture now than I can recall in those past golden ages.

There has been an existential shift in illustration practice from 2000 to the present that has fostered its own distinctive identity, personality, and attitude. Illustration is going through a kind of climate change (and getting hotter all the time), an evolutionary stage that is best described in the catchphrase "the illustrator as author." There have been illustrators, including most of the veterans in this book, who are known for their formidable styles, but today their pictorial approaches—and content—are telegraphing more intimate viewpoints on a level comparable to the construct of art for art's sake (the ideal that absolute art serves itself and its maker before any other master). Conversely, illustration will (and should) always be defined as a response to external stimuli—the assignment; only these days, many assignments are either self-initiated or redefined to be more responsive to the artist's needs. Illustration must still solve a client's need but the old bugaboo of having to be slavishly literal to someone else's concept is on the way out. Clients want independent thinking—I think!

An impressive number of the illustrations selected to appear in this volume unapologetically satisfy the illustrators' own political beliefs, social concerns, and aesthetic. This is not exactly illustration without a client but the point of view is what draws the client to the illustrator in the first place. Work by Sue Coe, Anita Kunz, Maira Kalman, Christoph Niemann, Steve Brodner, Edel Rodriguez (and I can go on and on) are among the dozens of illustrations that began as personal commentaries and found outlets that reached their public. Their work and a lot more on the following pages have integrity apart from their respective contexts. Viewers need not even know the starting point for the art, although matching concept to the problem being solved is part of fun in deciphering an illustration.

What's more, illustrators are creatively prospering in ways that have exponentially increased their powers of innovation and their value as creators, inventors and conjurers of all kinds of content. It is an old canard, but illustrators have long been seen as stepchildren to artists in the art world(s). This seemingly pragmatic distinction made sense when the needs of "art" and the demands of "commercial illustration" could be easily polarized. Of course, there remain huge gaps between what is deemed illustration compared to that which is hung in a gallery or museum (and this impacts the monetary worth of art as well as its cultural-historical standing in the world), but motivational differences between art and illustration are not widening—in fact, they are shrinking. Which has forced gallery artists to radically experiment with form and media in ways that will not be confused with illustration. Abstract Expressionism was a mid-century break with the representational art that illustrators were known for and fought for, until some of them began using abstraction in their own work. It happens like that: you're viscerally against something, then all of a sudden—"presto"—it's the greatest thing since stuffed artichokes. Today, many of the art styles of the past have pushed like a liberating army into the hearts of illustrators and fans alike. Conversely, bio- and performance art have not yet found a welcome berth in the illustration space.

One goal of today's conceptual illustration is to provide the audience, through aesthetics and intelligence, with an additional sensory experience once the puzzle is decoded. For me, there are few better examples of this than Melinda Beck's New York Times Old English type "T" logo atop Donald Trump's body with top of the letter form made to look like President's formidable coif (p.28). But this is just one highlight out of a fount of them. Paul Davis reveals how he's evolved from his popular portrait style into a collagist of comic juxtapositions (p.138). Matt Dorfman's eye slinking off abstract yet suggestively human shapes is hilariously eerie (p.156). Catalina Estrada's exquisitely hypnotic patterns beg the viewer to see beyond the surface of her art (p.188). John Hendrix's packed tableaux carry so much narrative they are epic (p.228). The fantasies of Jeremyville are like falling into a deep REM dream (p.266). And Igor Karash's reminiscences of the Soviet regime are documents of comic horror (p.290). Obviously, you will soon see and be inspired for yourself.

This book, *The Illustrator*, is extraordinary for the quality, diversity, intensity, comedy, vivacity, and exceptionality of the work, but also because it is just the tip of the proverbial iceberg. These are the "Best From Around The World" but there are likely 100 more waiting in the wings. Multiply the amount of work for each illustrator here, add a similar amount for the talented others and, if nothing else, there is mathematical proof that illustration is very much alive, well and illustrious.

THE
PROFILES

"One of the side effects of the digital age is that it has shown how visually literate our audience is, and no medium can celebrate this literacy quite as well as illustration."

CHRISTOPH NIEMANN

> "I identify as a feminist and I consider some—but not all—of my work to be a form of low-key activism. This isn't always obvious in the outcome, though, because a major part of it is just about standing up for my beliefs when working with clients." for *i-D*

SARA ANDREASSON

Bold and sassy, Sara Andreasson's colorful, attention-grabbing images exude a confidence that reflects female empowerment and gender equality. Voluptuous or musclebound figures inhabit vibrant block-color scenes—to dispel stereotypes she references male images to depict women, and vice-versa—accentuating an observational savvy that teases the viewer with sexual playfulness. Andreasson approaches fashion illustration on her own terms, exploring themes of alt femme, relationships, and everyday social noise with a sense of assurance. Born in Kristinehamn, Sweden, in 1989, she studied in Gothenburg, first completing a BSc in Product Design Engineering at Chalmers University of Technology in 2011, before attending the HDK Academy of Design and Crafts, where she graduated with a BFA in Design in 2015. The same year, she gained recognition for her work in the *Pick Me Up* graphic arts festival at Somerset House in London, as well as her contributions to *The Guardian* and *The New York Times*. To date, Andreasson has notched an impressive tally of commissions from the likes of Converse, *Le Monde*, Spotify, and Tumblr. Together with her friend Josefine Hardstedt, she has also co-edited and art-directed the independent feminist magazine *BBY* in Gothenburg. Andreasson is currently based in London.

Selected Exhibitions
2017, *Clueless*, solo show, Ninasagt, Düsseldorf · 2016, *New Nordic Fashion Illustration*, group show, Estonian Museum of Applied Art and Design, Tallinn · 2015, *Pick Me Up*, group show, Somerset House, London

Selected Publications
2015, *Illusive IV*, Gestalten, Germany · 2015, *Behind Illustrations 3*, Index Book, Spain

p. 14 Whatever, 2016
Personal work; digital

opposite Muddy, 2018
Personal work; digital

Fiery, 2017
*Süddeutsche Zeitung
Magazine*; digital

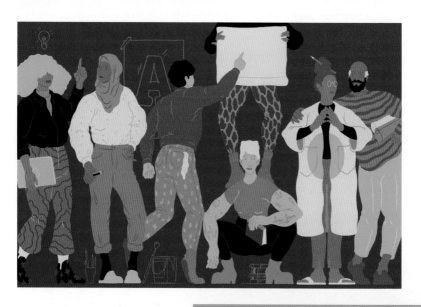

pp. 18/19 Vårens Böcker, 2018
Svensk Bokhandel, book cover;
digital

Årsrapport, 2017
Svenska Tecknare, book cover;
digital

Untitled, 2017
Personal work; digital

opposite Fizzy Flowers, 2017
Personal work; digital

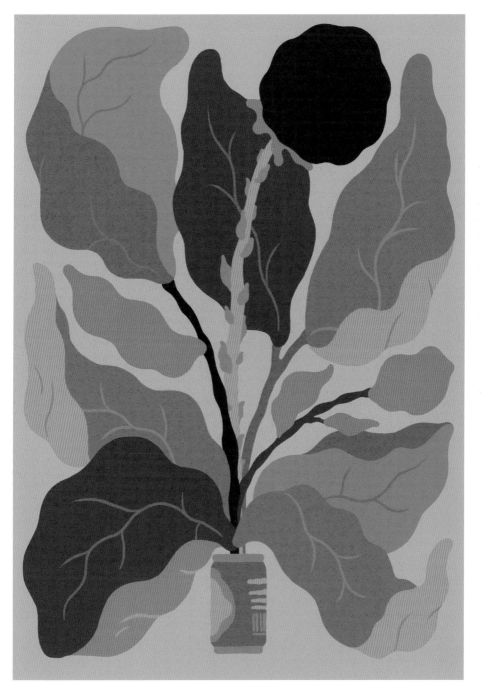

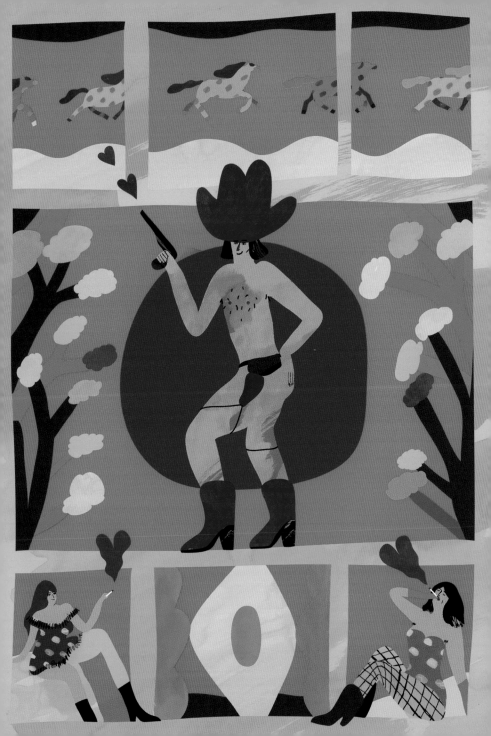

CLARA SELINA BACH

Copenhagen native Clara Selina Bach has emerged as one of the freshest voices in Danish illustration today. Born in 1989, she attended The Royal Danish Academy of Fine Arts—Schools of Architecture, Design and Conservation (KADK), where she studied illustration, narratives, and graphic design. After graduating with a BA in 2015, she continued at KADK doing postgraduate studies in visual communication, whilst undertaking freelance graphic projects for *Newspaper Information* and Danish not-for-profit organization INDEX: Design to Improve Life. In a short space of time, her commissions have ranged from urban planning projects, editorial, book illustration, storytelling, and surface pattern design. Her clients include children's clothing brand Comme Ci Comme Ça; We Do Democracy, a Copenhagen-based independent change agency; and the municipality of Fredensborg Kommune. Bach's instinct to explore new visual textures and formats is reflected in her eclectic portfolio. Fluid in various media, from acrylics and watercolor to pencils, ink, and digital, she approaches her subjects with intuition and honesty. People in everyday scenarios, in both urban communities and the natural world, are rendered with a playful abstraction and sense of equilibrium.

p. 22 Spaghetti Western, 2018
Private commission, poster;
digital, pencil, acrylic, ink

opposite Boyfriend With White
Tennis Socks, 2018
Personal work; digital

Untitled, 2018
Personal work; painting,
acrylic, color pencils

The Future of
Nivå City Center, 2018
Municipality of Fredensborg;
digital; art director: Signe
Bjerregaard (Andel)

Untitled, 2016
Personal work;
ink, pencil, digital

Selected Exhibitions
2014, *100th Anniversary Exhibition of H. J. Wegner*, group show, Tønder Art Museum, Denmark · 2014, solo show, Art Rebels, Copenhagen

Selected Publications
2018, *Women, Gender & Research*, University Press of Southern Denmark

MELINDA BECK

Born in New York in 1966 to graphic designer parents, Melinda Beck grew up playing with Letraset, rubber cement, and T-squares. In 1989, she graduated with distinction in graphic design from Rhode Island School of Design, and has since enjoyed a highly accomplished career as an illustrator, animator, and graphic designer. With a range of styles to hand—from abstract and surreal to collage and silhouette—Beck's work displays both technical mastery and conceptual adeptness. Equally at home in color or monochrome, she draws and paints, sometimes employing found objects before working digitally. A distinctive quality is her ability to deliver a clear visual message—on tone and on target—through either complex or reduced compositions, whether patterning everyday symbols for op-ed layouts or children's books. Her broad visual language has attracted clients from publications and retail, including *The New Yorker*, Random House, and Neiman Marcus. An active educator and communicator, Beck has lectured at Parsons School of Design (New York) and Grafill (Oslo), and served as the vice president of ICON9, the Illustration Conference. Among her tally of awards are two Emmy nominations and a Gold Medal from the Society of Illustrators. In 2018, Beck won an American Illustration International Motion Award for a cheery animation she created for *Harvard Business Review*. Beck lives and works in Brooklyn.

2018, *Drawn to Purpose: American Women Illustrators*, group show, The Library of Congress Gallery, Washington, D.C. · 2018, *Art as Witness*, group show, School of Visual Arts, Chelsea Gallery, New York · 2018, *Illustration: Women Making A Mark*, group show, University of Indianapolis Gallery · 2017, *The Narrative Image: Melinda Beck & Julia Rothman*, group show, Rhode Island School of Design ISB Gallery, Providence · 2014, *The Art of Melinda Beck*, solo show, The University of the Arts, Philadephia

2018, *Drawn to Purpose: American Women Illustrators*, The Library of Congress, USA

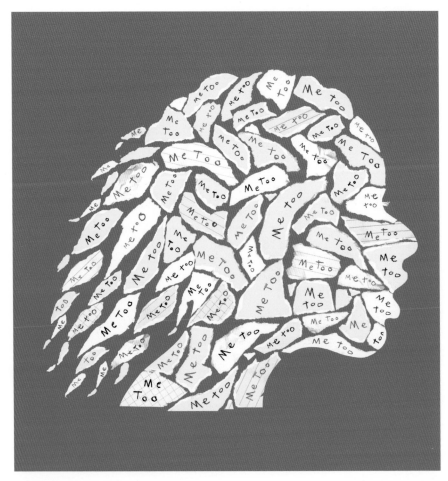

p. 28 When All the News
That Fits Is Trump, 2017
Columbia Journalism Review; vector

opposite Me Too a Year of
Reckoning, 2018
The New York Times; mixed media

The Enigmatic Trans-Pacific
Partnership Trade Agreement, 2016
Harvard Law Bulletin; mixed media

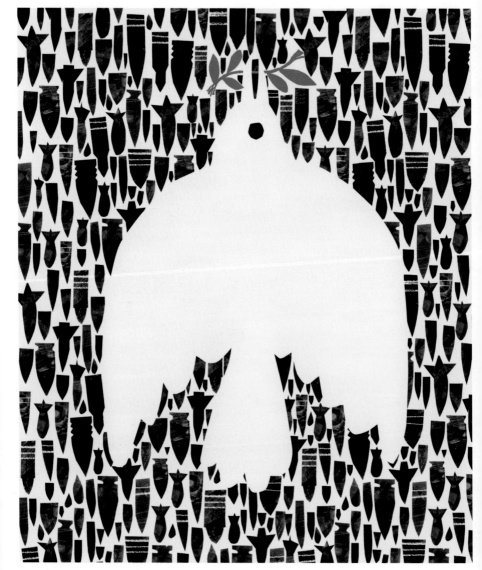

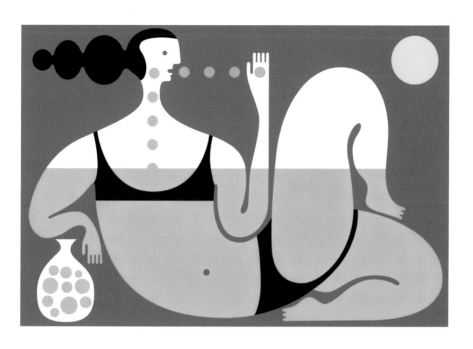

opposite Advocating Diplomacy
Over War, 2017
The New York Times, newspaper;
mixed media

Edible Sun Screen, 2016
The New York Times; vector

Freedom of Speech:
A New Vision of Norman
Rockwell's America, 2017
Smithsonian magazine;
mixed media

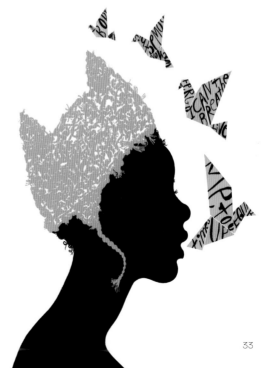

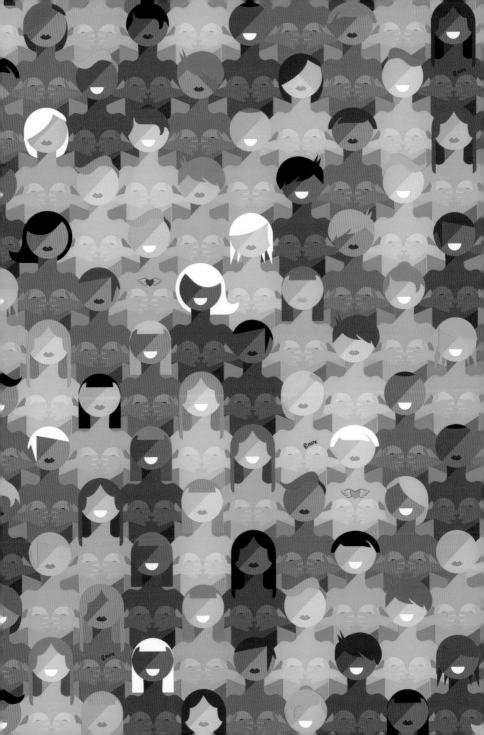

"I've always been a huge fan of Pop Art and early 1980s graffiti (the NYC Wild Style era), so I learned from the greats about how to use color, to be brave with color, and to find a balance between different colors."

for *Design Tutsplus*

BEN THE ILLUSTRATOR

Ben O'Brien (aka Ben the Illustrator) was born in London in 1976. After a foundation course at Central St Martins School of Art in the mid-1990s, O'Brien went on to study animation at Surrey Institute of Art and Design, attaining a BA in 1999. Armed with his showreel, he gained entry into the music promo business, animating and directing for the likes of Skint Records and Sony Japan before leading a small animation design studio in London. Realizing his main passion, he jumped ship in 2005 and went freelance as "Ben the Illustrator," teaching himself Adobe Illustrator in two sleepless weeks. Commissions for the BBC and Airside soon followed. A big break arrived with an invitation to illustrate for Smart Cars. A self-confessed color addict, Ben gets excited by shapes and forms, and the way things move. His boundless enthusiasm rubs off through his rainbow-colored pictographic arrangements. What distinguishes Ben's work from countless other flat vector graphics is the interplay between his trinity of shape, color, and form—straight lines and curves intersect and overlap to create a clarity and depth, accentuated by the odd brush spatter. Nothing gets lost in translation. Today, O'Brien lives and works in Frome, Somerset. His work can be found on everything from Innocent Smoothie bottles to retailers' walls. In 2017, Ben designed and conducted a survey of his own profession, asking 1,261 illustrators about their working lives.

Selected Exhibitions
2017, *Endless Summer*, group show, Atelier Meraki, Paris · 2016, *Festifeel*, group show, House of Vans, London · 2016, *Prince Exhibition*, group show, Fred Aldous, Manchester · 2016, *Secret 7's*, group show, Sonos Studio, London · 2012, *Art V Cancer*, group show, TwentyTwentyTwo, Manchester

Selected Publications
2018, *CreativePool Annual*, CreativePool, United Kingdom · 2017, *Pattern Euphoria*, Sandu, Hong Kong · 2015, *Yellow*, Studio OL, United Kingdom · 2013, *Illustration 2*, Zeixs, Germany · 2008, *Beyond Trend*, HOW Books, USA

Monty Python, 2018
Personal work; vector

p. 34 Festifeel, 2016
CoppaFeel!, exhibition,
House of Vans, London; vector

Madonna, 2018
Personal work; vector

pp. 38/39 Metropolis, 2016
Box Pensions, website; design and
concept: We Launch, London

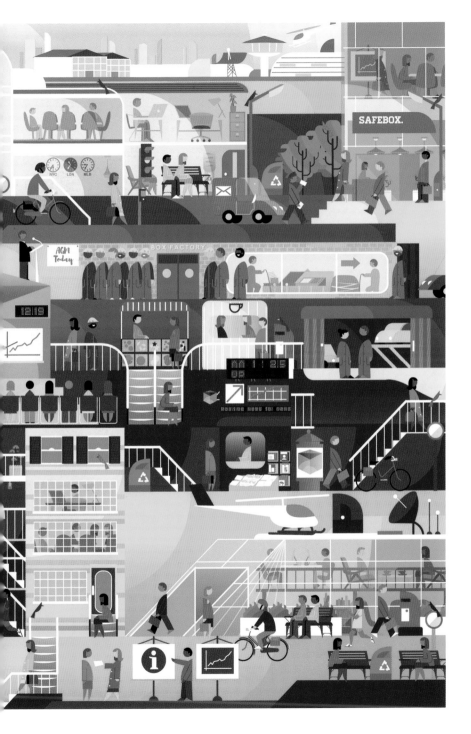

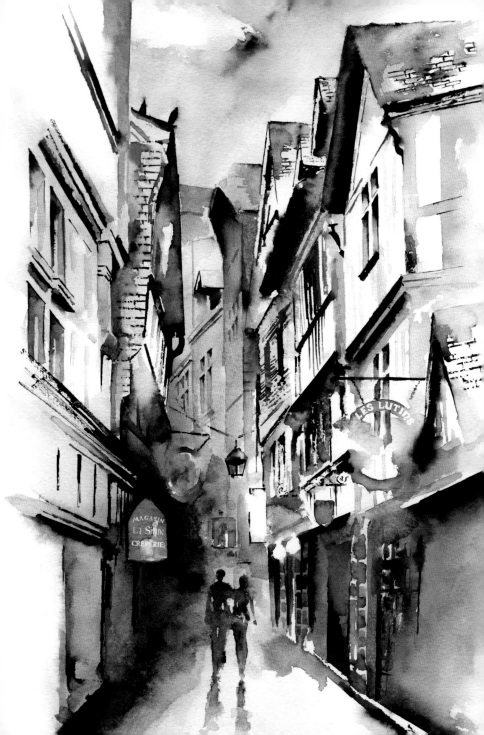

"I like to work in black ink and watercolor to express the movement and transiency of fashion and to mirror the joy that looking at beauty creates in us."

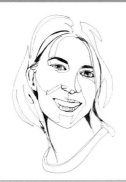

MAYA BEUS

Whether attending fashion shows, client events, or openings, Maya Beus never leaves her studio without her sketchbook and iPad. Born in the small medieval town of Vrgorac, Croatia, in 1981, Beus studied at the School of Fashion and Design in Zagreb, graduating in 2009. After briefly working for an architecture design studio she moved to London, where she realized that illustration was her calling. Beus's evolving practice stems from a deep exploration of her chosen field. From pencil studies to digital painting over photos, or ink blots and bleeds accentuated by bold brushstrokes, her illustrations give her subjects mood, form, and texture, with a sketchiness that captures the fleeting catwalk moment or a delicate burst of fragrance. Beus has worked for the likes of CC KUO, *Harper's Bazaar* (Turkey), LVMH, Oscar de la Renta, San Pelegrino, St Regis Hotels, and Mercedes-Benz Fashion Week Australia. In 2013, she was selected Best Fashion Illustrator at the Fashion Fringe, part of London Fashion Week. In 2015, Beus had her first solo exhibition at the luxury Le Méridien Lav hotel in Split. She lives and works in Zagreb.

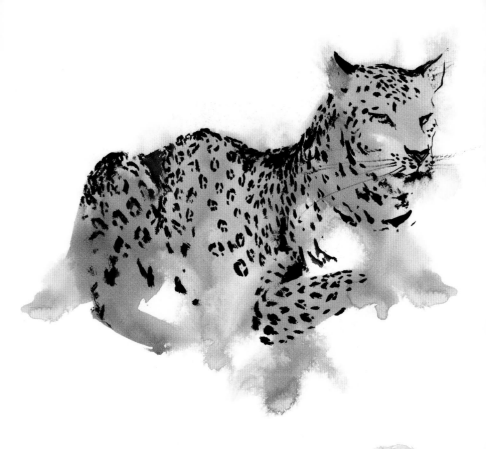

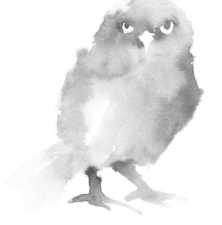

p. 40 St. Michel, 2018
Lodestars Anthology
magazine; watercolor

Wild Animal, 2017
Personal work;
watercolor and ink

Baby Owl, 2018
Bambini Furtuna,
packaging; watercolor

opposite Perfume Table, 2016
Good Weekend magazine;
watercolor and ink

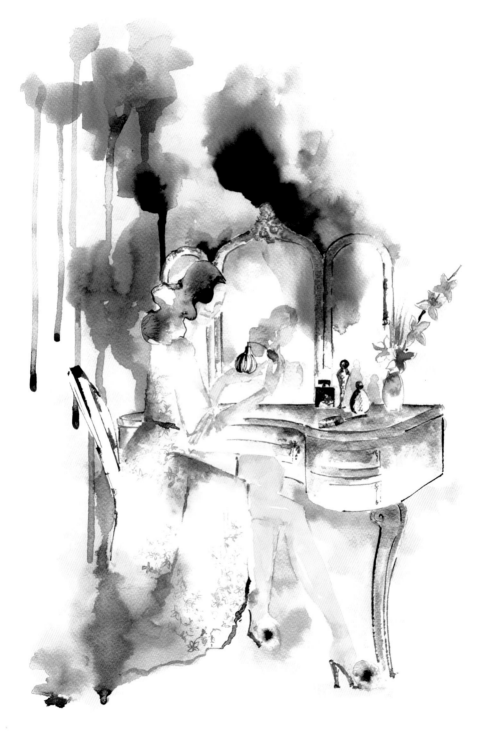

Untitled, 2018
Personal work; black ink

Tom Ford Spring/Summer 2019
Personal work; black ink

opposite Butler Laundry
Service, 2016
St. Regis Istanbul; watercolor;
creative and brand management:
Igor Novakovic

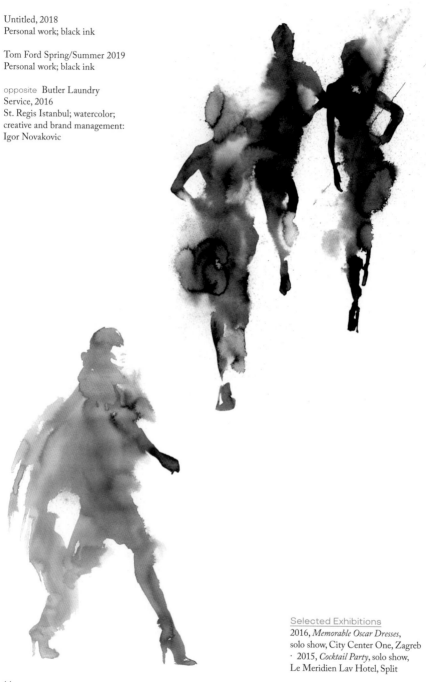

Selected Exhibitions
2016, *Memorable Oscar Dresses*,
solo show, City Center One, Zagreb
· 2015, *Cocktail Party*, solo show,
Le Meridien Lav Hotel, Split

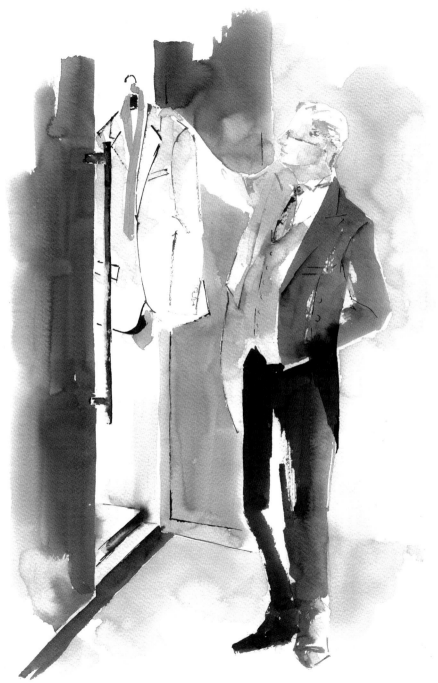

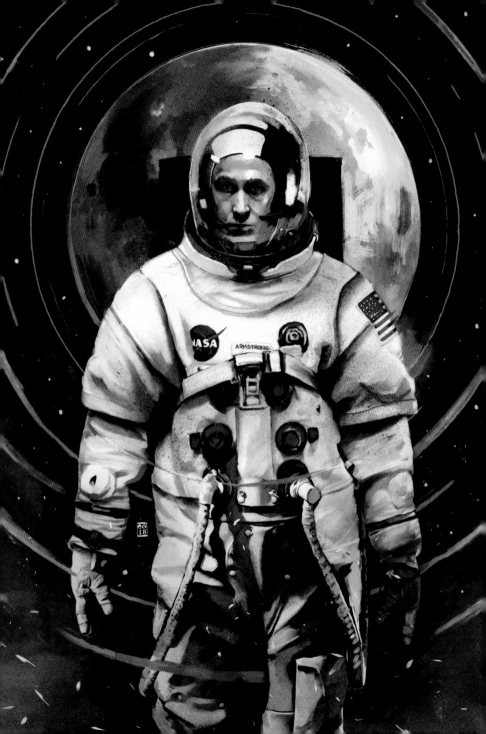

> "I am a designer and a draftsman. I love poems. I learned about fine arts from an artist I happened to meet, and decided to shape my future in this field."

ETHEM ONUR BILGIÇ

Ethem Onur Bilgiç was born in 1986 in the coastal town of Inebolu on the Black Sea in Turkey. During his teens he moved to Ereğli in Anatolia, where a local painter spurred him on his creative path. In 2019, he completed his studies in graphic design at the Mimar Sinan Fine Arts University in Istanbul. While a student, he began undertaking commissions for various publications, as well as movie and theater posters. His moody, atmospheric style fuses attributes of the graphic novel with a color-graded, cinematic feel—allowing his work to cross over naturally from print to the moving image. Bilgiç works in both traditional media, such as acrylic, watercolor, ink, and marker pen, and digital tools, through which he translates a handcrafted aesthetic. In addition to his commercial work as an illustrator and motion-graphics artist, he also produces short films. Turkish literature and Japanese anime are close to his heart. Based on the poem "Salkim Söğüt" by romantic revolutionary writer Nazim Hikmet Ran, his first animated short *Weeping Willow* (2014) was selected for numerous film festivals. Bilgiç has participated in exhibitions throughout his native country and beyond. His inaugural solo show *Sweet Nightmares* opened at Milk Gallery in Istanbul in 2013. Bilgiç's clients include the Akban Film festival, Coca-Cola, Denizbank, and Turkish Airlines.

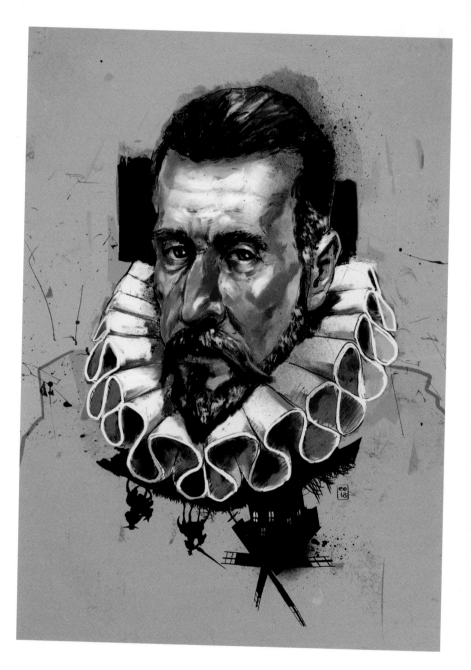

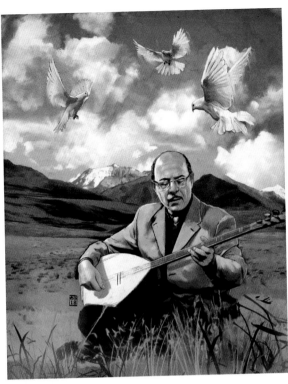

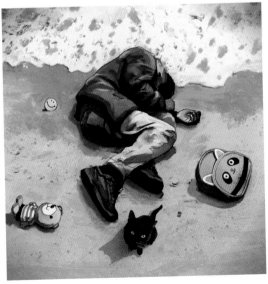

p. 46 First Man, 2018
United International Pictures
Turkey, poster; digital

opposite Miguel de
Cervantes, 2018
ArkaKapak, magazine cover;
digital

Neset Ertas, 2018
Oz Cekim, magazine; digital

Waves, 2018
Personal work; digital

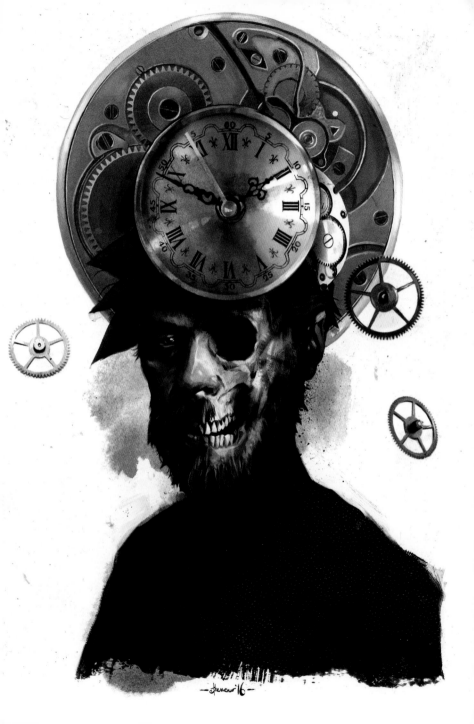

Selected Exhibitions
2018, *Mix-Tape*, solo show, Izmir
International Fair, Izmir Art Center,
Turkey · 2018, *The Big Picture*,
group show, Depo, Istanbul · 2018,
Illustrators, group show, Dada Salon
Art Gallery, Istanbul · 2017,
Tovbeler Tovbesi, solo show, Bang
Mag. Havuz/Bina, Istanbul · 2013,
Sweet Nightmares, solo show, Milk
Gallery & Design Store, Istanbul

Selected Publication
2015, *Bant Mag. Artist Dossier No.2,
Ethem Onur Bilgiç*, Bant Mag.,
Turkey

opposite Time, 2016
Personal work; digital

The Little Prince, 2018
Tuhaf, magazine; digital

Rabbit, 2017
Personal work; digital

> "I like to keep it simple. I work with two key colors and, of course, black, white, and gray. People think that working with computers is very constrained and controlled, but those accidents offer the never-to-be repeated moments of creativity that every artist strives for."
>
> for *Marshwood Vale Magazine*

PAUL BLOW

Paul Blow was born in Falkirk, Scotland, in 1969, but grew up near the Dorset coast in England, where he lives and works today. His love of drawing is rooted in his childhood during the 1980s, when he escaped through the world of comics. He received his BA (Hons) from Maidstone College of Art in 1992 before completing an MA in Narrative Illustration at the University of Brighton. Working from his studio in an old rope-making factory, Blow is a firm believer in concept over style. Wit and nostalgia abound in his work. Often inspired by vintage photos, his characters are rendered by wispy lines that crease and fold to give expression. He mixes his own hues, creating a bold, minimal palette that lends his work an enchanting warmth. Blow has a list of prominent editorial clients to his name, from *The Washington Post* to *The Guardian*, and his passion also extends to collaborative projects for small enterprises, like an ethical bike-skate clothing firm. His work adorns everything from murals on old furniture to T-shirts. He has also created animations for VH1 and was an art lecturer at the Arts Institute at Bournemouth.

p. 52 Jackass TV, 2018
MTV; digital

The Last Polar Bear, 2018
Greenpeace magazine; digital

Go With the Flow, 2017
WeTransfer; digital

opposite A.I., 2017
Caspian, magazine,
Real Deals; digital

Food Lover, 2018
Personal work; digital

opposite War in Yemen series, 2018
International Rescue Committee;
digital

57

Hangin' Out, 2017
Handsome Frank agency,
promotional; digital

opposite top Animal Farm, 2017
Soulpepper theatre
company; digital

opposite bottom Turkey, 2018
The Economist,
magazine; digital

Selected Publications
2017, *American Illustration*, USA ·
2017, *Society of Illustrators*, USA ·
2017, *Communication Arts*, USA ·
2014, *IdN*, Systems Design Ltd,
China · 2007, *Nobrow 1*, Nobrow,
United Kingdom

"My work is feminine, playful and colorful. I think cute is also a good word to describe it."

for *Metal* magazine

BODIL JANE

Combining delicious, flat colors with a hint of the exotic, Dutch illustrator Bodil Jane celebrates the diversity of the modern lifestyle through her wide range of subjects—from empowered women, relationships, and interiors to food, nature, plants, and animals. Born in Amsterdam in 1990, Bodil Jane moved to Haarlem, where her creative seeds were nurtured by her freelance artist parents. Whilst studying illustration at the Willem de Kooning Academy in Rotterdam, she was already proactively mapping out pathways with an Erasmus exchange program in visual communication at the School of Design, Copenhagen, followed by commissions for ad agencies and internships with design shops. Since receiving her degree in 2014, her career has snowballed—thanks largely to her entrepreneurial streak and Internet savvy. Today she shares her daily practice with hundreds of thousands of online followers. As for style and technique, all her work is rendered entirely by hand in watercolor, pencil, and ink. Her diverse output encompasses editorials, ad campaigns, stationery, and home furnishings. In 2015, she was honored with a Silver Award at the European Design Awards. To date, her clientele includes Air Canada, Casetify, *Flow Magazine*, Jamie Oliver, Rabobank, UNICEF, and Waitrose. In 2018, she selected ten inspirational women, from civil rights activist Rosa Parks to Nobel Prize laureate Malala Yousafzai, for an illustrated French children's book *Il était une fois des femmes fabuleuses*.

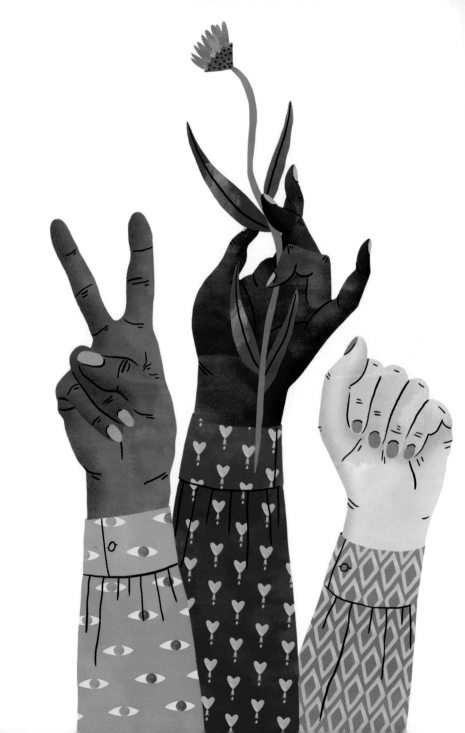

p. 60 Bloom, 2018
Happinez magazine;
analogue textures, digital

opposite Hands, 2017
Happinez magazine;
analogue textures, digital

Air Pollution, 2016
UNICEF, online campaign;
analogue textures, ink, digital

<u>Selected Publication</u>
2018, *Il était une fois des femmes
fabuleuses*, Larousse Jeunesse, France

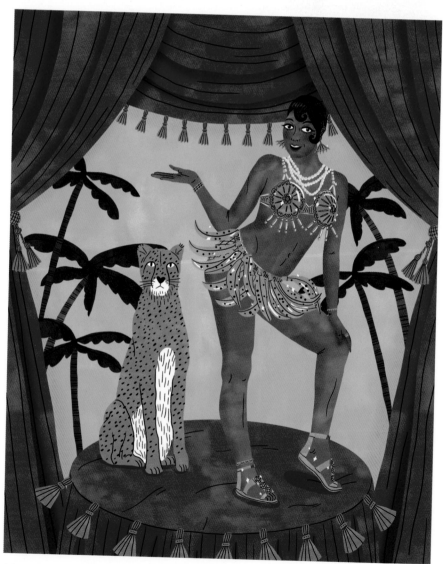

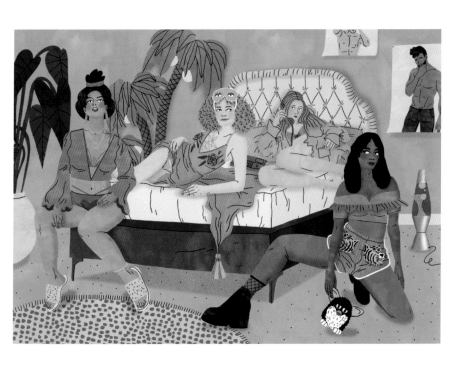

opposite Joséphine Baker, 2018
Il était une fois des femmes fabuleuses,
book, Larousse Jeunesse;
analogue textures, digital

Slumber Party, 2018
Personal work; analogue
textures, digital

> "The quantity of images we
> consume daily and the speed at
> which everything happens don't
> allow us to stop for a moment
> and enjoy—or suffer, or simply
> be conscious of the here and now."

for *Café Babel*

PAULA BONET

Born in 1980 in Villarreal, in the Valencian Community of Spain, Paula Bonet joined a drawing academy at the age of 14. Although her peers tried to persuade her to go into a more secure profession, she followed her passion, gaining a BFA at the Polytechnic University of Valencia in 2003 before traveling and completing her studies at the Pontifical Catholic University of Chile in Santiago and New York University, as well as taking short courses in Urbino, Italy. Returning home, she pursued a career in teaching and painting before devoting her to time to free-lance work. Although she has exhibited in Spain, as well as in London, Paris, and Berlin, it is through the Internet that her talents have gained her the attention of hundreds of thousands of followers on social media. In 2009, she began applying her engraving and oil-painting techniques to a broader mixed-media practice. Bonet's work combines text and images, giving equal weight to both. Whether working in pencil, ink, watercolor, or engraving, her expressionist and contempla-tive subjects entice the viewer through surface layers and into a deeper visual narrative. This approach has naturally resulted in several illustrated books of writings and poetry, among them *Qué hacer cuando en la pantalla aparece The End* (2014) and *813* (2015), the latter a tribute to the French film director François Truffaut. In 2016 she published *La sed*, an illustrated poem about sentimental and emotional disorientation that breaks with all previous aesthetics. *Roedores. Cuerpo de embarazada sin embrión* (2018), a book in diary format accompanied by an animated painting, gives voice to silence, breaks a taboo, and normalizes a reality as common as miscarriage. Bonet also created the paintings and engrav-ings for Joan Didion's *The Year of Magical Thinking* (2005).

Selected Exhibitions
2018, *Por el olvido*, solo show, Pepita Lumier, Valencia · 2017, *Una habitación oscura*, solo show, La Fábrica, Madrid · 2017, *La sed*, solo show, Miscelánea, Barcelona · 2016, *813/Truffaut*, solo show, Galería de Cristal, Centro Cibeles, Madrid · 2015, *No te acabes nunca*, solo show, Ailaic, Barcelona

Selected Publications
2018, *Por el olvido*, Lunwerg Editores, Spain · 2018, *Roedores/Cuerpo de embarazada sin embrión*, Random House, Spain · 2017, *Quema la memoria*, Lunwerg Editores, Spain · 2016, *La sed*, Lunwerg Editores, Spain · 2015, *813/Truffaut*, La Galera, Spain · 2014, *Qué hacer cuando en la pantalla aparece The End*, Lunwerg Editores, Spain

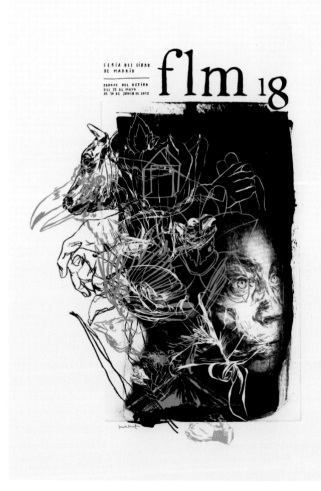

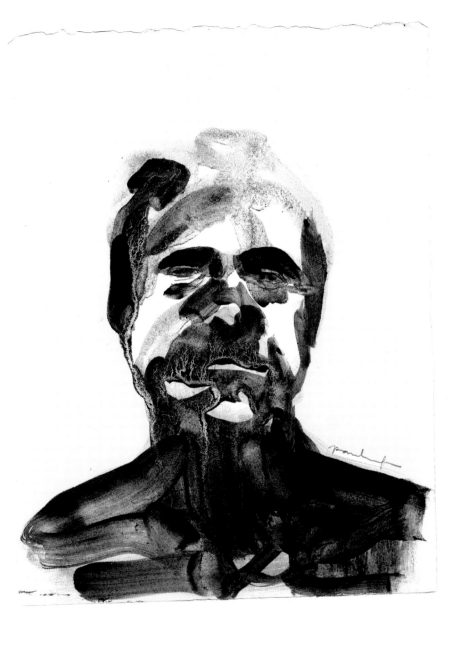

p. 66 Untitled, 2016
La sed, Lunwerg Editores, book

opposite Madrid Book Fair, 2018
Poster

The European Cinema Festival of
the City of Segovia, MUCES, 2018
Poster

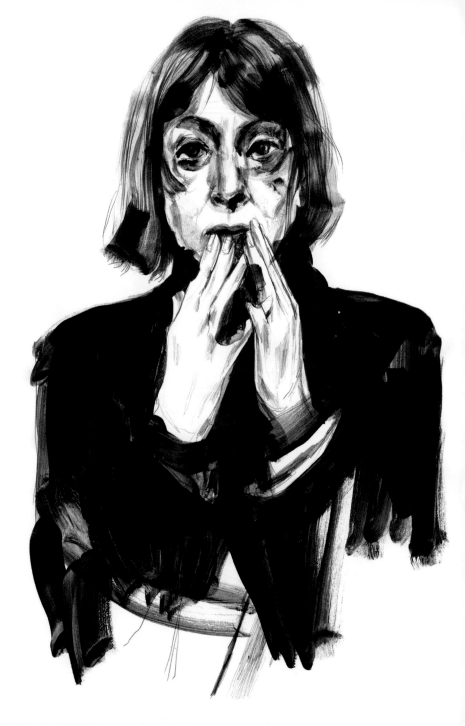

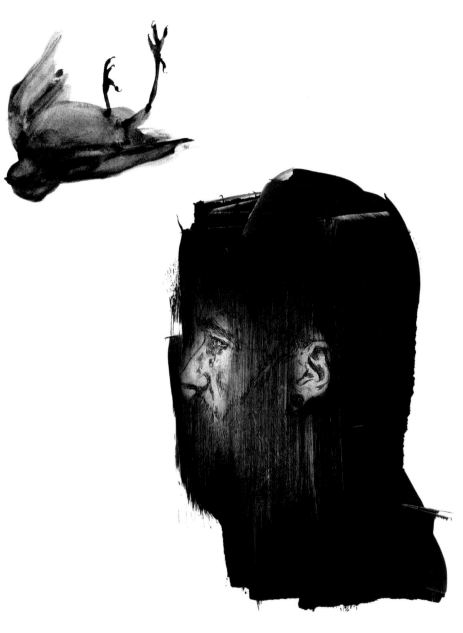

opposite *El año del pensamiento mágico*, 2019, by Joan Didion
Penguin Random House
Grupo Editorial, book

La sed, 2016
Lunwerg Editores, book

Por el olvido, 2018, by Aitor Saraiba
Lunwerg Editores, book

"I don't come from a typically 'artsy' family, but I do come from a family with a lot of meticulously skilled tradespeople, like carpenters, woodworkers, and bricklayers."

for *The Great Discontent*

DARREN BOOTH

Born in 1978, in the city of Sault Ste. Marie, Ontario, Darren Booth is an award-winning Canadian illustrator and lettering artist with a unique visual vocabulary. After graduating in illustration from Sheridan Institute in 2001, Booth's distinctive, handmade style began to attract the attention of major brands. Today, his impressive tally of clients includes Google, Coca-Cola, AOL, Target, Pinterest, Penguin Books, and Disney. His colorful and uniquely shaped lettering designs, sometimes blending into abstract compositions, have adorned book covers for imprints such as Crown Publishing and Picador. His jacket design for actor Steve Martin's novel *The Object of Beauty* (2010) was selected for the *Communication Arts Design Annual* and the American Institute of Graphic Arts' 50 Books/ 50 Covers. His personal work includes ongoing experiments with patterns, which have appeared on home furnishings, notebooks, and skis. Booth has an instinctive approach to his creative process. He keeps journals and sketchbooks that are separate from his illustration work; he blogs and tweets, and favors simple briefs that give him *carte blanche* to create. He lives with his family in St. Catherines, Ontario.

Selected Exhibitions
2018, *Society of Illustrators 60th*, group show, New York · 2017, *Heavyweights*, group show, Redefine Gallery, Orlando · 2015, *Society of Illustrators 57th*, group show, New York · 2003, *The Art of Burlesque*, group show, Gladstone Hotel, Toronto · 2003, *Heaven & Hell*, group show, various, USA

Selected Publications
2017, *Expressive Type*, Rockport, USA · 2017, *Society of Illustrators 60*, USA · 2017, *Creative Pep Talk*, Chronicle Books, USA · 2017, *IdN: Illustration in Pattern Making*, International Designers Network, China · 2016, *Illustration Annual*, Communication Arts, USA

U Can Read This, 2019
The Cut & Paste Bureau; digital

p. 72 Blue Grid, 2018
Superfit Hero; acrylic, collage

Monster, 2018
Personal work; digital

> "The drawing process is actually a way of depicting insight in visualized code. It's kind of an infographic about a face."
>
> for John Hopkins University

STEVE BRODNER

Since the late 1970s, Steve Brodner has been keeping the US political establishment in check through his satirical visual commentary. Coming from a long-standing tradition of political caricature, Brodner possesses the deft ability to elicit a response with his informed brand of art journalism. Born in 1954 in Brooklyn, he won the 1974 Population Institute Cartoon Contest—receiving the award from his idol, Al Hirschfield. Upon graduating with a BFA from the Cooper Union in 1976, his first job was as editorial cartoonist for the *Hudson Dispatch* in Union City, New Jersey. His talents were quickly noticed, and commissions followed for *The New York Times Book Review*. In the early 1980s, he began contributing "Ars Politica," a regular monthly feature in *Harper's Magazine*. As the decade progressed, most of the nation's leading editorials were clamoring to print his cutting visual essays, from *Esquire*, *National Lampoon* and *Playboy*, to *Sports Illustrated* and *Spy*. Throughout his career, Brodner has covered numerous campaigns and national political conventions, from the Reagan era through to posting art live on social media during the Trump–Clinton race in 2016. Constantly broadening his platform, he has lectured widely, produced movie caricatures for *Rolling Stone*, poster art for Warren Beatty, and backdrop murals for Alec Baldwin, as well as making several guest appearances on national television. His prolific output was condensed into his book *Freedom Fries* (2004). Among his many accolades, Brodner's 2008 exhibition *Raw Nerve* was the first retrospective by a living illustrator to be presented at the Norman Rockwell Museum in Stockbridge, Massachusetts.

Selected Exhibitions
2018, *Art as Witness*, group show,
School of Visual Arts, New York ·
2018, *American Illustration 38*, group
show, New York · 2018, *Society of
Illustrators*, group show, New York ·
2008, *Artists Against the War*, group
show, Society of Illustrators, New
York · 2008, *Raw Nerve*, solo show,
Norman Rockwell Museum,
New York

Selected Publication
2004, *Freedom Fries*, Fantagraphics
Books, USA

p. 76 Talk to the Hand, 2017
The American Bystander, magazine;
hand drawing, watercolor

Buffoon Tycoon Baboon, 2018
The Nation, online magazine;
hand drawing, watercolor

opposite Worlds Collide, 2017
Village Voice, newspaper;
hand drawing, watercolor, digital

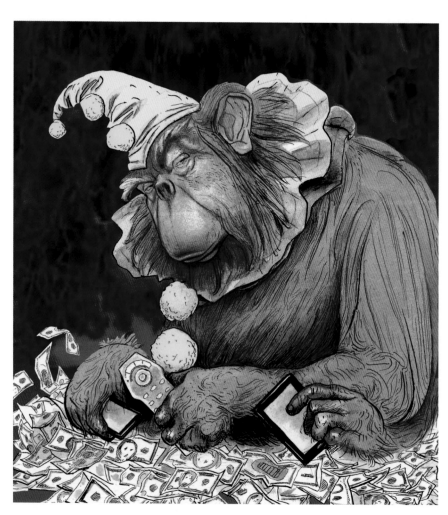

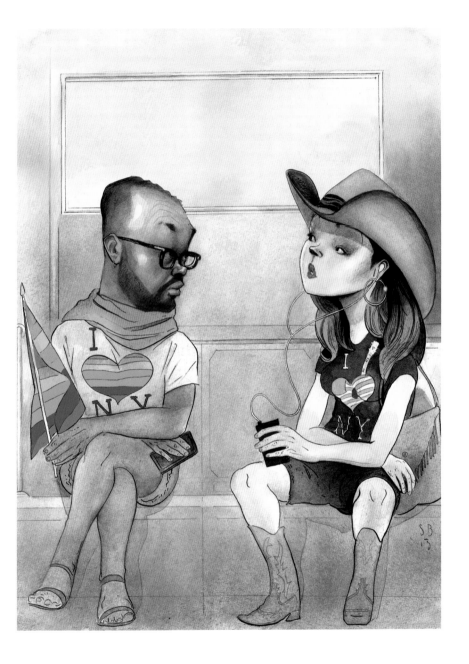

79

Barry, 2018
Riverhead, by Barry Blitt, book;
hand drawing, watercolor, digital

Bridging the Divide, 2016
The Nation, 150th anniversary issue;
hand drawing, watercolor, digital

Cosby, 2017
GQ magazine; hand drawing,
watercolor, digital

"For me, ideas come from the most mysterious of places, so my process tends to be nonlinear."

for *Wow x Wow*

MARC BURCKHARDT

Marc Burckhardt was born in Rüsselsheim, Germany, in 1962, and raised in Waco, Texas. His father was a German academic and his mother a painter from Chicago. Childhood summer vacations in Europe would leave an indelible imprint on his later visual perspective. After studying art history and printmaking at Baylor University, he attended ArtCenter College of Design in Pasadena, graduating with a BFA in 1989. New York beckoned, where he started out as a freelancer, later also teaching at the School of Visual Arts. Imbued with symbolism from myths and fables to religious iconography, Burkhardt's take on the modern world through an art-historical lens offers viewers a fresh perspective. References to the Flemish Masters and English painters of the 18th century abound in his oeuvre, whilst elements of Americana and Mexican folklore emerge from his Texan milieu, resulting in a wonderful interplay of cultural streams. With studios in Austin, Texas and Bremen, Germany, Burckhardt travels back and forth frequently, dividing his time between fine art (his work is part of several notable collections) and commercial illustration. With a client list that scrolls from *Time* magazine and *Rolling Stone* to Sony Music and Pentagram, his arresting imagery has gained him worldwide attention and a slew of awards, including the 2011 Society of Illustrators Hamilton King Award. Burckhardt illustrated *The Legend: Johnny Cash*, which won the 2006 Grammy for Best Limited Edition Box Set Packaging. The singer also commissioned him to paint a portrait of his late wife, June Carter. Burckhardt is a former president of the Icon Illustration Conference.

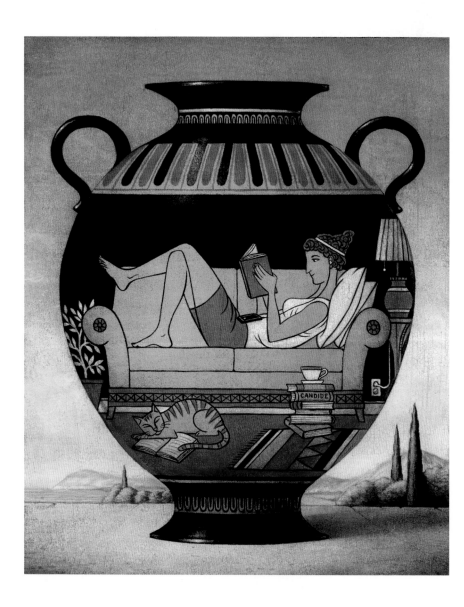

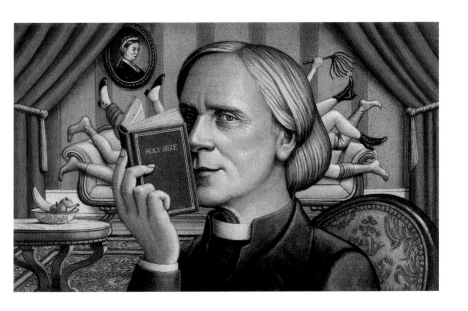

p. 82 Shrinking Animals, 2018
Scientific American, magazine;
acrylic and oil on panel;
art direction: Jason Mischka

opposite Literary Classics, 2016
Denison magazine, EmDash Design;
acrylic and oil on panel;
art direction: Erin Mayes

Archbishop Richard Benson, 2016
Atlantic Monthly, magazine;
acrylic and oil on panel;
art direction: Paul Spella

Ananke, 2017
Copro Gallery, *Blab!*, group show;
acrylic and oil on panel

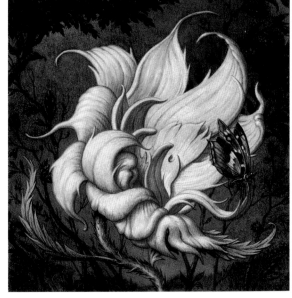

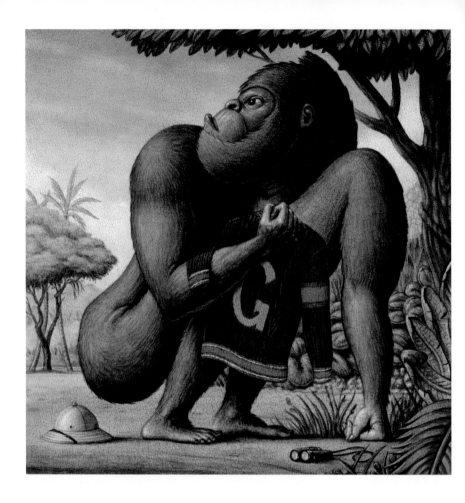

2017, *Ornithology*, solo show, Paul
Roosen Contemporary, Hamburg ·
2016, *Allegorical Narratives*, solo
show, Gallery Shoall Creek, Austin ·
2016, *MenschTierWir*, group show,
Affenfaust Gallerie, Hamburg ·
2014, *Mythmaker*, solo show, Mindy
Solomon Gallery, Miami · 2012,
Cathedral, Silas Marder Gallery,
Bridgehampton, New York

Selected Publications
2017, *Hey! Modern Pop & Culture,*
619 Publcations, France · 2017,
The Illustrated Man, Folio Society,
USA · 2016, *Dante's Inferno,* Easton
Press, USA · 2016, *Virginia
Quarterly Review,* National Journal
of Literature, USA · 2016, *Variations
on a Rectangle,* University of Texas,
USA

opposite Gucci Gorilla, 2018
Gucci, advertising;
acrylic and oil on panel;
creative direction: Alberto Russo

Three Fates, 2016
Gallery Shoal Creek,
Allegorical Narratives, solo show;
acrylic and oil on wood

The Vision, 2016
Paul Roosen Contemporary,
Fault Lines, duo show;
acrylic and oil on paper
mounted on wood

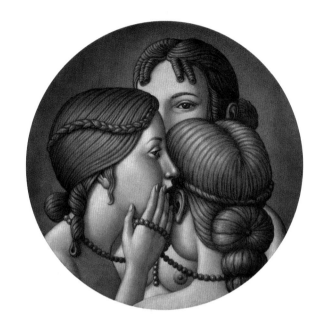

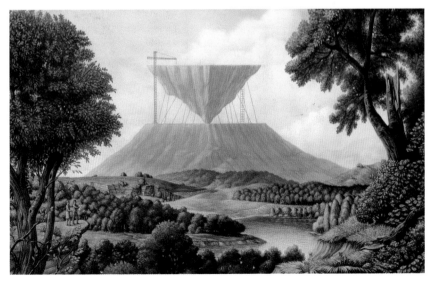

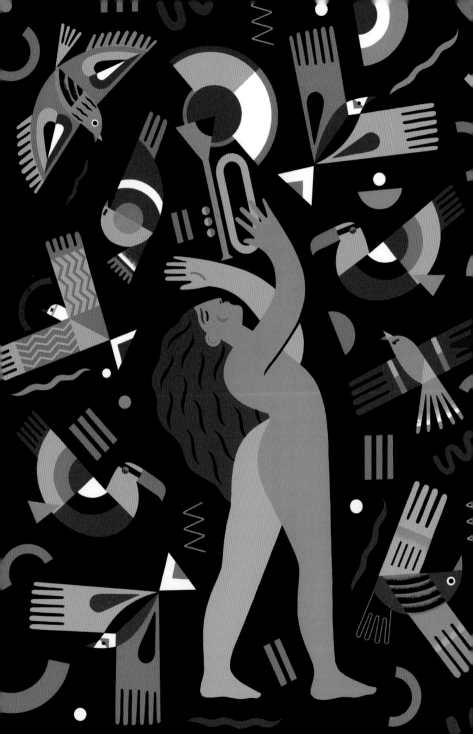

> "Earthy and folk-inspired, my work also draws on fantastical elements and wild imagination."

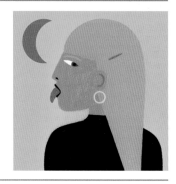

MARGAUX CARPENTIER

Margaux Carpentier's alluring images are characterized by light, color, and pattern. Drawing inspiration from urban and natural environments she creates vibrant works in various scales—from paintings and screenprints to wall-size murals. Tinged with the exotic, her style hints at the Post-Impressionism of Henri Rousseau and the cut-outs of Matisse, mixed with symbolism from world folklore. Born in 1987 in the town of Suresnes, on the outskirts of Paris, she studied in the capital for one year then transferred to the graphic communication degree course at the University of Creative Arts in Surrey, where she graduated in 2010. Together with fellow alumni Lana Hughes and Rory Elphick she formed the creative trio Animaux Circus, noted for producing a broad-ranging portfolio of corporate and educational projects. The group, who have a penchant for wildlife and fantasy scapes, have received several commissions throughout London, from designing a mural at Waterloo Station for Southbank London to conducting creative workshops at Tate Britain and the Victoria and Albert Museum. Carpentier also works as an independent freelancer from her studio in Stoke Newington, North London. Her 2016 solo show *In the Heart of a Whale* at NOW Gallery, part of the fifth East London Comics and Arts Festival, showcased her ability to create a fresh narrative by illustrating on different surfaces, such as 3D sculptures and hanging mobiles.

Selected Exhibitions
2018, *La vie secrete des etres*, solo show,
Print Van Gallery, Paris · 2017,
Blisters, group show, MC Motors,
London · 2016, *Jungle Book Club*,
group show, The Book Club, London
· 2016, *In the Heart of the Whale*, solo
show, Now Gallery, London · 2015,
Art against Knives, group show,
Jealous Gallery, London

p. 88 Incantation, 2018
Personal work; screen print

Le voyage (Stolen Dream), 2018
Personal work; screen print

opposite Farès, 2018
Painting for restaurant;
gouache on paper

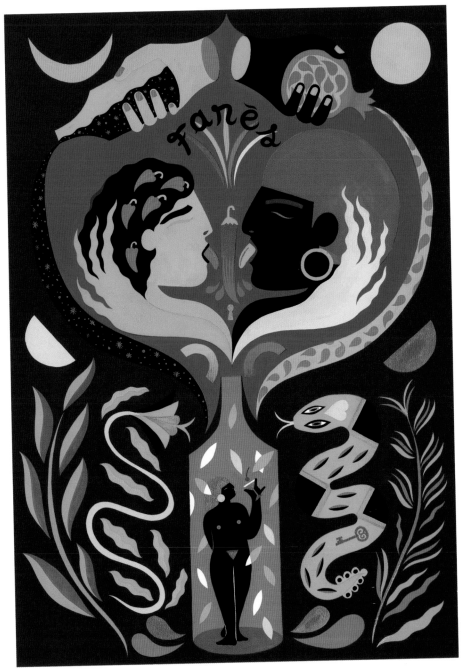

opposite Love at the Time
of Cholera, 2017
Blisters, the Paperback Show,
Print Club, London; screen print

Mandril, 2018
Djeco, Flexanimals Kaleidocycles;
digital

Girlfriends & Messy Hair, 2018
BBC News, "Festival Love Stories"
online article; digital

> "What separates children from animals or plants is as meaningful as what unites them."

HSIAO-RON CHENG

The strange visual world of Taiwanese digital artist-illustrator Hsiao-Ron Cheng reveals a complex interplay of emotion and fantasy, where realist human subjects are juxtaposed or sometimes obscured by flora and fauna in surreal dreamscapes. She describes her work as alluding to "the deformation that physically separates children from plants and animals," with her aim being to convey "different kinds of the fragile and oppressive anima in life." A lifelong Taipei native, Cheng was born in 1986, and gained her BFA from Taiwan University of Art in 2010. After a brief stint as a concept artist for an animation studio, she launched herself as a freelancer, gaining almost immediate attention through her nomination for the 2012 Young Illustrators Award. Cheng's work has since featured in *Communication Arts*, *Hi-Fructose*, *Interview*, and *Juxtapoz* magazine. Her work has also been exhibited in Beijing, Berlin, Chania (Greece), Las Vegas, New York, and Vancouver. Working exclusively with digital tools, Cheng invites the viewer to enter her subconscious realm of muted color. Her projects include jacket artwork commissioned by Pentagram for Penguin Books, interior murals for Sydney-based artisanal chocolatier Zokoko, and album covers for Canadian singer-songwriter Cœur de pirate, and actor-singer and YouTube star Troye Sivan. In 2016, Cheng was invited by Paramount Pictures to the New Zealand set of the movie *Ghost In The Shell*, for which she contributed to the official social media promotional campaign.

Selected Exhibitions

2014, *Castles in the Air*, group show, Mare Gallery, Chaniá, Crete · 2014, *Show #3*, group show, Spoke Art Gallery, San Francisco · 2013, *Illustrative*, group show, Direktorenhaus, Berlin · 2013, *Kindred*, group show, Bold Hype Gallery, New York · 2013, *Image Makers*, group show, O Gallery, Beijing

Selected Publications

2012, *Juxtapoz New Contemporary*, book, USA · 2012, *Joia Magazine*, vol.25, Chile · 2012, *Hi-Fructose Magazine*, #24, USA ·

p. 94 Untitled, 2016
Personal work; digital

Troye, 2018
EMI; digital

opposite Ghost in the Shell, 2017
Paramount Pictures; digital

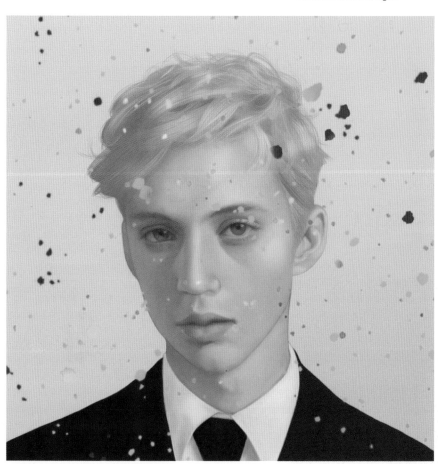

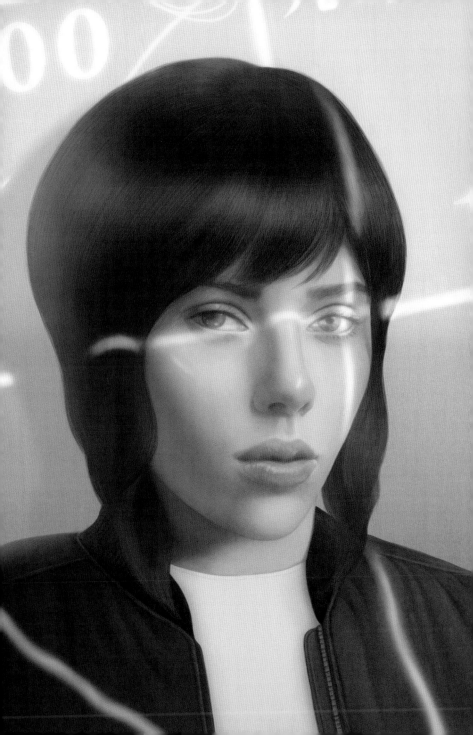

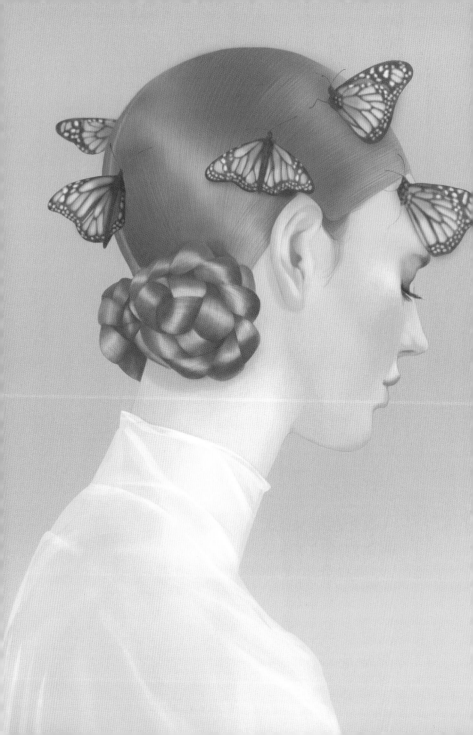

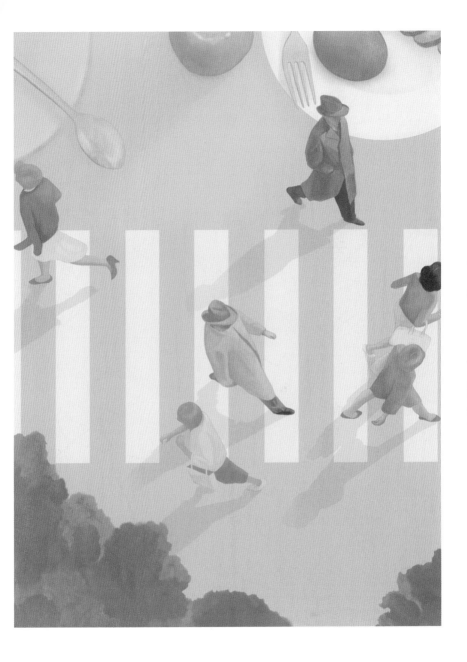

opposite Untitled, 2016
Personal work; digital

Untitled, 2015
Personal work; digital

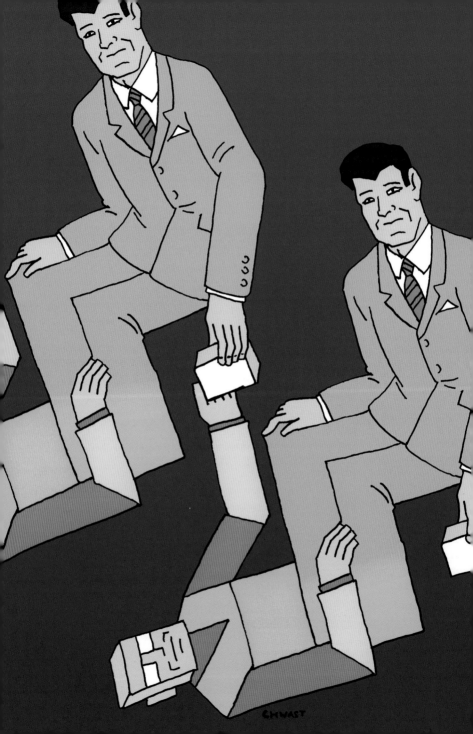

> "Generalists have more freedom, which helps us stay enthusiastic. My lack of specialization has allowed me to explore many different ways to solve problems."
>
> for *Design Boom*

SEYMOUR CHWAST

For six decades, Seymour Chwast has been reinventing the wheel of graphic illustration in an oeuvre that has left an indelible imprint on American visual culture. Born in the Bronx in 1931, he attended the Cooper Union, receiving his BFA in 1951. Together with Milton Glaser, Reynold Ruffins, and Edward Sorel, he founded the legendary Push Pin Studios in 1954. With his unique brand of absurdist wit, Chwast was instrumental in transforming the commercial art landscape in the 1950s and 1960s. He supplanted the nostalgic realism of Norman Rockwell, reviving period styles beyond mere pastiche—taking socio-historical and cultural referents and graphically sculpting them in a way that captured the aesthetics of the zeitgeist—all the while laying conceptual foun-dations for successive generations of visual communicators. From expressionist woodcuts to bold flat colors, Chwast has experimented with the complete gamut. An obsessive innovator, he created typefaces, including Artone (1964) and Blimp (1970), and was an early adopter of merchandizing his creations. In 1983, he was inducted to the Art Directors Hall of Fame. Two years later saw the publi-cation of his first monograph, *The Left-Handed Designer*. Chwast's work has appeared in editorials, book covers, record sleeves, packaging, animation, and stage backdrops. His illustrations belong to several major collections. In 2015, the D.B. Dowd Modern Graphic History Library at Washington University acquired a complete collection of Chwast's posters. Among his many accolades are honorary doctorates from Parsons School of Design and Rhode Island School of Design. Chwast lives and works in New York with his wife, the renowned graphic designer Paula Scher.

Selected Exhibitions
2019, solo show, Binghamton
University Museum of Art, New
York · 2018, solo show, Bienal
Internacional del Cartel en México ·
2018, *Art as Witness*, group show,
School of Visual Arts, New York ·
2016, *Poster Power*, solo show, Payne
Gallery at Moravian College,
Bethlehem · 2016, *All the Wars*,
solo show, Society of Illustrators,
New York

Selected Publications
2018, *The Jickle and Other Curious
Pets*, Page Publishing, USA · 2017,
*At War with War: 5000 Years of
Conquests, Invasions, and Terrorist
Attacks – An Illustrated Timeline*,
Seven Stories Press, USA · 2016,
The Pancake King, Phyllis La Farge,
Princeton Architectural Press, USA ·
2015, *Dr. Dolittle*, Creative Company,
USA · 2009, *Seymour: The Obsessive
Images of Seymour Chwast*, Chronicle
Books, USA

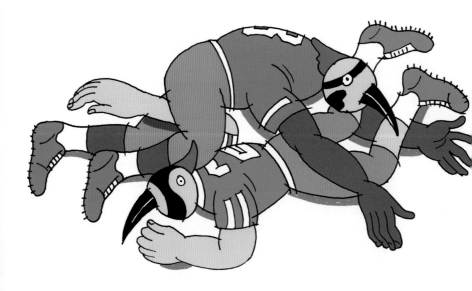

p. 100 Artificial Intelligence, 2017
MIT Technology Review, drawing
and ink on paper, digital color

How Woodpeckers Will
Save Football, 2016
Nautilus, magazine;
ink on paper, digital color

opposite Who Are All These
Trump Supporters?, 2016
The New Yorker, magazine;
ink on paper, digital color

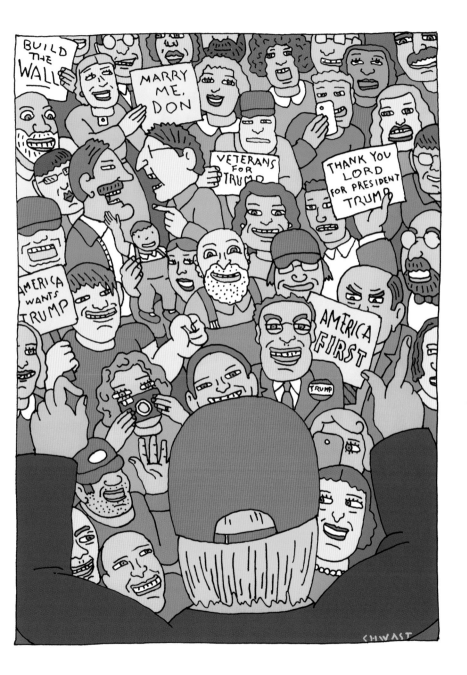

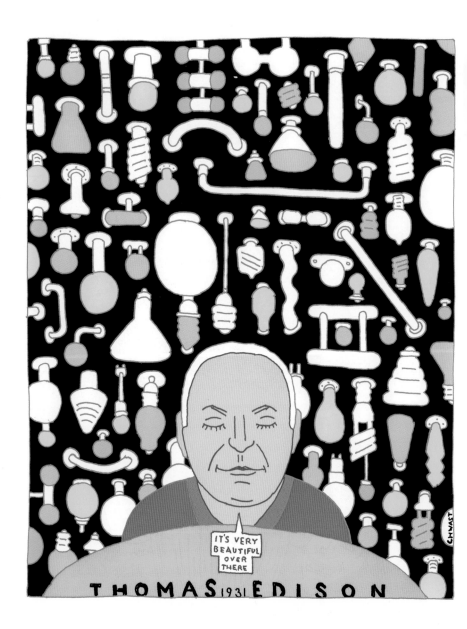

THOMAS 1931 EDISON

IT'S VERY BEAUTIFUL OVER THERE

opposite Famous Last Words, 2017
Print magazine; ink on paper,
digital color

The Light Years, 2016
Playwrights Horizons;
ink on paper, digital color

Captain America, 2018
Personal work; woodcut

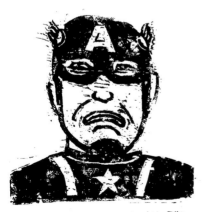

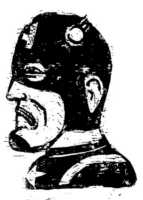

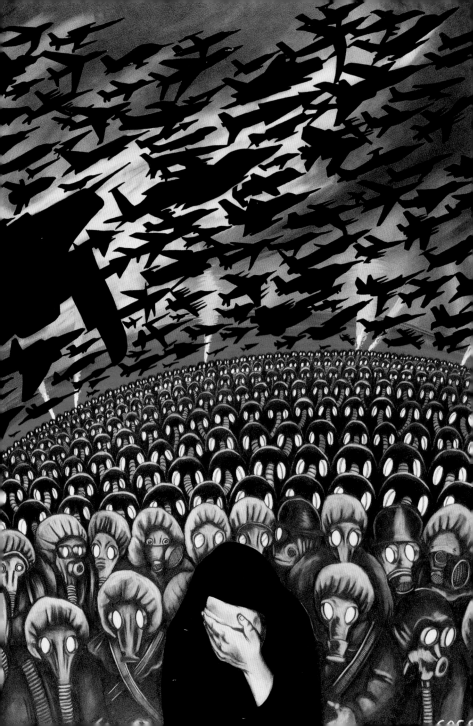

"I prefer pencil then woodcut then litho. I prefer to draw as if I am painting and cut wood like a drawing. It's elegant and simple."

for Parsons School of Design

SUE COE

Sue Coe's Twitter account profile reads: "Vegan Artivist," an apt self-description for the British artist who has devoted her entire career to giving a visual voice to activism. Born in Tamworth, Staffordshire, in 1951, Coe grew up near a farm slaughterhouse, an experience that would later spur her on a personal crusade for social change. Accepted at Chelsea School of Art in London at the age of 16, she received her BA in 1970, then enrolled in the Royal College of Art. After graduating with an MA in Graphic Design, Coe moved to New York, where she lived and worked from 1972 to 2001, before relocating upstate. She draws and makes prints in woodcut and lithograph, with a graphic style that veers from neo-expressionist to realist and harks back to the nightmarish imagery of Hieronymus Bosch, the dystopian terror of Orwell, and the panoramic scale of Sebastião Salgado. Coe's books, comics, and visual essays have spotlighted such highly charged topics as factory farming, meat packing, apartheid, sweat shops, prisons, AIDS, and war. Her work has been published in *The Nation*, *Newsweek*, and *Mother Jones*, among countless others. Since the late 1990s, Coe has used her exhibition platforms to raise funds for animal rights organizations. Her work is in several major collections, including Cooper Hewitt, the Museum of Modern Art (MoMA), and the Stedelijk Museum in Amsterdam. In 2013, she was a visiting artist at Parsons School of Design, where she taught about social awareness in art. A full Academician of the National Academy of Design since 1994, Coe has been recognized by several prominent institutions. In 2017, she received a Southern Graphics Council International Lifetime Achievement award in printmaking.

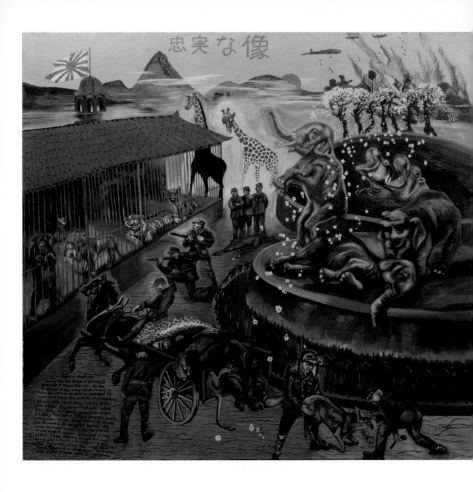

忠実な像

Selected Exhibitions

2018, *All Good Art is Political: Käthe Kollwitz & Sue Coe*, group show, Galerie St. Etienne, New York · 2018, *Graphic Resistance: Sue Coe*, solo show, MoMA PS1, New York · 1994, *Sue Coe*, solo show, Hirshorn Museum and Sculpture Garden, Washington, D.C. · 1989, *Porkopolis: Animals and Industry*, solo show, Galerie St. Etienne, New York · 1987, *Police State*, solo show, traveling exhibition, USA and Europe

Selected Publications

2018, *Zooicide,* AK Press, USA · 2017, *The Animals' Vegan Manifesto,* OR Books, United Kingdom · 2012, *Cruel,* OR Books, United Kingdom · 1996, *Dead Meat,* Four Walls Eight Windows, USA · 1992, *X. The Life and Times of Malcolm X,* The New Press, USA

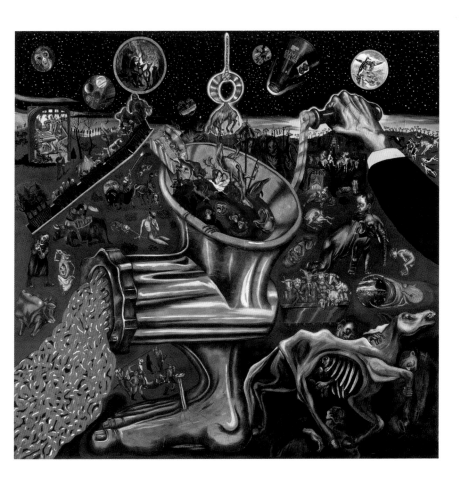

p. 106 War, 1991
Private collection, courtesy
Galerie St. Etienne, New York

opposite Faithful Elephants, 2009
Courtesy Galerie St. Etienne,
New York

Second Millennium, 1998
Courtesy Galerie St. Etienne,
New York

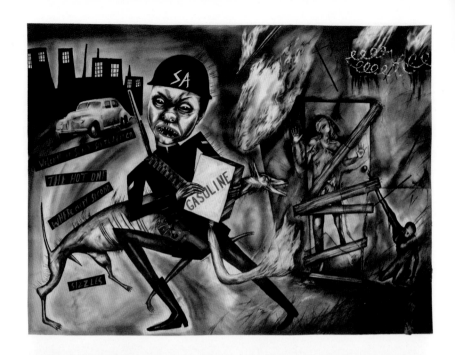

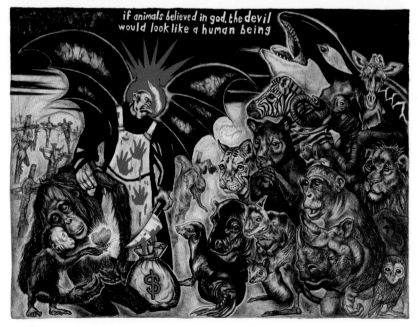

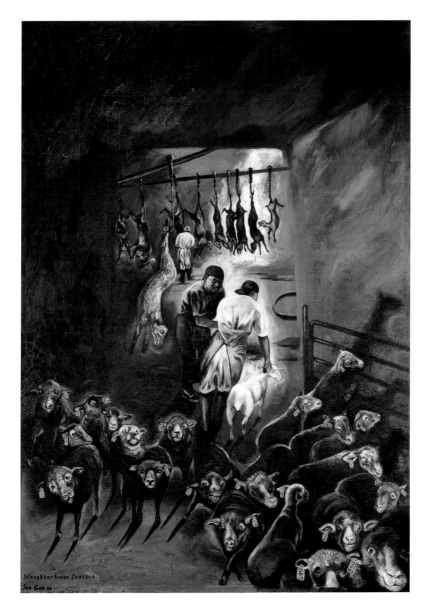

Slaughterhouse Trenton
Sue Coe 06

opposite top Welcome to
Sunny South Africa, 1983
Courtesy Galerie St. Etienne,
New York

opposite bottom If Animals
Believed in God the Devil Would
Look Like a Human Being, 2018
Courtesy Galerie St. Etienne,
New York

Slaughterhouse Trenton, 2006
Courtesy Galerie St. Etienne,
New York

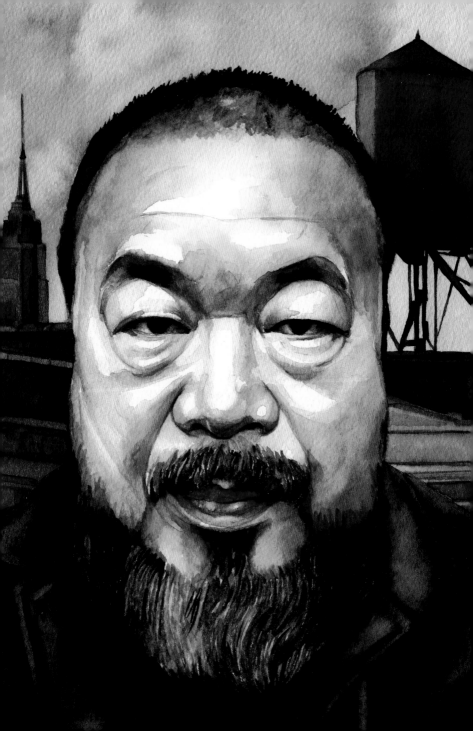

> "I believe in the magic of the painting so when I do a portrait I feel close to the model, even if I don't know him or her."

ALEXANDRA COMPAIN-TISSIER

Alexandra Compain-Tissier is a French illustrator renowned for her work in the fashion, style, music, and publishing arenas. Her personal passion is for the intimacy of books and exhibitions that bring her work in direct contact with the viewer. Born in Versailles in 1971, she dreamt of being a painter from the age of 13. After graduating from the Paris-Cergy National School of Arts with a Higher National Diploma in Plastic Arts in 1995, she spent three years living and working in New York at the turn of the millennium. Upon her return she published her first book, a collection of pencil drawings from photographs called *Dumbo Alex* (2001). A foray into animation resulted in a music video for the band TTC on the Ninja Tune label before she joined American creative agency Art Department. Compain-Tissier approaches her subjects with a warmth and affinity, creating observational studies that range from portraits to still lifes and outdoor environments. As well as having been displayed in exhibitions around the world, her natural, realist style of watercolors or high-contrast pencil work have enriched the pages of *Elle*, *GQ*, *Cosmopolitan*, and *Dazed & Confused*, whilst her list of clients includes Air France, LVMH, Diesel, and American Express.

Selected Exhibition
2017, *Ambassade Excellence*, group
show, Renaissance Palace, Paris

Selected Publications
2013, *Anouck*, Ding ding dong
éditions, France · 2001, *Dumbo Alex*,
Éditions Flux, France

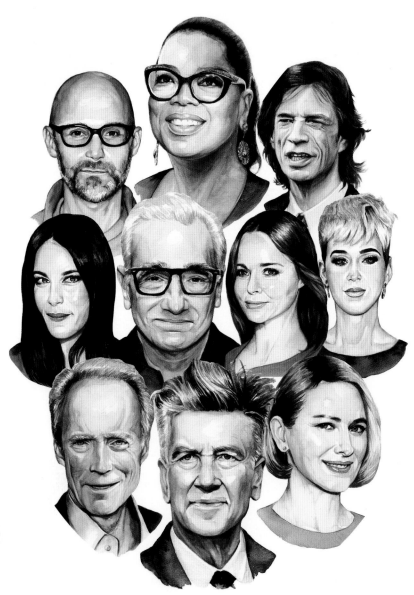

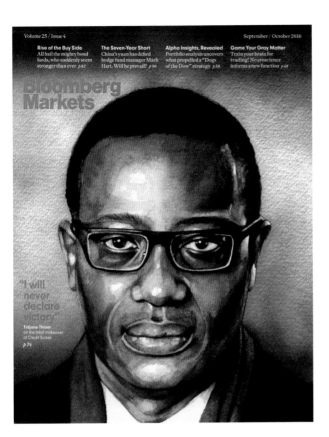

Rise of the Buy Side
All hail the mighty bond lords, who suddenly seem stronger than ever *p.82*

The Seven-Year Short
China's yuan has defied hedge fund manager Mark Hart. Will he prevail? *p.90*

Alpha Insights, Revealed
Portfolio analysis uncovers what propelled a "Dogs of the Dow" strategy *p.58*

Game Your Gray Matter
Train your brain for trading? Neuroscience informs a new function *p.48*

Bloomberg
Markets

"I will never declare victory"

Tidjane Thiam
on the total makeover of Credit Suisse
p.74

p. 112 Ai Weiwei, 2017
ArtNews magazine; watercolor

opposite Stars, 2018
Grazia magazine; watercolor

Tidjane Thiam, 2016
Bloomberg Markets magazine;
watercolor

Sharon Stone, 2018
V Magazine; watercolor

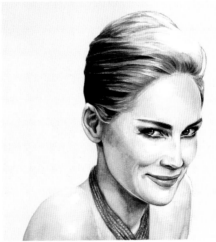

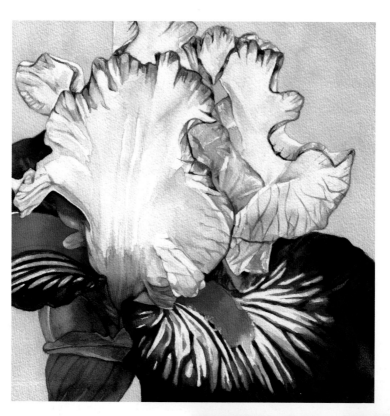

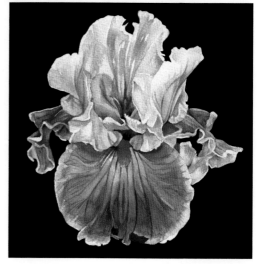

Iris Cristal & Iris Opéra, 2017
Personal work, exhibition,
Ambassade excellence,
Hôtel Renaissance République;
watercolor on fine art paper

opposite Still life, 2017
Grazia magazine; watercolor

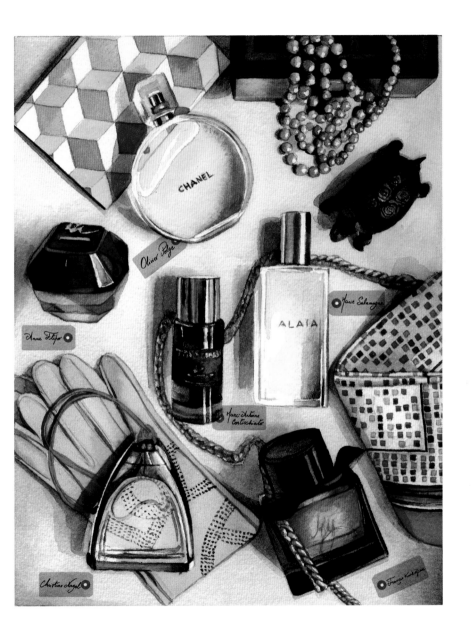

CHANEL

Oliver Polge

ALAÏA

Marie Salamagne

Anne Flipo

Marc-Antoine Corticchiato

Christine Nagel

Francis Kurkdjian

117

> "I always try to create a marriage between a good synthesis of the character and its image, and a solid idea, no matter how simple it is."

COSTHANZO

Augusto Costhanzo (simply known by his family name) was born in Buenos Aires in 1969. Raised within an artistic family he took to pen and paper as soon as he could walk, later enrolling in local art classes at 15. His inspirations were the titan Argentine graphic humorists of the day, such as Roberto Fontanarrosa, Caloi, and Quino. From the outset of his career in 1989, Costhanzo worked in various styles, eventually synthesizing these into his now identifiable look. Loaded with wit, Costhanzo's appealing imagery is wonderfully simple, with well-known personalities from the arts, film, music, entertainment and sport as recurring inspirations. Using an economy of bold outlines and flat colors, his signature front-facing, near-symmetrical caricatures are endearing. Costanzho's delightfully pictographic take on the world has transcended the borders of his native Argentina, where his work is part of the cultural fabric. Absolut Vodka, *AdWeek*, *Corriere della Sera*, *El País*, and *Vanity Fair* are just a few of his international clients. Costhanzo is of that ilk of illustrator to have successfully married a traditional practice with digital tools. To redress the balance, he enjoys escaping his studio and creating murals whenever he can.

Selected Exhibitions

2018, *Costhanzo en su laberinto*, solo
show, Usina del Arte, Buenos Aires ·
2011, *AC/DC*, solo show, Parque
España, Rosario · 2010, *AC/DC*,
solo show, Centro Cultural Recoleta,
Buenos Aires · 2004, *Muertes
vulgares para animales célebres*,
solo show, Centro Cultural España,
Córdoba · 2002, *Muertes vulgares
para animales célebres*, solo show,
Centro Cultural Recoleta,
Buenos Aires

p. 118 Costhanzo en su
laberinto, 2018
Usina del Arte, solo show, poster;
vector

Guillermo Del Toro, 2018
El País, newspaper article; vector

opposite Stephen King, 2017
Personal work, poster; vector

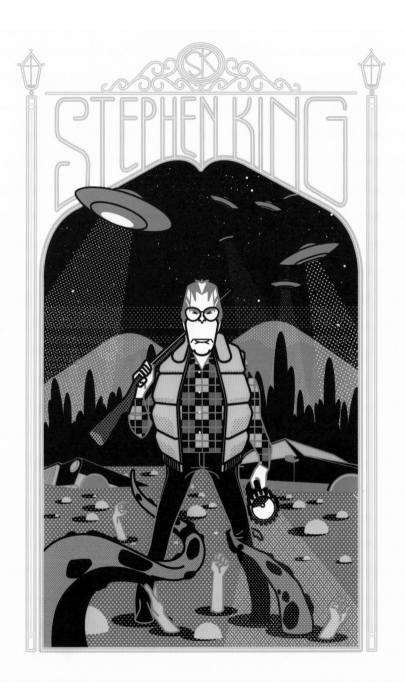

STEPHEN KING

opposite New York, 2017
Personal work, "Music & Cities"
poster series; vector

Seinfeld, 2016
Personal work; vector

Sherlock, 2017
Personal work; vector

123

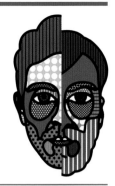

"So much of what we love and do feeds into our work, and vice versa, so it never really feels separate from life." for *Design Boom*

CRAIG & KARL

Craig & Karl are an Antipodean art and design duo producing some of the most colorful and striking communication graphics on offer today. Both born in 1978, and hailing from Australia, Craig Redman (Gloucester, New South Wales) and Karl Maier (Gold Coast, Queensland) met on their first day at Queensland College of Art in Brisbane and have been joined at the creative hip ever since. Following their graduation as bachelors of design studies, the pair joined forces with a few college mates to form the acclaimed Rinzen art and design collective, before honing their skills in corporate identity at the same Sydney design studio. When Craig transplanted to Manhattan's Lower East Side in 2007 and Karl moved to London in 2012, their transatlantic collaboration blossomed—the pair officially launching as a joint brand in 2011. The duo epitomize cloud-based collaboration—ideas ping back and forth through the wonders of Skype and Dropbox. Craig & Karl's unique form of graphics contains a collision of high- and low-culture references. Bold colors, often in thick-tubed outlines, purvey their "crazy, pop stylings," as Maier puts it. From famous portraits (such as Obama's 2012 re-election for the cover of *New York* magazine) and mural installations like the sensory-exploding *72DP* in a Sydney car park, to packaging for Wacom and Nespresso, Craig & Karl like to keep things fresh, leapfrogging from medium to medium. Transcending the realms of branding, accessories, editorial, and public art, the pair have also exhibited worldwide, including at the Museum of Advertising in the Louvre, and the Liu Haisu Art Museum in Shanghai.

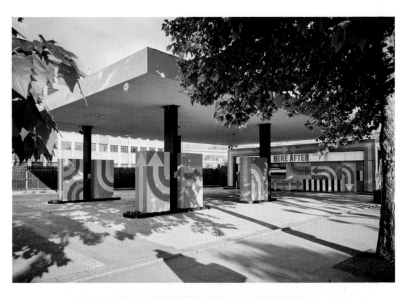

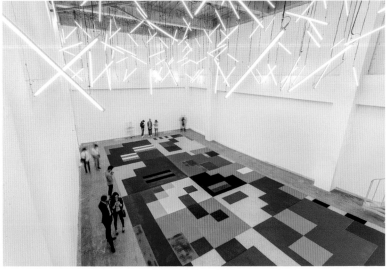

Here After, 2017
Stanhope, installation;
acrylic; agency: Purple PR

Optimystic, 2016
Personal work, installation;
colored sawdust

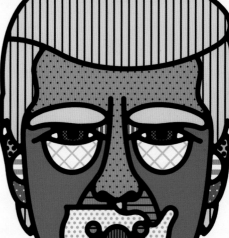

p. 124 Tropics, 2016
Personal work; vector

Trump, 2017
Süddeutsche Zeitung Magazin,
cover; vector; art direction:
Christian Toensmann

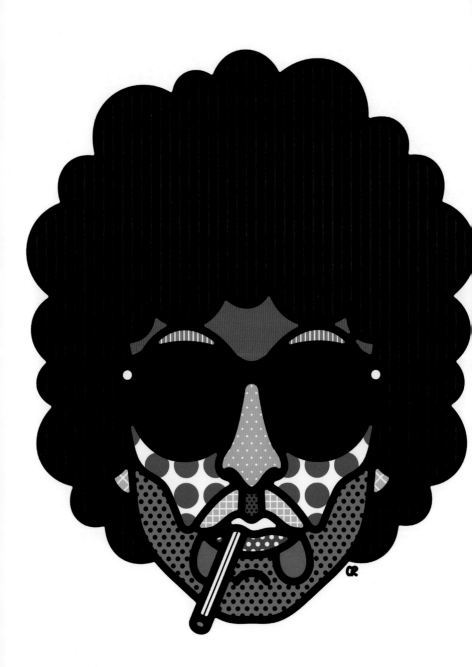

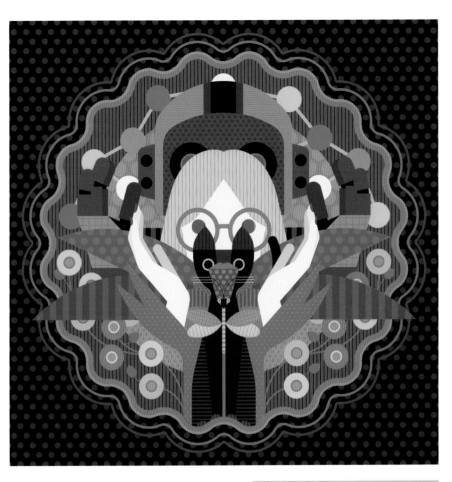

opposite Bob Dylan, 2018
Personal work, poster; vector

So It Grows, 2016
Wacom, packaging, digital, print;
vector; agency: Hazel Brands

Baskin-Robbins, 2018
packaging; vector

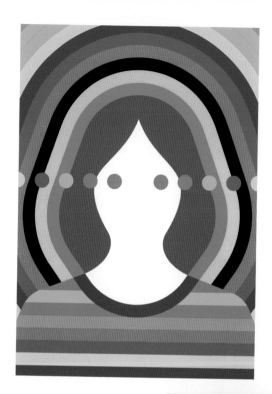

Selected Exhibitions
2018, *Shanghai Art & Design*, group show, Liu Haisu Art Museum, Shanghai · 2017, *Here After*, solo show, White City, London · 2016, *Optimystic*, solo show, Fox International, Guatemala City · 2016, *Wow*, group show, C-Mine Cultural Institution, Genk · 2016, *Creep*, solo show, M-One, Manchester

Selected Publications
2018, *It's Nice That*, United Kingdom · 2018, *Computer Arts*, United Kingdom · 2018, *Playboy*, USA · 2018, *Graphic Fest*, Victionary, Hong Kong · 2017, *Design Boom*, USA

Woah, 2017
Personal work; vector

Mexico City,
Roma Norte, 2018
Personal work; vector

opposite Grace Jones, 2016
Another Planet Entertainment,
poster; vector

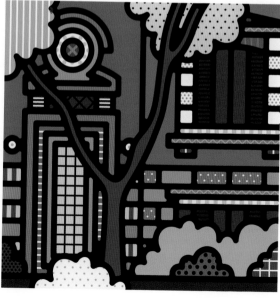

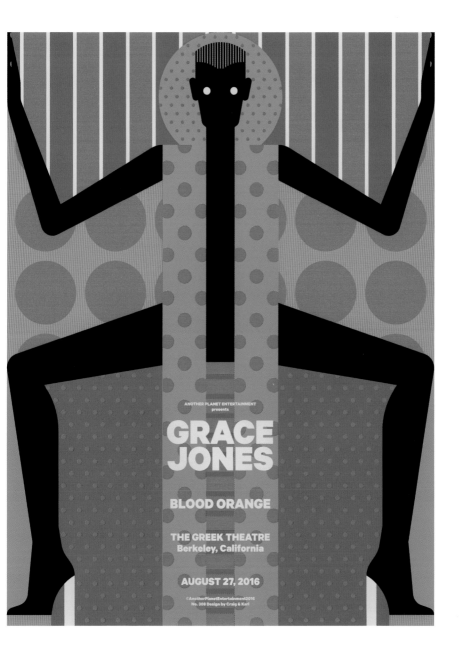

ANOTHER PLANET ENTERTAINMENT
presents

GRACE
JONES

BLOOD ORANGE

THE GREEK THEATRE
Berkeley, California

AUGUST 27, 2016

©AnotherPlanetEntertainment2016
No. 208 Design by Craig & Karl

131

> "I am a traditional artist, through and through. I like working with my hands and feeling the art grow under my fingertips."

CUSTOM, BY SOPHY

"Death inspires me like a dog inspires a rabbit," muses Custom, by Sophy on her Instagram profile. The artist and illustrator behind the moniker is Sophia Fredriksson, a freelancer based in the city of Kristianstad, Sweden. Born in Enköping in 1983, she found an early creative outlet working as a tattoo artist whilst still at high school. Later, she got a job as a scientific illustrator. Both disciplines would influence her style and approach. After a period of designing shoes and accessories as a hobby, Fredriksson amalgamated her interests into a self-employed practice in 2015. Primarily drawn with inks, including ballpoint pen—though she also uses watercolor and gouache—her subjects are folkloric and darkly mythical. It's a world inhabited by nature spirits and fantastic creatures—beautiful anatomical renderings fused by flora and fauna and rune symbols. She draws inspiration from queer feminism and literature. Fredriksson graduated with a BA in Information Design from Mälardalen University in 2010. She also has a BA and MA in English Language and Literature from Dalarna University, where she graduated in 2013. As well as undertaking commissions, Fredriksson has created a range of limited-edition prints, from Tarot cards to her *100 Days of Anatomical Hearts* project, for which she interpreted the human organ in a richly eclectic series of drawings.

p. 132 Black Elf, 2018
Personal work;
fineliner pen on paper

The Day the Mountain
Came to Visit, 2018
Personal work; ballpoint
pen on paper

opposite The Kraken, 2018
Personal work;
fineliner pen on paper

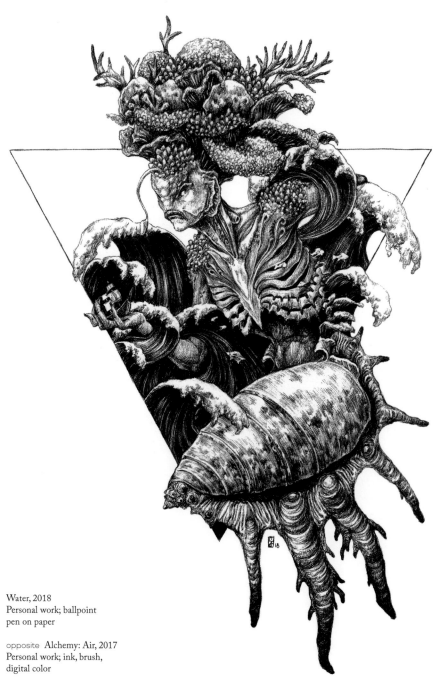

Water, 2018
Personal work; ballpoint
pen on paper

opposite Alchemy: Air, 2017
Personal work; ink, brush,
digital color

 137

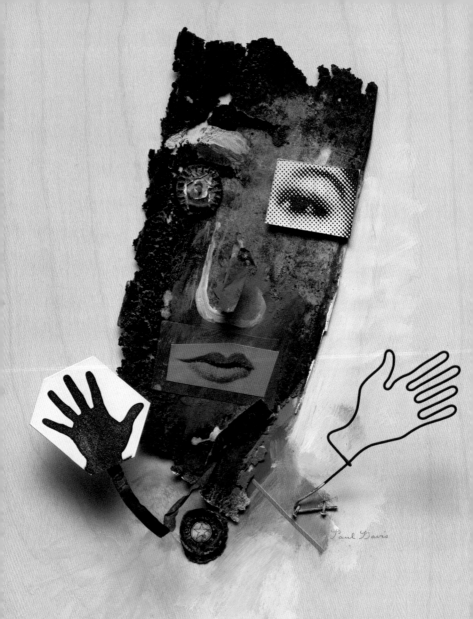

Paul Davis

> "I am most satisfied in my work when I am able to convey some sense of the peculiar and particular emotional qualities that I perceive in daily life."

PAUL DAVIS

Paul Davis belongs to that generation of illustrators swept along by the tide of revolt in late-1950s America. His ability to blend in new forms made him a driving force during the 1960s and 70s: "Style is a voice one chooses for its effect, and I want to be able to use as many voices as possible," he once remarked. Born Paul Brooks Davis in Centrahoma, Oklahoma, in 1938, he left for New York at 17, where he took classes at the Cartoonists and Illustrators School (later the School of Visual Arts). His first commission came via Art Paul, the founding art director of *Playboy*. In 1959, Davis landed a job at Push Pin Studios. Inspired by the incendiary Pop Art of Jasper Johns and Robert Rauschenberg, he began distilling the essence of American folk art with a touch of surrealism. Davis left Push Pin in 1963 and began his solo ascent. Regular assignments for the likes of *Sports Illustrated* and *Esquire* gave him artistic freedom. In 1967, his portrait of Cuban revolutionary Ernesto Che Guevara for the cover of *Evergreen Review* became an era-defining poster. The 1970s heralded further departures from style and convention, notably in his typographic experiments in the theater posters for Joseph Papp's New York Shakespeare Festival. Davis would later assume art directorship of the festival itself. In 1977, a solo exhibition of his works formed part of the opening of the Centre Georges Pompidou in Paris. He was awarded the prestigious American Institute of Graphic Arts medal in 1989. Davis lives in Sag Harbor, New York.

p. 138 Imagine, 2002
Personal work; mixed media

Blue Bottle, 2001
Personal work; collage, acrylic

opposite Pride, 2005
Personal work; mixed media

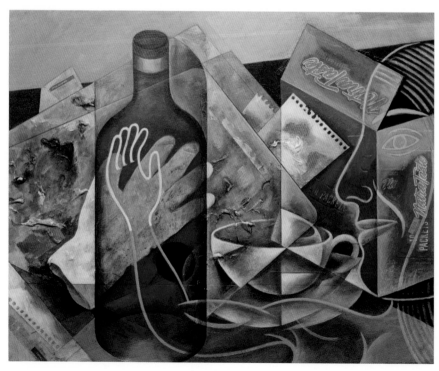

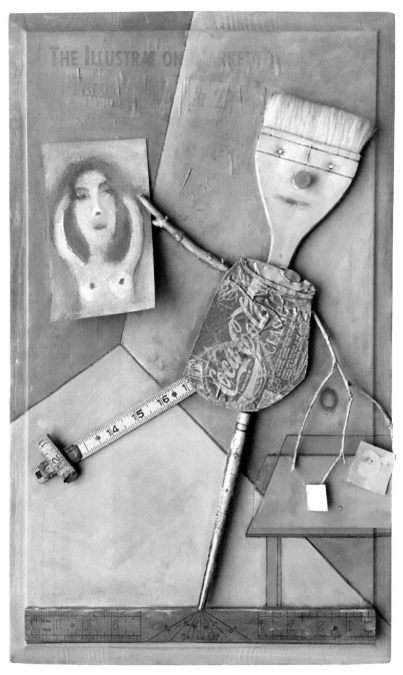

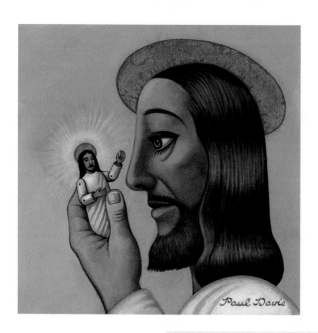

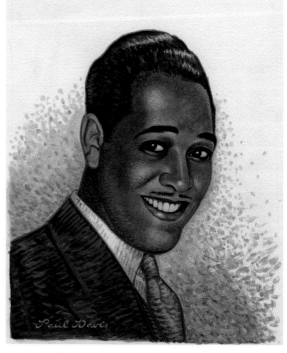

American Jesus, 2003
Boston Magazine; acrylic;
art direction: Robert Parsons

Duke Ellington, 2010
Jazz at Lincoln Center,
program cover; acrylic

opposite I. L. Peretz, 2015
Pakn Treger, magazine cover;
acrylic; art direction:
Alexander Isley

142

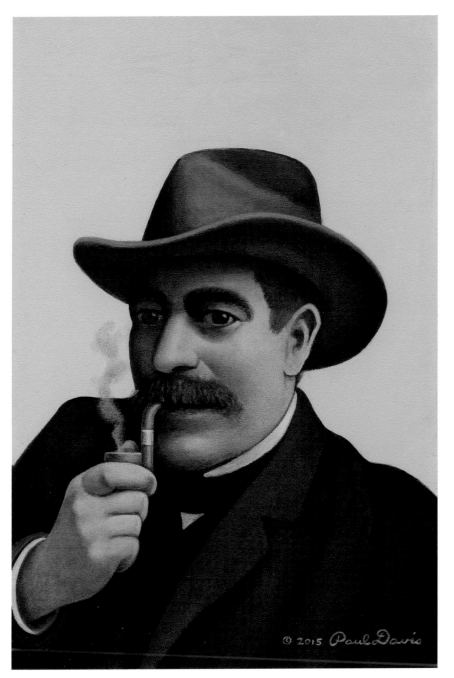

© 2015 Paul Davis

> "I aim to express someone's personality with the minimum of essential details. I always suggest the body language and physical presence, not just the face."

JEAN-PHILIPPE DELHOMME

Painter, writer, poet, and satirist, Jean-Philippe Delhomme is a cultural chronicler with a sharp eye and visual wit. Born in Nanterre, France, in 1959, Delhomme's creative bent was shaped whilst growing up in Normandy and later Paris. His surgeon father was an amateur landscape painter while his grandfather became the first Creative Director of Lancôme. He studied at the National School of Decorative Arts in Paris but felt disconnected from the abstract leanings of his contemporaries. Seeing the touring exhibition *Hockney Paints the Stage* in 1983 was a turning point for Delhomme, inspiring him to experiment with different media. He began to play with snapshot photography as a basis for his illustrational process. After transporting himself to New York, he soon began circulating in and capturing the *beau monde* milieu in what would become his customary, lampooning cartoon style. Through his quivering gouache fills or color pencil and pastel flourishes, Delhomme's quick, whimsical style has provided the perfect antidote to glossy photo ads aimed at the luxury brand customer—a notable example being his award-winning ad campaign for Barney's New York in the early 1990s. Along with a slew of self-penned and illustrated novels and columns under his by-line, and visual observations in almost every fashion publication of note, Delhomme has exhibited worldwide, produced animated ads for Saab USA and Visa France, and created postcard collections for Moncler. He lives and works in Paris.

Selected Exhibitions

2019, *Fina Estampa*, group show,
ABC Museum, Madrid · 2017,
Studio aux dimensions variables, solo
show, Lucien Terras, New York ·
2017, *Dessins de Mode*, solo show,
Galerie Martine Gossieaux, Paris ·
2015, *Bushwick Landscape*, solo show,
Lucien Terras, New York · 2013,
New York, solo show, Galerie Martel,
Paris

Selected Publications

2019, *Artists Instagrams,* August
Editions, USA · 2018, *M Le Mag,*
Le Monde, France · 2018,
Purple Magazine, France · 2017,
Apartamento Magazine, Spain ·
2013, *The Unknown Hipster Diaries,*
August Editions, USA

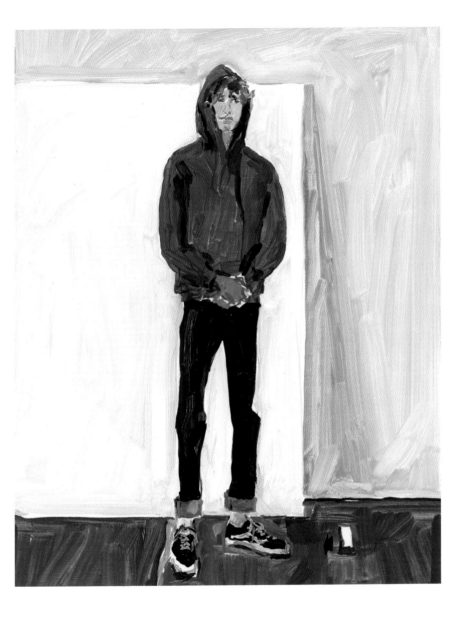

p. 144 Margiela, 2018
Document Journal, magazine;
gouache; creative direction:
Nick Vogelson

opposite Lomane, 2018
Personal work; oil

Emile with Blue Hood, 2017
Personal work; oil

Gramercy Park, 2017
August Journal, magazine;
color pencil

LA Sunset, 2018
Personal work; oil

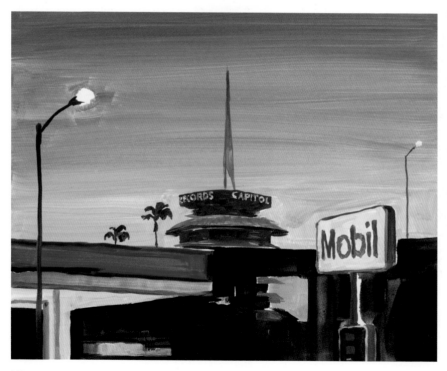

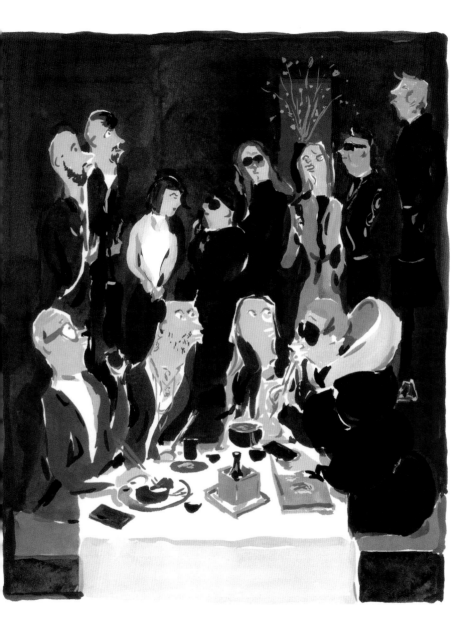

Fashion Gossips, 2018
System magazine;
gouache; creative direction:
Thomas Lenthal

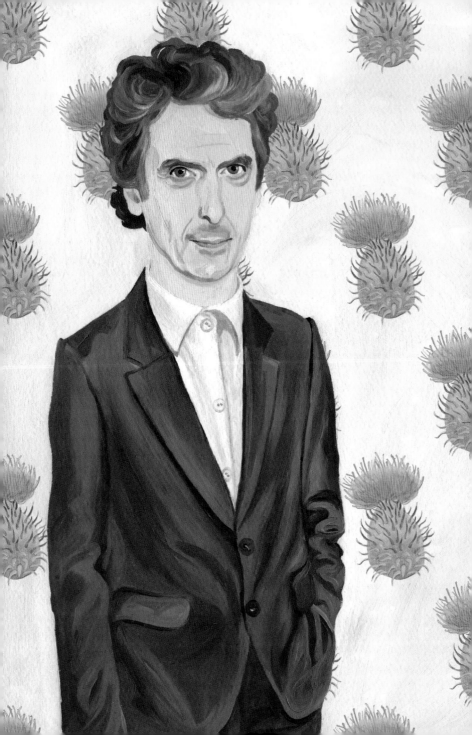

"I like to capture a face at its most vulnerable, with all the interesting imperfections. No gloss, no fluff, just the raw basics with a depth of character."

VANESSA DELL

British artist Vanessa Dell draws and paints everything from objects to landscapes and seascapes, but is best known for her endearing, colourful, and uncannily real portraits. She renders her subject's features with the slightest of hint of caricature, choosing oils or colored pencils as her preferred media, with Photoshop occasionally used for composition and touching up in the latter stages. Dell was born in Carshalton, Surrey, in 1983. Her interest in faces evolved from drawing cartoon characters like Bugs Bunny and Sylvester the Cat. Later influences would include Lucian Freud, Stanley Spencer, Peter Blake, Sidney Nolan, and Patrick Heron. In 1995, she attained a degree in graphic design from Kingston University and has since gone on to enjoy a successful career illustrating book covers, magazine features, posters, and ad campaigns both in the UK and abroad. As well as working with a host of commercial clients, including *Time Out*, the BBC, Macmillan Publishers, and Saatchi & Saatchi, Dell also undertakes private portrait commissions and produces her own fine art. She is based in Surrey, where she lives with her family and an Irish Terrier named Twiggy.

Selected Publications
2015, *Stellenwert,* Stampfli Verlag,
Switzerland · 2013, *100 Illustrators,*
TASCHEN, Germany ·
2010, *Illustration Now! Portraits,*
TASCHEN, Germany · 2005,
Illustration Now! Vol.1, TASCHEN,
Germany

p. 150 Peter Capaldi, 2017
Personal work; oil and colored
pencils on paper

opposite Hilary Haters, 2016
Slate Magazine, oil on paper

Housing's Diversity Challenge, 2017
Inside Housing magazine;
oil on paper, digital

The Labor Game, 2018
Greenhouse Management magazine
cover; oil, gouache, and colored
pencils on paper

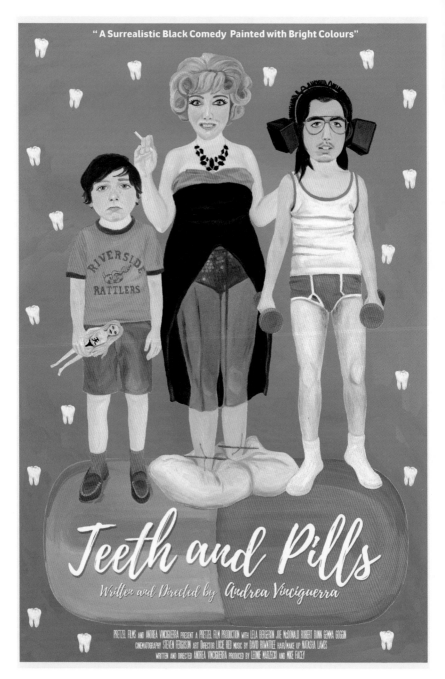

"A Surrealistic Black Comedy Painted with Bright Colours"

Teeth and Pills

Written and Directed by Andrea Vinciguerra

PRETZEL FILMS and ANDREA VINCIGUERRA present a PRETZEL FILM PRODUCTION with LELA BERGERON JOE McDONALD ROBERT DUNN GEMMA BIGGIN
CINEMATOGRAPHY STEVEN FERGUSON ART DIRECTOR LUCIE RED MUSIC BY DAVID ROWNTREE HAIR/MAKE UP NATASHA LAWES
WRITTEN AND DIRECTED ANDREA VINCIGUERRA PRODUCED BY LEONE MARZECKI and MIKE FACEY

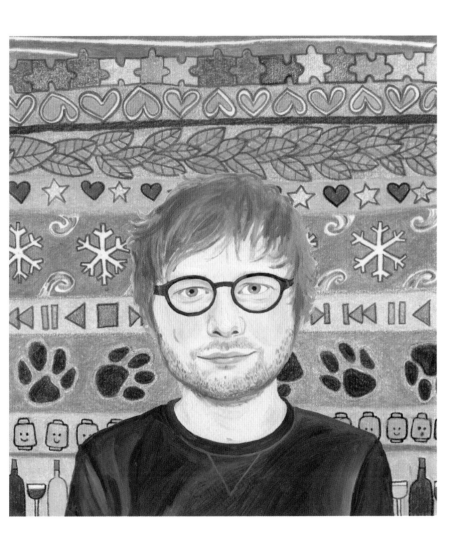

opposite Teeth & Pills, 2018
Poster; oil and gouache on paper

Ed Sheeran, 2017
Personal work; oil and
pencil on paper

"I'm a big disciple of
using abstraction to highlight
emotional conditions."
for *AI-AP*

MATT DORFMAN

Employing a cut-and-paste style akin to the Dadaist photomontages of John Heartfield, the kitchen-sink psychedelia of Victor Moscoso, and the pioneering graphic communication of Quentin Fiore—all of whom rank highly among his influences—Matt Dorfman mashes up found images with lettering and various media to create illustrations that are both potent and witty. His wizardry lies in his peculiar ability to imbue visual meaning into text-based content that seems to defy the two-dimensional plane of the printed page. No surprise then that Dorfman is an in-demand global talent. When not conjuring up imagery for *The New York Times Book Review*, he keeps busy with a continual stream of commissions through his own freelance practice Metalmother, active since the mid-2000s. Born in Philadelphia in 1977, Dorfman majored in illustration at Syracuse University before renouncing the discipline in favor of design. A job offer as a production manager for a major record company prompted a move to New York at the turn of the millennium, but this was not the creative springboard he had anticipated. For over a decade, he worked within the music industry by day whilst developing his graphic portfolio at night. In 2011, his perseverance finally paid off when he was offered the coveted art director's chair at the op-ed page of *The New York Times*. Dorfman's freelance client list reads like a who's who of the publishing world—from Anchor Books, *Esquire*, and Knopf to *Time*, *Vanity Fair*, and *Wired*. Other projects have included rebranding the identity for the National Public Radio talk show *Fresh Air with Terry Gross* (2015). He has also been a juror for the American Illustration competition, and a speaker at events hosted by the Society of Publication Designers and the Type Directors Club.

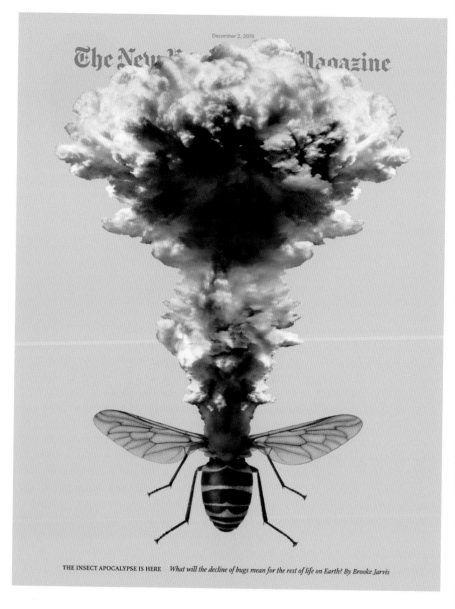

December 2, 2018

The New York Times Magazine

THE INSECT APOCALYPSE IS HERE *What will the decline of bugs mean for the rest of life on Earth? By Brooke Jarvis*

The Insect Apocalypse
Is Here, 2018
The New York Times Magazine,
cover; collage, digital; art direction:
Gail Bichler

Whiskey and Ink, 2018
The New Yorker, magazine;
collage, digital; art direction:
Nico Schweizer, Nicholas Blechman

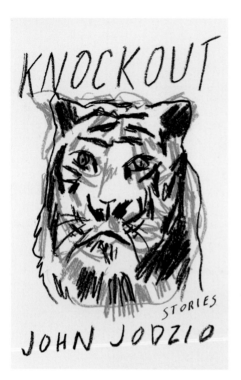

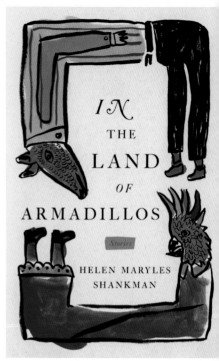

Knockout, 2016
Soft Skull Press, book cover;
grease pencils; art direction:
Kelly Winton

In the Land of Armadillos, 2016
Scribner Books, book cover;
ink, brush, watercolor;
art direction: Jaya Miceli

opposite Bach's Holy Dread, 2017
The New Yorker, magazine;
collage, digital; art direction:
Chris Curry

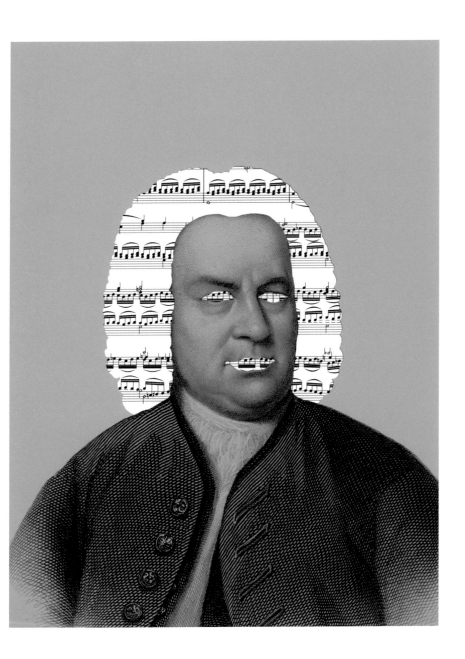

Downer #1, 2018
Personal work; collage,
found material

opposite Really Good
Birthday, 2018
Personal work, party favor bag for
a five-year-old's birthday party;
collage, found material

Selected Publications
2018, *American Illustration 38*,
Amilus, USA · 2017, *American
Illustration 37*, Amilus, USA · 2016,
American Illustration 36, Amilus,
USA · 2013, *Fully Booked*, Gestalten,
Germany · 2010, *Penguin 75:
Designers, Authors, Commentary (the
Good, the Bad…)*, Penguin, USA

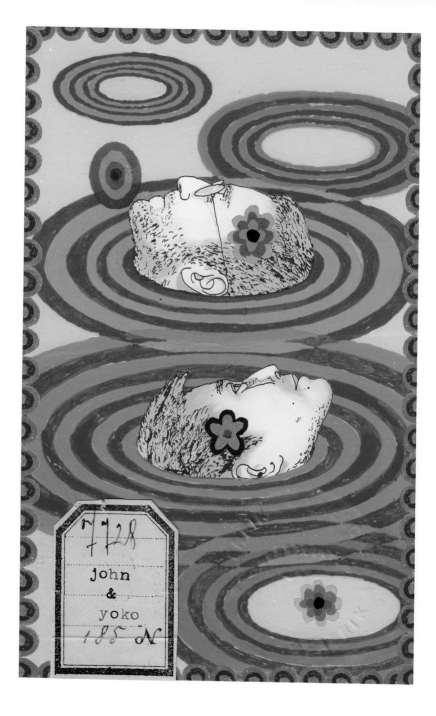

john
&
yoko

> "My mind has always been alert to image debris, keeping ideas and images in books, which then spill into my painting and illustration. In my image-making I try to convey the idea of 'everything at once'."

HENRIK DRESCHER

Henrik Drescher was born in Copenhagen in 1955. When he was 12, his family immigrated to the United States. He was awarded a full scholarship at the School of the Museum of Fine Arts in Boston in 1972, but decided to drop out after one semester. This signaled a period of extensive travel throughout America and Europe, during which he began keeping visual notebooks as a place to record his ideas. His renouncement of academia led to an exploration of and affinity with Outsider Art. After settling in New York in 1982, Drescher began working full-time as an illustrator. His first book, *The Strange Appearance of Howard Cranebill, Jr.*, was named *The New York Times* Best Illustrated Book of 1982. He has since produced over 50 titles, including children's books. Drescher's work has graced the pages of *Rolling Stone*, *Time* magazine, and *The Washington Post*. In 1992, he was honored with a solo show at the United States Library of Congress. His practice has extended to murals and installations. In the 2010s he began to develop Nervenet, an evolving gallery construction or "thought diagram," as the artist has described it, where he mounts images from his notebooks on wires. His aim is to convey a sense of totality: "In my image making I try to register the idea of 'everything at once,' a sort of Sears & Roebuck [sic] mail-order catalog filled with an inventory of all that has ever existed in the course of organic history and human memory... scars, tattoos, cracks, memories, impressions, flashbacks, and forgotten instructions." In the 2000s, Drescher began exploring shan shui, the traditional Chinese art of landscape painting, which is documented in his 2014 book *China Days—A Visual Journal from China's Wild West*. Dreschler now lives with his wife, the artist Wu Wing Yee, and divides his time between New York and Dali, Yunnan Province, China.

Selected Exhibitions
2017, *Big Rock Candy Mountain*, solo
show, Jack Fisher Gallery, San
Francisco · 2009, *Comeundone*, solo
show, Stir Gallery, Shanghai · 1994,
Mental Pictures, solo show, Library of
Congress, Washington, D.C.

p. 164 Johnyoko, 2019
Personal work,
Psychadelicious series;
acrylic, colored ink

Ventriloquist, 2019
Personal work,
Psychadelicious series;
acrylic, colored ink

opposite Forever Young, 2019
Personal work,
Psychadelicious series;
acrylic, colored ink

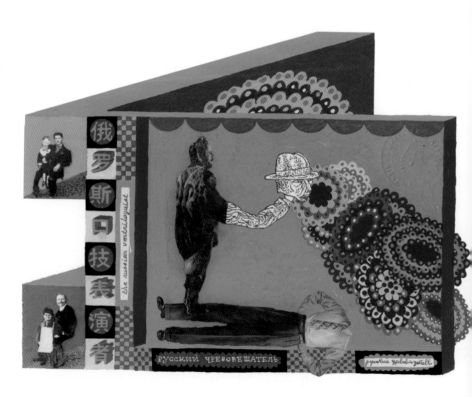

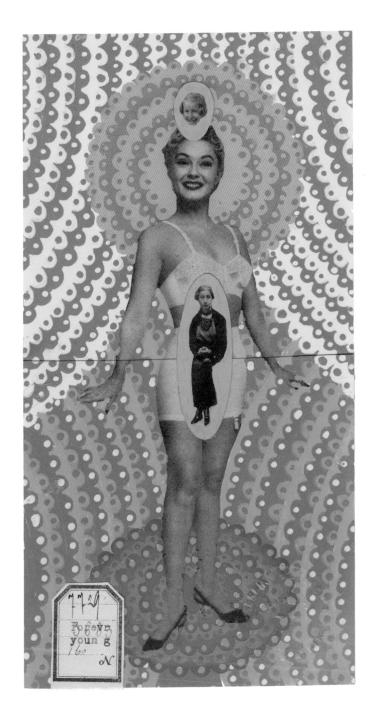

Roaster, 2019
Personal work; acrylic on board

opposite Thumb Shine®'s
series, 2019
Personal work; paper, ink,
and markers on paper

A Pudgy Cheeked Boy saw The Visitor and The Handsome little Boxer entering his building.

As night fell The Visitor climbed to the roof top where he started to assemble an odd shaped contraption.

169

> "When I don't have a clear idea, I usually sit with my trusty sketchbook and doodle a few thumbnails, or even write down words that I feel relate to the project."

CHRISTI DU TOIT

André Christiaan "Christi" du Toit (b.1991) is a South-African-born illustrator and designer with Franco-Dutch heritage. As a child growing up in the small coastal town of Gordon's Bay (his father was an architect and mother an artist) his creativity was unleashed through drawing. Eventually the big city beckoned, and in 2014 he graduated with a degree in graphic design and visual communication from AAA School of Advertising in Cape Town. Like many in his field, du Toit honed his creative and professional skills under the auspices of various illustration and design studios. Now an independent freelancer, his style and practice combines traditional hand-drawing with digital conjuring. As well as illustration, du Toit specializes in custom lettering, typography, and animation. An avid experimenter, he has even produced his own set of brushes for Photoshop. Du Toit's wide-ranging style is infused with a handcrafted quality that translates perfectly into print and the digital domain. With a broad commercial output, du Toit is equally at home visualizing briefs for British Airways and Vans as he is indulging in his love of music and pop culture, through his posters and merchandise for rock and metal bands and his own interpretations of fan art. He lives and works in Cape Town.

p. 170 The Eighth Merchant, 2018
Beer label; digital

Tattoodles, 2018
Personal work, print; digital

opposite Gravity, 2016
Vini Vici, poster; digital

174

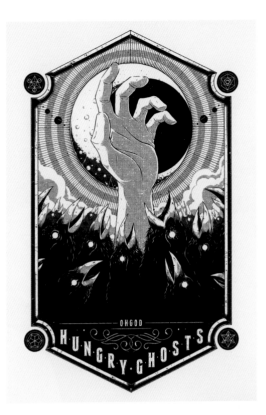

opposite Intergalactic, 2017
Marie & Boone, book cover; digital

Hungry Ghosts, 2018
Ohgod, merchandising; digital

Zero Division, 2017
Jeandré Viljoen, album cover; digital

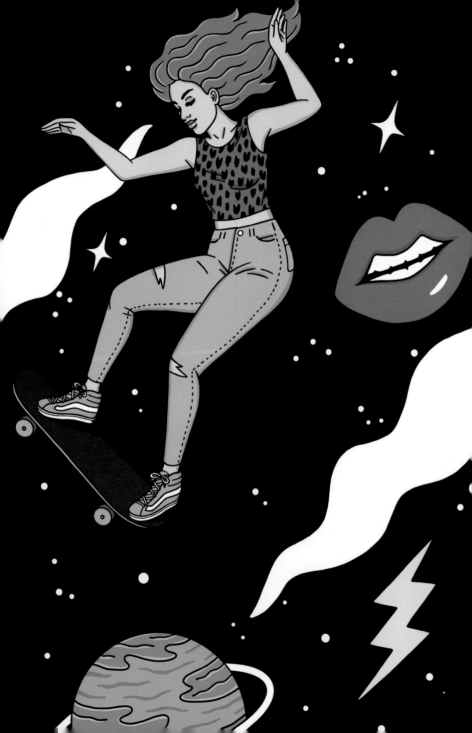

> "I'm optimistic to the point of it being kind of silly."

ROBIN EISENBERG

Los Angeles native Robin Eisenberg is one of those inherently obsessive creatives who have managed to turn a doodling compulsion into a successful profession. Born in 1983, she grew up in Eagle Rock and Glendale, California, on a staple diet of pop culture and sci-fi TV. A talented pianist, she was awarded a jazz scholarship to study at San Diego State University, which she forfeited by skipping class to get her drawing fix. She later switched to English, receiving her bachelor's in 2007, though it wasn't until 2010 that Eisenberg would finally begin to transform her lifelong hobby into a career. Whilst touring as keyboardist for indie-pop band Crocodiles, she found herself living in Berlin on an artist visa, and designing album covers for other bands. In an interview she once described her work as "a weird neon dream about alien babes, junk food, solitude, and space." Indeed, women outnumber men by ten to one in her compositions—assertive, pizza-munching skate chicks and mermaids who inhabit a brightly colored, space-pop landscape. Eisenberg's vision has attracted some memorable collaborations, including with Vans, and *Thrasher* magazine. Other notable works include GIF animations for Canadian rapper Drake's *More Life* (2017) playlist on Apple Music through Tumblr Creatrs, and in 2018 she created the artwork for, and co-directed (with Kris Baldwin), the animated music video for British singer Chelou's single, "Out of Sight." She spends most of her time at her desk and, when not working on commissions, turns her visual musings into enamel pins, stickers, and zines.

p. 176 Untitled, 2018
Vans; digital

opposite Untitled, 2019
Personal work; digital

Untitled, 2018
Personal work; digital

Out of Sight, 2018
Chelou, album cover; digital

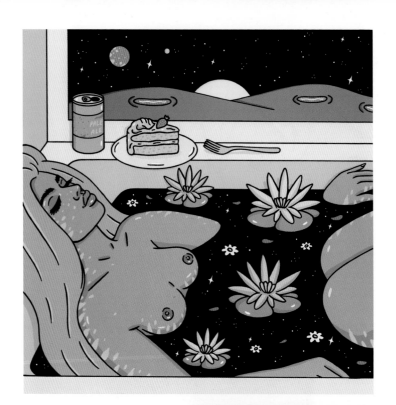

Untitled, 2018
Personal work; digital

Untitled, 2018
Personal work; digital

opposite Untitled, 2018
Personal work; digital

181

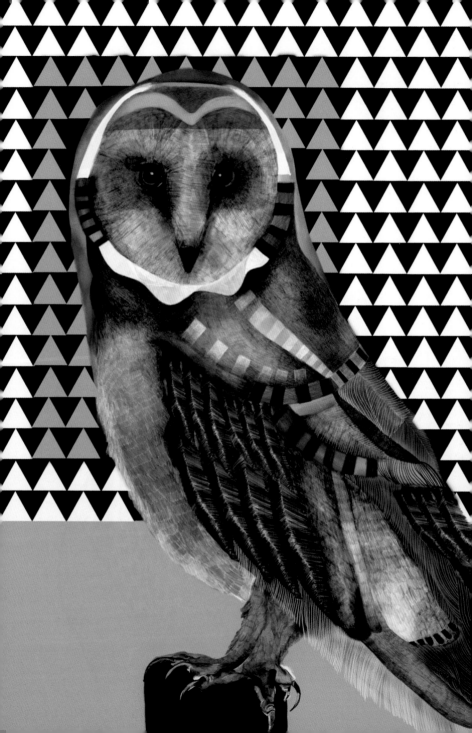

"I believe that in creativity
it's important to be able to observe
the social and cultural surroundings,
and to translate that information
into art with honesty and
simplicity." *for Fashion Africa Now*

DIANA EJAITA

Born in Cremona, Italy, in 1985, to an Italian mother and Nigerian father, today Diana Ejaita is an illustrator and textile designer based in Berlin. Her work references symbols and ideograms from the ancient Nsibidi system indigenous to southeast Nigeria—a decorative script associated with rituals and secret male societies—and the wisdom symbols of Adinkra, which originated in Ghana. Her practice is staunchly feminist and, as well as critiquing a range of themes from identity, race, and gender, also celebrates cultural diversity. Ejaita's distinctive images reveal a fascinating interplay between sharp, contrasting black-and-white spaces and soft organic forms. Elements are overlaid and patterns are repeated, creating an almost abstract illusory effect. Her process involves making stamps by engraving on wood, painting, and silkscreen printing. Ejaita grew up traveling with her family, with periods of study in both France and Germany. In 2014, she established her own ethical fashion and textile brand WearYourMask. Ejaita's work has appeared in a variety of publications, including covers for the *World Policy Journal* and feminist culture magazine *Bitch*. In 2017, she participated in an artist-in-residence program with Waaw in Saint-Louis, Senegal, where she exchanged printmaking workshops with local artisans.

p. 182 Barbagianni, 2018
Erri Spotti, by Anna Mori, book; pencil, digital

Baldwin's Speech, 2017
Migrate magazine; pencil, silkscreen

opposite Untitled, 2016
Personal work, digital

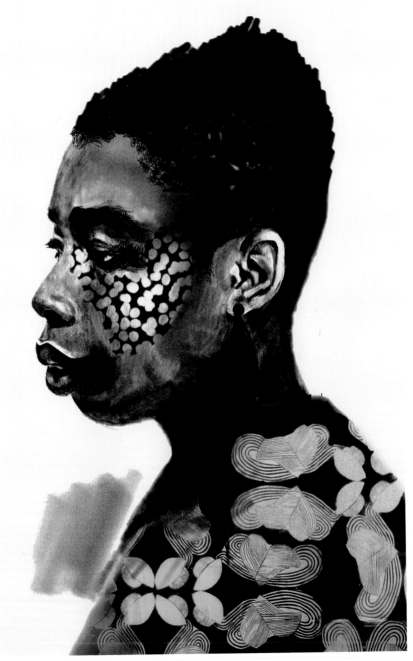

opposite Iya Ni Wura
(Mother Is Gold), 2019
The New Yorker, magazine cover;
linocut, digital

Untitled, 2016
Personal work; silkscreen

Amos Tutuola, 2018
Personal work; linocut, digital

"My work consists of all the colors and power of Latin-American folklore, refined with a subtle touch of European sophistication."

CATALINA ESTRADA

Born in Medellín, Colombia, in 1974, artist-illustrator Catalina Estrada Uribe has been based in Barcelona since 1999. As a child, she would roam the countryside in a reverie and fill up boxes of images taken from labels, tags, and magazine cut-outs. She went on to study graphic design at the Pontifical Bolivarian University in Medellín, receiving an honors degree in 1998. After working in her qualified field for a number of years, she switched to illustration in 2005. This breakthrough year saw her visual interpretation of "Aladdin and the Wonderful Lamp" published in a 16-illustrator anthology of *1001 Nights: Illustrated Fairy Tales from One Thousand And One Nights*. In addition, she was featured as a new talent in both *Communication Arts* and *Computer Arts* magazines. "My heart needs rhythm, my mind needs harmony and my soul needs color," exclaims Estrada on her website, with a passion that courses through her visual work. Inspired by the natural world, her ability to reimagine the folkloric traditions of Latin America in a kaleidoscope of color and symmetry has resulted in mesmerizing optical creations for brands such as Brazilian fashion label Anunciação, packaging for Shakira's fragrance, and digital murals for Starbucks. Estrada works exclusively with digital media for commercial projects and uses paints for her fine art.

p. 188 Jungle at Night, 2015
Arrels Barcelona; drawing, vector

Tiger-jungle, 2018
Coordonné, wallpaper;
drawing, vector;
photography: Sandra Rojo;
art direction: Helena Agustí

opposite Peking Duck, 2017
Personal work; drawing, vector

São Jorge, 2018
Anunciação, fashion collection;
drawing, vector

Guacamayas, 2015
Arrels Barcelona; drawing, vector

opposite Jaguares, 2015
Museo de Arte Moderno de
Medellín, bags, cups, wallets;
drawing, vector

Selected Exhibitions
2013, *Sala a cielo abierto*, solo show, Museo de Arte Moderno Medellín · 2009, *Desarmando sueños*, solo show, Iguapop Gallery, Barcelona · 2007, *Sweet Company*, solo show, La Luz de Jesus Gallery, Los Angeles · 2006, *No me quieras matar corazón*, solo show, Iguapop Gallery, Barcelona · 2005, *Once Upon a Time*, solo show, Roa La Rue Gallery, Seattle

Selected Publications
2013, *100 Illustrators*, TASCHEN, Germany · 2013, *A Life in Illustration*, Gestalten, Germany · 2008, *12 Exceptional European Illustrators*, *Print* magazine, USA · 2007, *Illusive*, Gestalten, Germany

opposite Pheasants, 2015
Personal work; drawing, vector

Font Vella, 2016
Special edition label; drawing, vector

"That was always my goal: to voice an opinion, not with Twitter but with a picture. Now that people take my image and make it theirs, because we share the same ideals and the same opinion, it's the best thing ever." for *Mic*

LENNART GÄBEL

Lennart Gäbel was born in Hanover, Germany, in 1981. After initially studying economics, followed by a period working for marketing and advertising agencies, he became disgruntled, moved to the Netherlands, and commenced studies in illustration at the Minerva Art Academy, Groningen, before attending the Willem de Kooning Academy in Rotterdam and then the School of Visual Arts in New York. Gäbel's studio is now located in a shared hall in the Schanzenviertel quarter of Hamburg, where he combines an "analog" practice of freehand illustration using ink, oil, and watercolor, with a Wacom tablet and MacBook for "digital" work. Often inspired by news and current affairs, his output encompasses a broad mixture of editorial and commercial illustration. His work has appeared on the cover of *Amnesty International* magazine and featured as wallpaper on WeTransfer. Other clients of his include *Der Spiegel*, *Playboy*, *The Huffington Post*, Samsung, and Tommy Hilfiger. Gäbel's political cartoons earned him a German Art Directors Club Award in 2017.

Selected Exhibitions
2018, *NYC*, solo show, Zurück zum Glück, Hannover · 2018, *World Illustration Award*, group show, Somerset House, London · 2017, *ADC Award Germany*, group show, Museum der Arbeit, Hamburg · 2017, *World Illustration Award*, group show, Somerset House, London · 2016, *Stimmt's?*, solo show, Projektor, Hamburg

Selected Publications
2018, *Signs of Resistance*, Artisan, Bonnie Siegler, USA · 2018, *World Illustration Award Catalogue*, Association of Illustrators, United Kingdom · 2017, *Resist! Vol. II*, Françoise Mouly & Nadja Spiegelman, USA · 2016, *IO Setbook*, Illustratoren Organisation, Germany · 2016, *Read* magazine, Radar Hamburg, Germany

p.196 Creativity, 2019
Harvard Business Manager,
magazine; digital;
art direction: Judith Mohr

opposite Law 15: Crush Your
Enemy Totally, 2016
Personal work, exhibition; digital

(Merkel's) End Times, 2018
Der Spiegel, magazine cover; digital;
art direction: Katja Kollmann

Turkey, 2017
Personal work, exhibition; digital

Escapade, 2017
Playboy, magazine; digital;
art direction: Stefan Müller

> "I try to achieve a balanced mixture of delicacy and forcefulness."

CARMEN GARCÍA HUERTA

Carmen García Huerta is one of Spain's most renowned illustrators. Born in Madrid in 1975, she went on to study advertising and PR at the Complutense University of Madrid, gaining a bachelor's degree in 1999. She spent her early career working in the communications sector before moving into fashion illustration in 2001. Her work has graced the style pages of news publications like *El País* and high-end fashion magazines like *Vanidad*. Her clientele ranges from high-profile agencies such as Publicis Dialog Paris and Custo Barcelona to fashion labels Roberto Verino and Louis Vuitton. Her subjects include glamorous, sophisticated, and sexy women and men, and stylized arrangements of flora and fauna. She cites Louise Bourgeois as an inspiration and philosophizes on fashion in sociological terms—as an industry, a sense of design, material, trend, and attitude. She translates these complexities and intangibilities through a duality of styles, either stylized chic for commissioned works or minimalist reductions. Lines and brushstrokes create languid contours that accentuate her subject's expressions; marbled hues fade into each other, and fabrics fold. The Madrileña artist's work has featured in gallery exhibitions as far and wide as Shanghai and Tel Aviv, and has adorned notebooks and album covers.

Selected Exhibitions

2018, *Dionaea Muscipula*, solo show, La Fábrica, Madrid · 2018, *Gabinete Art Fair*, group show, Centro Cultural de la Villa, Madrid · 2017, *Decodé*, group show, We Crave Design, Madrid · 2016, *Aliadas*, group show, Centro Cibeles, Madrid · 2014, *Tres de 100*, group show, Ministerio de Asuntos Importantes, Madrid

Selected Publications

2014, *100 Illustrators*, TASCHEN, Germany · 2013, *Fashion Illustration Now!*, TASCHEN, Germany · 2010, *The Beautiful*, Gestalten, Germany · 2007, *Fashion Unfolding*, Victionary, Hong Kong · 2005, *It's a Matter of Illustration*, Victionary, Hong Kong

p. 202 The Year of the Dog, 2018
El Corte Inglés, advertising;
color pencil, digital

opposite Adele, 2016
Revista Sábado, magazine,
El País newspaper;
color pencil, digital

Makech Collection, 2018
Suarez Jewellery, shop displays and
windows; color pencil, digital

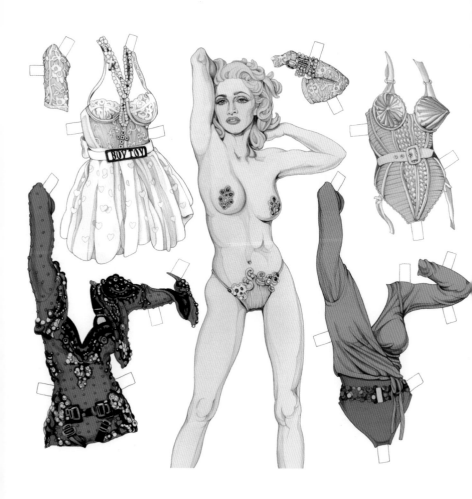

206

opposite Gufa para
el fan de Madonna, 2016
Revista Sábado, magazine,
El País newspaper;
color pencil, digital

Black Power, 2017
Vein, magazine;
graphite pencil

> "My work conveys the deep sense of respect and passion I feel for the ocean through a style that is clean and intense."

DANI GARRETON

Dani Garreton lives and breathes the life aquatic. Born in Santiago, Chile, in 1983, at an early age she discovered the seduction of the sea and a creative talent for making things. After high school she moved to Europe and worked in design in Hamburg before settling in the Spanish coastal city of San Sebastián in 2010. Here, she would marry her love for all things maritime with illustration. Much of Garreton's imagery focuses on the fisherman icon as a metaphor. Through facial features and expressions she evokes the "intensity and emotion" of humankind's relationship with water. It comes as no surprise that surfing and diving are also passions of the Latin American artist—both themes she has explored in her work. In collaboration with Posca pens, she created a special-edition "Poseidon" design for surf brand Ripcurl live in front of an audience in 2010. Garreton's work has been presented in group and solo shows across Europe, and her art has been sold at Christie's Green Auction in New York. She has also received media attention through various online and TV channels like Food Network (US), and through niche culture magazines like *Huck* (UK), *Wait* (Italy), and *Desillusion* (France).

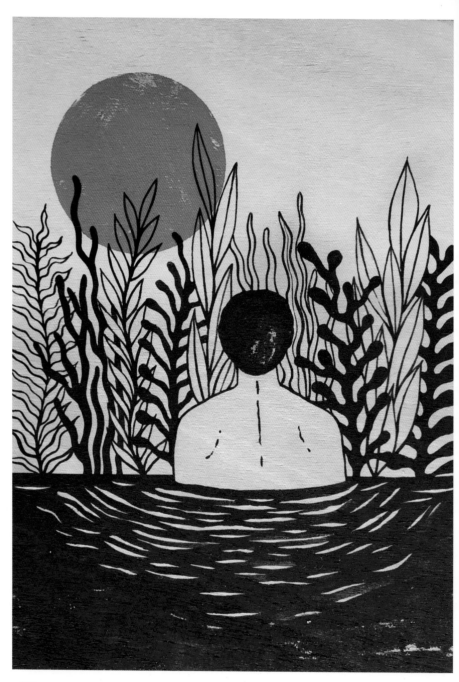

Selected Exhibitions
2017, *Pleamar*, solo show, Tabakalera,
San Sebastián · 2016, *Panthalassa*,
group show, Providence Guéthary ·
2014, *Sea Legend*, group show,
25 Hours Gallery, Hamburg ·
2014, *Working Artisans*, group show,
Huck Gallery, London · 2012,
Alamar, solo show, Nautilus Gallery
Aquarivm, San Sebastián

Selected Publications
2018, *C41 magazine*, Vice Digital,
Italy · 2017, *Mare Zeitung*,
Mare Verlag, Germany · 2014,
Huck magazine, TCO London,
United Kingdom · 2013, *Bluemag*,
Blue Media Network, Germany ·
2012, *Lamono magazine*, Spain

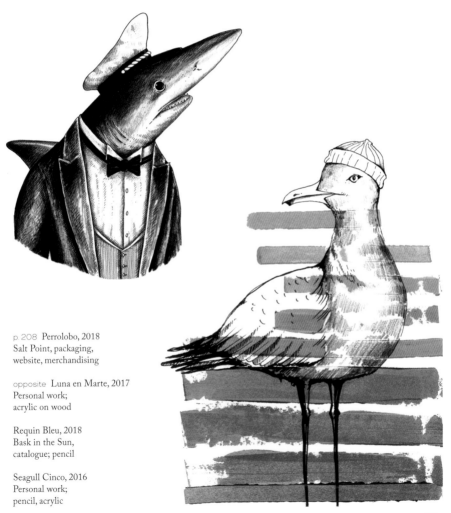

p. 208 Perrolobo, 2018
Salt Point, packaging,
website, merchandising

opposite Luna en Marte, 2017
Personal work;
acrylic on wood

Requin Bleu, 2018
Bask in the Sun,
catalogue; pencil

Seagull Cinco, 2016
Personal work;
pencil, acrylic

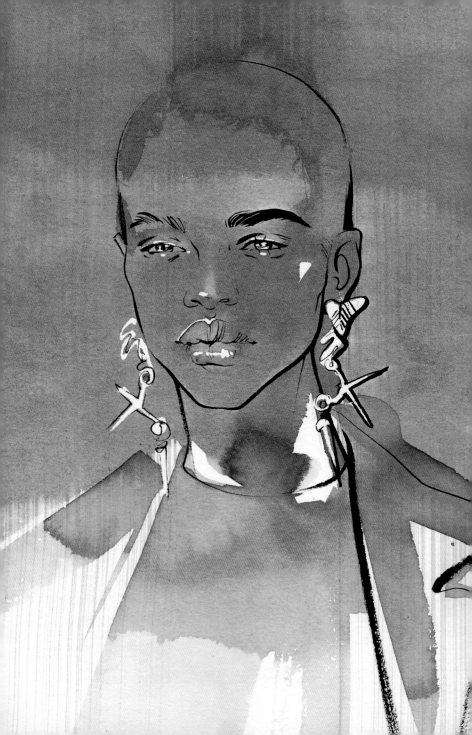

"I have found a means of narration through blending modern fashion illustration with figurative painting. To bring illustration to life I have dropped digital images in favor of the intuitive expression through hand-painting with coal, watercolor, and acrylic."

ALINA GRINPAUKA

Born in Ventspils, Latvia, in 1989, Alina Grinpauka's alluring style encapsulates the progression of fashion illustration from the post-WWII era through to the present, yet with a very fresh appeal. She favors traditional techniques over digital. Watercolors and inks disperse over pencil lines and blot on paper, creating a rich contrast of shadow and light. Grinpauka lists her inspirations through such juxtapositions as "iconoclast heritage vs redefining; craftsmanship vs deconstruction; mystery vs modern elegance; conceptualism of modern art vs mundane Wednesday morning coffee." Her philosophy and research-based approach stems from her education. She graduated with a BA in Industrial Design from the Art Academy of Latvia in 2014, and prior to that studied environmental design at the Riga School of Design and Art. After freelancing as an illustrator in New York, Grinpauka returned to live and work in her native Latvia. With a growing portfolio of work to her name, including book covers for social media entrepreneur Mimi Ikonn and illustrated editorials for the Latvian edition of *Cosmopolitan*, Grinpauka continues to experiment with materials and evolve her style.

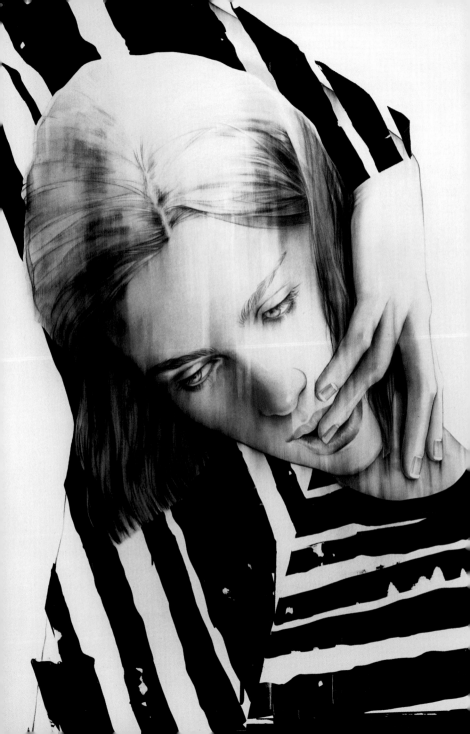

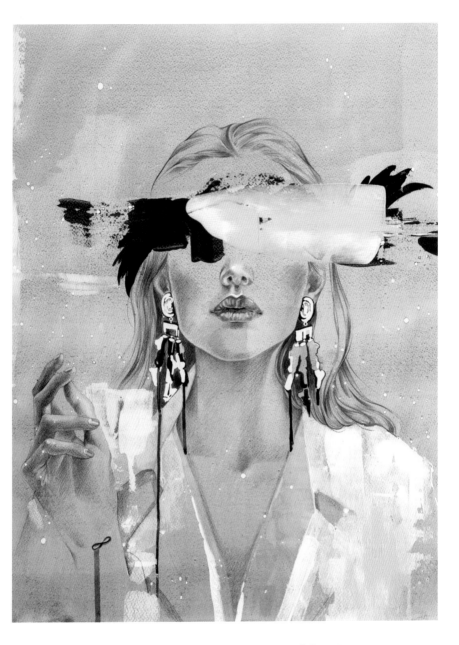

p 212 Valentino Spring/
Summer 2018
Personal work; watercolor, ink

opposite Untitled, 2017
Personal work; charcoal on canvas

Infinity, 2016
Personal work; watercolor, acrylic

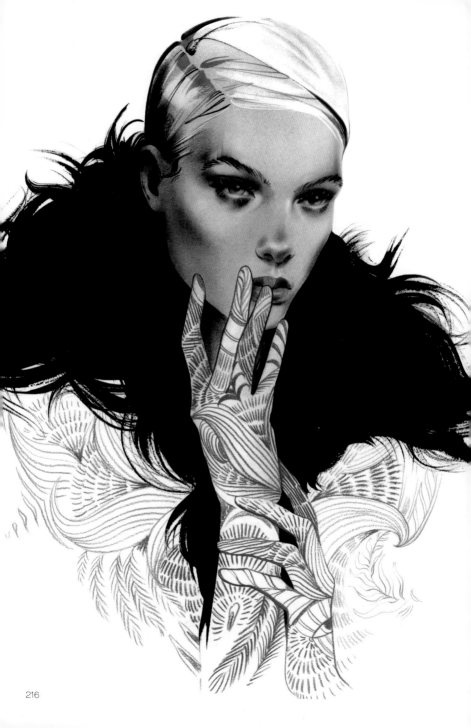

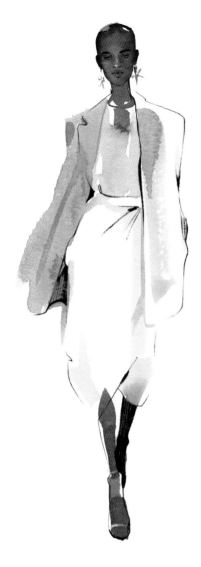

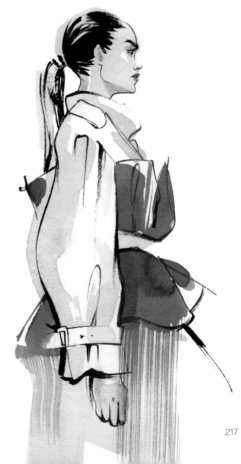

opposite Dries Van Noten
Fall/Winter 2018/2019
Personal work; ink, pencil, charcoal

Valentino Spring/Summer 2018
Personal work; watercolor, ink

Maison Margiela
Spring/Summer 2018
Personal work; watercolor, ink

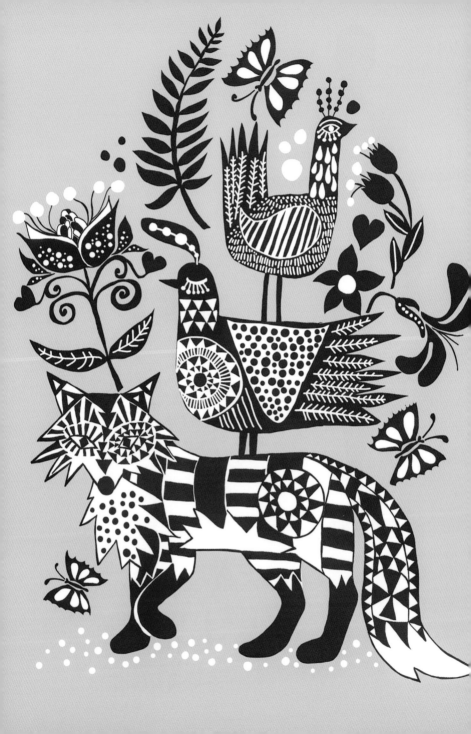

> "I want to invite people into my universe, where rabbits, owls, butterflies, and mysterious cats rule the world, and neon-pink plants, patterns, and mushrooms entice you to remember the magic in everyday life."

LISA GRUE

Born in 1971, Lisa Grue's modest upbringing in the Danish seaport of Kalundborg did not stop her from using her creative talent to fulfil her ambitions. She and her sister entered drawing competitions whenever the opportunity arose, most of which they won; prizes ranged from ghetto blasters to skiing holidays and, most importantly, drawing equipment. As she grew older, the Royal Danish Academy of Design beckoned. There, in 2001, she received a master's degree in graphic design. From that point her career blossomed into a varied practice—a confluence of illustration, design, and fine art. Grue is constantly experimenting, with a visual language inspired by her love of nature and the urban environment. Whether working in pencil, acrylic, digitally, or crafting in embroidery and porcelain, she is in her element with a variety of media. Feminine and charming, with hints of folklore and fairytale, Grue's imagery has a distinctly Scandinavian essence, though it is unclichéd and has a worldly outlook. She has been awarded grants from the Danish Arts Foundation and her reputation has steadily grown on an international scale, with an impressive client list spanning Ace Hotel in New York, Fujifilm, *Nylon* magazine, Anna Sui, and Vogue. In addition, she also designed the official t-shirt for *Dukale's Dream* (2014), a documentary following actor Hugh Jackman's exploration of the fair trade coffee industry. Together with her designer husband, Denis Sytmen, Grue founded the design studio "Summer will be back" in 2014, based in the old meatpacking district of Copenhagen.

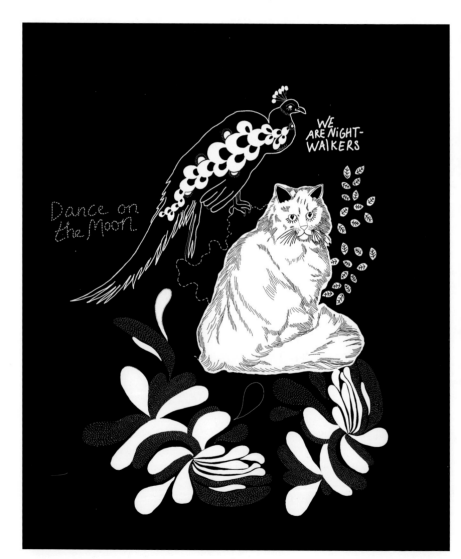

Selected Exhibitions
2017, *Top Drawer*, group show,
London · 2016, *Tent*, group show,
London Design Fair · 2015,
New Nordic Fashion Illustration, vol. 2,
group show, Tallinn · 2011,
Owls Have More Fun, solo show,
New York · 2011, *AvantGarden*,
group show, London Design Fair

Selected Publications
2018, *Friendship, a Fill-in Keepsake*,
Abrams Books, USA · 2018, *Luk
naturen ind (Re-connect with Nature)*,
Gyldendal, Denmark · 2016, *Dream
Diary*, Lindhardt & Ringhoff,
Denmark · 2011, *Illustration Now!
Portraits*, TASCHEN, Germany ·
2007, *Fashion Unfolding*, Victionary,
Hong Kong

> "All his works look as if they are movie stills, segments of scenes from intriguing stories. They are just so gripping."
>
> by Yuko Shimizo

BENJAMIN GÜDEL

Benjamin Güdel (b. 1968) produces illustrations with a raw and edgy style akin to film noir, pulp detective covers from the 1950s, and rotoscoped animation (where drawings are traced over live-action motion-picture footage). After studying graphic design in his home city of Bern in the early 1990s, he became disenchanted with the discipline and began developing his skills as a cartoonist and publishing his own underground comics. His process utilizes traditional hand-drawn sketches, which he inks with brushes before scanning to digital for coloring and sometimes retouching. Güdel's gritty world of fiction is a far cry from his suburban family life in Zurich, where he confesses to occasionally mowing the lawn at home. Prior to resettling in Switzerland, Güdel spent a period in Berlin and in 2005 produced *Blood Sweat and Tears*, an artist's monograph featuring a collection of personal works as well as commissioned illustrations for the likes of Berlin's avant-garde Schaubühne Theater and innovative Swiss magazines *Du* and *Soda*. His editorial work has appeared in *Rolling Stone*, *Der Spiegel*, *Fused*, and *Time Out* (London), to name but a few.

Schizophrenia, 2016
Die Zeit, magazine;
mixed media

Marijuana, 2018
Der Spiegel, magazine;
mixed media

p. 222 Sleepless, 2016
Die Weltwoche, magazine;
mixed media

War, 2016
Die Weltwoche, magazine;
mixed media

opposite On The Road, 2017
Die Weltwoche, magazine;
mixed media

Lost Youth, 2016
Personal work, poster;
mixed media

Selected Exhibitions
2017, *Poster Bazar,* group show,
K-3000, Zurich · 2016, *Fumetto,*
group show, Fumetto Festival,
Luzern · 2015, *Mord und Totschlag,*
group show, Stauffacher, Bern ·
2014, *Poster Bazar,* group show,
K-3000, Zurich · 2013, *LTD
Edition,* group show, Walchenturm,
Zurich

Selected Publications
2013, *Doods,* SSE Project, South
Korea · 2010, *Fresh,* Slanted,
Germany · 2009, *3x3 Annual,*
USA · 2007, *American Illustration
Annual,* Society of Illustrators,
USA · 2005, *Blood Sweat and Tears,*
Gestalten, Germany

> "There is something beautiful about the solitude of pen, paper, and a voice. The joy of making images, to me, is telling a small story. Not a lofty goal, nor a unique one, to be sure."

JOHN HENDRIX

John Hendrix has had a lifelong passion for drawing. From depicting cartoon characters as a child, he has ascended in a career as an award-winning illustrator throughout the United States. Born in St Louis, Missouri, in 1976, Hendrix studied visual communication at the University of Kansas, graduating with a BA in 1999. After an initial period working in design, he made the pilgrimage to New York, where he attended the School of Visual Arts MFA "Illustration as Visual Essay" program, attaining an honors degree in 2003. Soon after, he received his first assignment for *The Village Voice*, which led to a longstanding relationship with *The New York Times*, for whom he worked as an assistant art director on the op-ed page. His work has appeared in the editorials of numerous major titles from *Entertainment Weekly* to *Esquire*. Hendrix's first children's book, *Abe Lincoln Crosses the Creek*, was chosen as the American Library Association's Notable Book of 2008. An active educationalist, Hendrix has taught at Parsons School of Design and served as Chair of Design in the Sam Fox School of Design & Visual Arts at Washington University in St Louis. In 2012, he became President of ICON 7, the Illustration Conference, and also chaired the Society of Illustrators 55th annual exhibition. His favored medium is pen and ink, with coloring in acrylic and occasionally gouache. With meticulous attention to form, color, and typography, Hendrix has an uncanny knack of being able to convey a clear message, sometimes through the most complex and dense compositions.

Selected Exhibitions
2019, *Society of Illustrators*, group show, New York · 2018, *Society of Illustrators*, group show, New York · 2018, *Communication Arts Annual*, group show, USA · 2018, *American Illustration*, group show, New York ·

Selected Publications
2018, *Summer Movies, The New York Times*, USA · 2018, *The Faithful Spy: Dietrich Bonhoeffer*, Abrams Books for Young Readers, USA · 2018, *Solar Sailing, National Geographic*, USA · 2018, *Best Books of 2018*, NPR, USA · 2015, *Drawing is Magic: Discovering a Sketchbook*, Abrams Books for Young Readers, USA

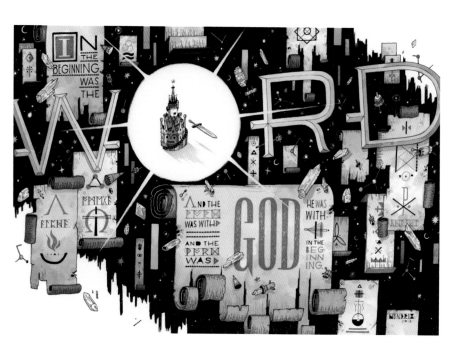

p. 228 Serpent Surfing, 2016
Plan Sponsor, magazine cover;
pen, ink, digital, fluid acrylics;
art direction: SooJin Buzelli

opposite Solar Sailing, 2018
National Geographic, magazine;
pen, ink, digital, fluid acrylics;
art direction: Marianne Seregi

The Word, 2017
Christianity Today, magazine;
pen, ink, digital, fluid acrylics;
art direction: Sarah Gordon

Will You Miss Me
When I'm Gone?, 2010
Gallery Nucleus, poster;
pen, ink, fluid acrylics

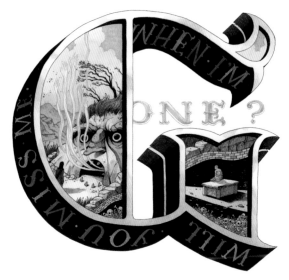

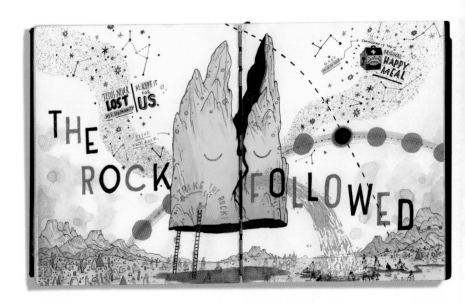

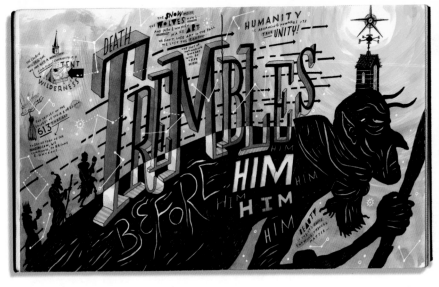

The Rock Follows, 2017
Personal work, sketchbook;
pen, ink, fluid acrylics

Trembles, 2017
Personal work, sketchbook;
pen, ink, fluid acrylics

opposite Wolves vs. Knights, 2013
Plan Sponsor, magazine cover;
pen, ink, fluid acrylics;
art director: SooJin Buzelli

> "I want to surprise, provoke, and even soften with portraits, and my aim is to create a special beauty and sensitivity."

MARIA HERREROS

Another millennial talent to have emerged on the Spanish scene is María Herreros. Born in Valencia in 1983, she graduated from the San Carlos Royal Academy of Fine Arts in 2007 and gained a postgraduate degree in professional illustration in 2009. Herreros went freelance straight away, and soon began attracting attention for her remarkable style. Her work plays with societal perceptions. Portraits of pop cultural icons are distorted and stretched, offering the viewer nuances and expressions previously unseen. Surface areas are watercolored with a peculiar palette, scored by sharp lines and shading marks. Herreros has published several books. Her first title *Fenómeno* (2012) is populated with a host of tattooed freaks and double-headed twins—or "phenomenal human beings" as the artist calls them—designed to challenge our preconceived notions of the grotesque and the beautiful. With a distinctive voice that defies categorization, Herreros has accumulated an enviable list of clients from Coca-Cola and Smart to Reebok and *El País*. A growing social media following coupled with gallery exhibitions in Madrid, Porto, Barcelona, Berlin, New York, and Beijing have put her firmly on the international map.

2018, *Maria Herreros*, solo show, SIPicture Institute of Arts, Seoul · 2018, *Got it for Cheap, international tour*, group show, Emma Pardos, Barcelona · 2017, *Illustrating Life*, group show, Prince Gong's Mansion, Ministry of Culture, Beijing · 2017, *Miss Representation*, group show, Junior High Gallery, Los Angeles · 2017, *Saturns Return*, solo show, Pepita Lumier, Valencia

Selected Publications
2018, *Paris sera toujours Paris*, Maxim Huerta, Lunwerg Editores/Planeta de Libros, Spain · 2018, *Nosotras*, Rosa Montero, Alfaguara, Random House, Spain · 2018, *Mi vida es un poema*, Javier García, SM, Spain · 2016, *Marilyn ten'a once dedos en los pies*, Lunwerg Editores, Spain · 2015, *Tea*, Diminuta, Spain

p. 234 Mermaid Ranch, 2017
Personal work, acrylic on wood

The Blind, 2016
Personal work, *Botanical Rage,* solo show; watercolor, graphite on paper

opposite Vogue, 2017
Personal work, exhibition, Junior High, Los Angeles; watercolor, graphite on paper

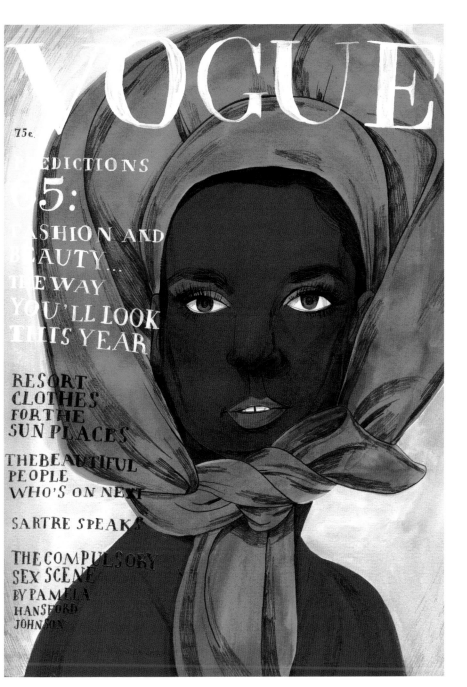

VOGUE

75c.

PREDICTIONS

5:

FASHION AND
BEAUTY...
THE WAY
YOU'LL LOOK
THIS YEAR

RESORT
CLOTHES
FOR THE
SUN PLACES

THE BEAUTIFUL
PEOPLE
WHO'S ON NEXT

SARTRE SPEAKS

THE COMPULSORY
SEX SCENE
BY PAMELA
HANSFORD
JOHNSON

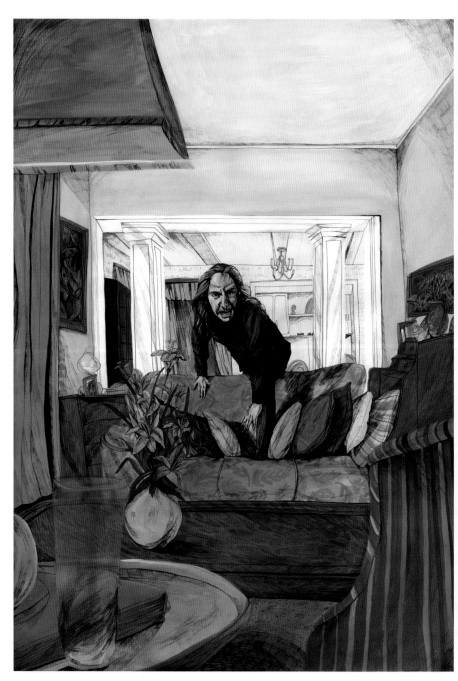

opposite Bob Is Real, 2017
Personal work; watercolor,
graphite on paper

Paula Vogel, 2018
Lenny Letter, online newsletter;
acrylic on wood

Travolta, 2016
Lunwerg Editores/Planeta
de Libros, book; watercolor,
graphite on paper

> "I do not plan much before I start. I simply take the ideas that run through my brain and, when I think they are beautiful, I make them."

for *Metal* magazine

MARÍA HESSE

Born in Huelva, Andalusia, in 1982, María Hesse grew up in Seville, in 1982 but grew up in Seville, where she began drawing at the age of six. After initial training to be a teacher she attended the San Telmo School of Art in Málaga before pursuing a professional career in illustration in 2012. After working for Edelvives publishers, she began illustrating for Spanish magazines, including *Jot Down* and *Maasåi Magazine*. Her subjects include characters from cinema and music who have influenced her: David Bowie as Ziggy Stardust and Mia Wallace from *Pulp Fiction*. A running theme in her work is the portrayal of women, which she explores through her favored medium of gouache and watercolor on cotton paper. Often centered in dark or white spaces with open ribcages and rich, red hearts in full view, Hesse's imagery reveals both the inner and external strength and sensitivity of her female characters. In 2014, she produced an illustrated biography of Frida Kahlo, which was followed by a delightful monochrome interpretation of Jane Austen's *Pride and Prejudice* (2017). In addition to her personal work, Hesse has collaborated with brands such as Compañía Fantástica, Louise Boutin, and Martini.

p. 240 Mirar al dolor, 2018
Personal work; gouache, ink

Have a Good Time, 2017
Personal work; gouache, ink

Que los libros te acompañen, 2017
Kireii; gouache, ink

opposite Techos de cristal, 2018
S Moda magazine, *El País*
newspaper; gouache, ink

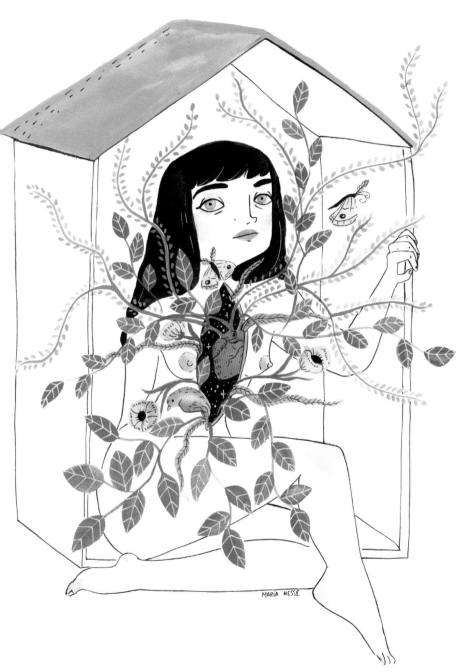

243

Bowie, 2018
Editorial Lumen; gouache, ink

opposite Algo anda mal, 2018
Personal work; gouache, ink

MARÍA HESSE

> "I don't confine myself to literal depiction because I like to employ a little magic realism in some of my pieces."

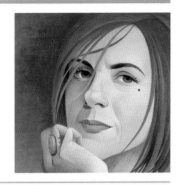

JODY HEWGILL

Born in 1961 in Montréal, Québec, Jody Hewgill recalls that in her early childhood she accompanied her father to his art supply store on weekends and drew pub customers on placemats as they ate their lunch. An entrepreneurial streak developed and by the age of 17 Hewgill had received her first commission: to illustrate Pier 1 products in newspaper ads. Jody Hewgill attended the commercial art program at Dawson College until 1981 before graduating from the Ontario College of Art and Design in Toronto in 1984, where her association continues to this day as a faculty member in the illustration department. Since the late 1980s, Hewgill's paintings and illustrations have graced countless book covers, posters, and interior retail murals. Her projects include pop music icons, such as Elton John for *Rolling Stone* and Morrissey for *Spin*, and commemorative stamps for the United States Postal Service. Among her numerous accolades are awards from *Communication Arts*, the Society of Publication Designers, and the Society of Illustrators in New York and Los Angeles. Hewgill's posters can also be found in the Permanent Poster Collection of the Library of Congress in Washington, D.C. Her process is largely handcrafted. She works with graphite or color pencil and finishes in acrylics. From first glance to deeper study, a myriad of art references seem to imbue her works, from Early Renaissance to 1920s Art Deco portraiture and beyond. Her figurative studies of celebrities and almost folkloric depictions of animals in nature draw the viewer through a fantasy realm, prompting us to question reality.

Selected Exhibitions

2018, *American Gods*, group show, Star Gallery, New York · 2018, *Women Making a Mark*, group show, Christel DeHaan Fine Arts Center Gallery, Indianapolis · 2011, *Instinct(s)*, solo show, Richard C. von Hess Gallery, Philadelphia · 2010, *Kaboom*, group show, La Luz de Jesus, Los Angeles · 2007, *Green*, group show, Robert Berman Gallery, Santa Monica

Selected Publications

2016, *AI-AP Profiles,* American Illustration, USA · 2011, *The Essence of Contemporary Illustration,* Gestalten, Germany · 2011, *Illustration Now! Portraits,* TASCHEN, Germany · 2008, *Icons & Images: 50 Years of Illustration,* Society of Illustrators, USA · 1997, *Communication Arts,* USA

p. 246 Balance, 2018
Personal work, fundraising auction catalogue; acrylic on Baltic birch panel

Two Marilyns, 2017
National Geographic, magazine; acrylic on gessoed panel; art direction: Marianne Seregi

opposite The Avett Brothers, 2016
Rolling Stone, magazine; acrylic on wood panel; art direction: Matthew Cooley

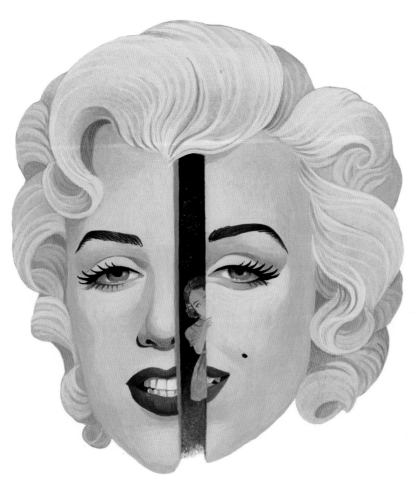

249

Pink Lady, 2017
Personal work, limited-edition prints
for Cancer Research fundraiser;
acrylic on masonite panel

opposite Courage, 2015
Middlebury, magazine;
acrylic on gessoed ragboard

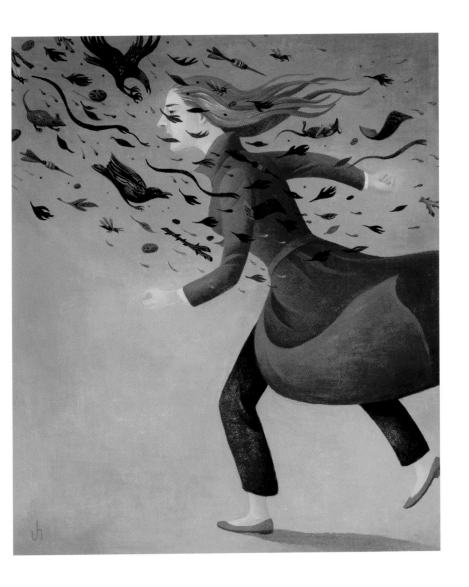

> "Whenever something that used to bring you joy no longer brings you joy, it's time to try something new. It's not that that thing will never give you joy again, it's just that you need some time away."
>
> for *Ways We Work*

JESSICA HISCHE

Jessica Hische is an illustrator whose penchant for lettering developed in grade school when she would customize her classmates' names on their Trapper Keeper folders. Little did she know that her doodling obsession would blossom into a celebrated career as a hand letterer and type illustrator. Born in Charleston, South Carolina, in 1984, Hische graduated from the Tyler School of Art at Temple University, Philadelphia, with a degree in graphic and interactive design in 2006. She soon found herself working as senior designer at Louise Fili Ltd in New York, and with them she created a "Love" stamp for the US Postal Service that sold over 250 million units. For over a decade, Hische's ornate, handcrafted style has adorned a plethora of book jackets, brands, and logos. Her client projects scroll from logo refreshes for MailChimp to movie title sequences for Wes Anderson. With a string of accolades to her name, including two consecutive citations in *Forbes* "30 under 30," and a Young Guns award from the Art Directors Club of New York, Hische has become one of America's in-demand lettering artists. A noted advocate in her field, she is a frequent speaker worldwide and has served on the Type Directors Club board of directors. In her own words an "avid Internetter," Hische runs logotype masterclasses online, and since 2009 has regularly posted an illustrative drop cap in her "Daily Drop Cap" project. In 2015, Hische authored the seminal *In Progress: See Inside a Lettering Artist's Sketchbook and Process, from Pencil to Vector*. She lives and works in San Francisco.

p. 252 Virtue, 2016
The Baffler, magazine; vector;
art direction: Lindsay Ballant

Chill Vibes, screen print, 2016
California Sunday Magazine;
vector with bitmap texture;
art direction: Leo Jung

opposite Heart of Darkness, 2018
Barnes & Noble, Sterling
Publishing; vector, art foil stamped
on leatherette; art direction:
Jo Obarowski

HEART
of
DARKNESS
and
OTHER STORIES

JOSEPH CONRAD

AMERICA
The Great Cookbook

FROM 100 OF

OUR FINEST CHEFS

AND

FOOD HEROES

EDITED BY

Joe Yonan

America: The Great Cookbook,
2017, by Joe Yonan, book,
Weldon Owen

opposite top More Salt, 2014
Snacks Quarterly; salt on wood;
art direction: Brad Simon

opposite bottom
Magical Bitch, 2018
Sonya Yu and Zack Lara; cast as
gold necklace; vector drawing

Love Stencil, 2018
Personal work; vector

opposite top
Forever Love Stamps, 2015
United States Postal Service,
postage stamp; vector

opposite bottom *Edgar Allan Poe* &
The Metamorphosis, 2017
Barnes & Noble, Sterling
Publishing, book covers; vector,
art foil stamped on leatherette;
art direction: Jo Obarowski

Selected Exhibitions
2018, *Text Me: How We Live in Language*, group show, Museum of Design, Atlanta · 2017, *We the People*, group show, The Cooper Union Gallery, New York · 2015, *Type Directors Club*, group show, traveling exhibition · 2010, *Jessica Hische*, solo show, Lamington Drive Gallery, Melbourne · 2009, *Lubalin Now*, group show, Cooper Union, New York

Selected Publications
2018, *Jessica Hische: Tomorrow I'll Be Brave*, Penguin Books, USA · 2017, *The Typography Issue, Print* magazine, USA · 2015, *In Progress*, Chronicle Books, USA · 2013, *30 Under 30, Forbes* magazine, USA

"Work philosophy: there must be any one of three things (if not all).
1. Lots of money;
2. Lots of freedom;
3. Lots of time."

MIRKO ILIĆ

Quite simply, Mirko Ilić has defined the direction of commercial illustration over the last four decades. Born in Bijeljina, Bosnia and Herzegovina, in 1956, he graduated from the School of Applied Arts in Zagreb, Croatia, and began publishing political comics in the early 1970s. Through posters, books, and record sleeves, Ilić's work became a representative visual force in the new wave music movement of the former Yugoslavia. In 1977, he began illustrating for American sci-fi fantasy magazines *Heavy Metal* and Marvel's *Epic Illustrated*, though by the early 1980s his focus had shifted to graphic design and illustration. A move to New York in 1986 would catapult his career on an upward trajectory. By the dawn of the 1990s, Ilić had become art director of *Time* magazine international edition, and soon after he took the helm of *The New York Times* op-ed pages, where he tore up the rule book and radically transformed their visual language. In 1995, he founded Mirko Ilić Corp to facilitate his diverse projects, from graphic design to motion-picture titles, such as the animated opening sequence to the hit comedy *You've Got Mail* (1998), which he created with Milton Glaser and Walter Bernard. Since 1999, Ilić has been an instructor at the School of Visual Arts for their MFA in illustration program. His works are in the permanent collection of the Museum of Modern Art (MoMA) and the Smithsonian Institution.

p. 260 Crisis in Black & White, 2016
The New York Times, newspaper;
pencil, digital

opposite Freedom to Vote
(and Make it Count), 2016
The Wolfsonian Museum, poster;
pencil, digital

In Command, 2014
The Serb National Council (Srpsko
narodno vijeće, SNV); pencil, digital

Demystifying the Blockchain, 2018
The New York Times, newspaper;
pencil, digital

The Glass Neck, 2018
Yugoslav Drama Theatre,
Belgrade, poster; digital

opposite top The Lion, 2015
Arena Stage Theater,
poster; pencil, digital

opposite bottom Demystifying
the Blockchain, 2017
The New York Times, newspaper;
pencil, digital

Selected Exhibitions
2018, *Posterfest*, group show, Budapest
· 2018, *Underground Images*, group
show, De Affiche Galerij, The Hague
· 2017, *Get With the Action: Political
Posters from the 1960s*, group show,
San Francisco Museum of Modern
Art · 2017, *1917–2017*, group show,
Media Centre of Zaryadye Park,
Moscow · 2017, *Mirko Ilić, Skyline*,
solo show, Madrid Gráfica 17,
Madrid

Selected Publications
2018, *The History of Graphic Design:
1960–Today,* TASCHEN, Germany
· 2018, *The Illustration Idea Book,*
Laurence King Publishing, United
Kingdom · 2018, *Graphic Style:
From Victorian to Hipster,* Harry N.
Abrams, USA · 2018, *Head to Toe:
The Nude in Graphic Design,*
Rizzoli, USA · 2017, *Graphic:
500 Designs That Matter,* Phaidon,
United Kingdom

> "You have to grab the angel by the neck and squeeze an idea out. I like working fast, and thinking fast. I don't like to over-think a project; usually my first instinct for a solution is the best." *for I love Mega*

JEREMYVILLE

Brooklyn-based Jeremyville is an illustrator-entrepreneur at the vanguard of art as a force for social change. Born in 1975 in Sydney, Jeremy Ville grew up in the aptly named Wonderland Avenue near Bondi Beach, where Lego, Smurfs, sea-monkeys, Tintin, and Mr. Men books were all part of his creative universe. At 19, while studying architecture at Sydney University, he edited the student newspaper, filling in the blank spaces with his cartoons, which quickly led to freelance editorial work for *The Sydney Morning Herald*. After graduating in 1996, he decided to forego architecture and open an illustration studio, despite having no formal qualifications. A notable early commission came in the mid-1990s, when he began illustrating wrappers for the confectionery brand Minties. In 2008 he co-founded Studio Jeremyville, with creative director Megan Mair. Under this moniker, the couple have diversified into such areas as product design and animation. Projects have included footwear for Converse, art toys for Kidrobot, and snowboards for Rossignol. In the mid-2010s, he started the daily online project "Community Service Announcements"—an ongoing series of positive visual messages on topics such as self-empowerment and the environment. Drawing inspiration from the Fleischer Studios cartoons of the 1930s and references from the history of modern art and pop culture, Jeremyville has evolved a distinctive visual voice. His simple pen and ink style, sometimes with characters set against detailed isometric landscapes, has endeared him to a growing fanbase throughout the world. Jeremyville has exhibited widely, including at the Andy Warhol Museum in Pittsburgh, La Casa Encendida in Madrid, and in the 798 Art District in Beijing. His 2004 book *Vinyl Will Kill!* is regarded as one of the first to focus on the designer toy movement. In 2018, he teamed up with Hugo Boss to produce a seasonal collection and campaign for the Boss label.

p. 266 Woodstock and Friends, 2019
APortfolio, Hong Kong, drawing for a vinyl toy series; digital

A Quest Unlimited, 2018
Personal work; acrylic on canvas

opposite Brooklyn Museum Streetscape, 2018, signed and numbered screenprint

269

FIND YOUR GROOVE
TO PLAY YOUR SONG.

SUDDENLY THINKING OF YOU.

opposite Find Your Groove
to Play Your Song and Suddenly
Thinking of You, 2019
Personal work, posters;
hand drawing

Yesterday/Today/Forever/Eternity,
2018
The Skateroom, skate deck series;
hand drawing

> "His style is effortless and full of humour, grinning at our modern world through a wry squint—an ability that most of the great illustrators through time have nearly all had in common."
>
> for *It's Nice That*

JEAN JULLIEN

Jean Jullien is a French artist based in Paris after a long period in London. He was born in Cholet in the Loire Valley in 1983, and grew up in Nantes. After post-baccalauréat studies in Quimper he moved to London, where he received a BA in graphic design from Central St Martins in 2008, followed by an MA in visual communication from the Royal College of Art in 2010. Jullien has since evolved a prolific output with his strikingly simple, doodling style manifesting in every conceivable form from posters and video to apparel, furniture, and installations. Jullien's hard work and rapid rise has led to the founding of a moving-image studio with his brother Nico, the publication of books—his first monograph came out in 2016—and the launch of a product range named Nounou with Jae Huh & Co. in South Korea. Jullien has collaborated extensively with Le Centre Pompidou, Amnesty International, *Vogue*, Petit Bateau, and hundreds of other clients. His iconic illustration of the Eiffel Tour inside a circle became the symbol of "Peace for Paris" in 2015. His most recent undertakings include collaborations with Galeries Lafayette and Maison Plisson in Paris, a poster for Netflix's *Stranger Things* season 3, and commissions for magazines including *Télérama* and *M Le magazine du Monde*.

MAISON PLISSON

ALIMENTATION GÉNÉRALE

p. 272 Dog's Own Spots, 2017
Personal work

opposite Maison Plisson, 2018
Illustrations for visual identity

Untitled, 2018
Onaji Umi, solo show
Gallery Target, Tokyo

Bottle, 2017
Kiblind, magazine cover

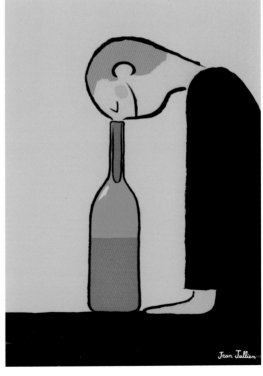

Series for *LineAge*, solo show,
2018, Studio Concrete, Seoul

Selected Exhibitions
2018, *GIB*, solo show, Arsham Fieg Gallery, New York · 2018, *Le Volet Jaune*, solo show, Encore Alice Gallery, Brussels · 2018, *Le Jardin Bleu*, solo show, Chandran Gallery, San Francisco · 2018, *Ona ji Umi*, solo show, Gallery Target, Tokyo · 2018, *LineAge*, solo show, *Studio Concrete*, Seoul

Selected Publications:
2018, *Why the Face*, Phaidon, USA · 2017, *Under Dogs*, Hato, United Kingdom · 2016, *This Is Not a Book*, Phaidon, United Kingdom · 2016, *Modern Life*, teNeues, Germany · 2016, *Ralf*, Frances Lincoln, United Kingdom

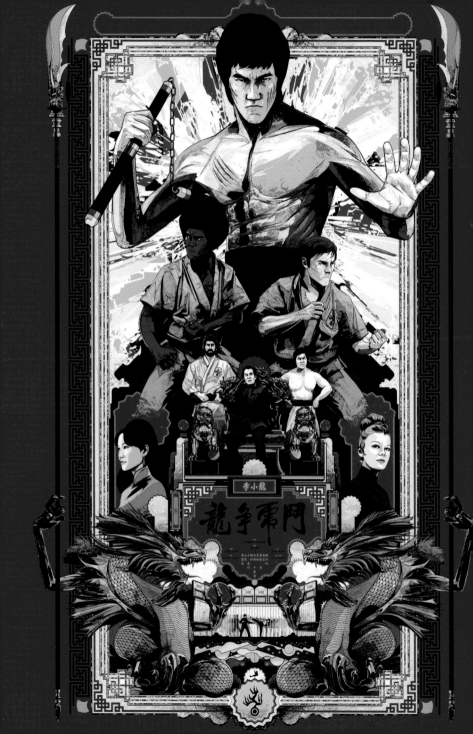

"I think we'll need more red and black."

KAKO

Born in São Paulo in 1975, Franco D'Angelo Bergamini has been conjuring up award-winning graphics as "Kako" since the early years of the millennium. Growing up in his native city, Kako and his brother spent afternoons learning to draw at a local comic-book school. His first job was as a camera assistant for an advertising company. A stint at art college followed but he dropped out in favor of freelancing in graphic and web design, eventually realizing his passion for illustration in 2002. Balancing technique and style, Kako creates vector-based imagery reminiscent of Japanese *ukiyo-e* prints. His muted palette elicits a distinctively "dark and dirty" landscape suited to his re-imaginings of Edgar Allan Poe's short stories (2018) or Ridley Scott's cult film *Blade Runner*. Indeed, it is the cinematic, subterranean atmosphere he dreams up that has earned him recognition by the Society of Illustrators, inclusion in *Lürzer's Archive*'s "200 Best Illustrators Worldwide," along with a Cannes Gold Lion to boot. As his career reaches its 20th year, Kako is working as a production designer at Arvore Immersive Experiences and looking forward to improving his understanding of creativity and communication through his exploration of virtual reality.

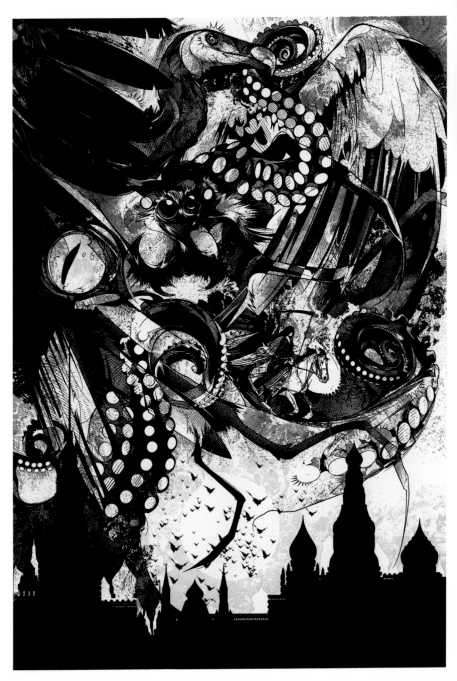

p. 278 Enter the Dragon, 2015
Limited-edition screen print; digital

opposite Ivan Turgenev,
Spirits, 2014
Editora Autêntica, book; digital

T-70 X-Wing, 2015
Hero Complex Gallery,
limited-edition screen print; digital

Righteous Rides, Le Mans, 2013
Hero Complex Gallery,
giclée print; digital

Selected Exhibitions

2015, *Strange Cities*, group show, Onassis Cultural Center, Athens · 2012, group show, Mondo Gallery, Austin · 2011, *Katalogue XXL*, group show, Museu Oscar Niemeyer, Curitiba, Brazil · 2009, *Society of Illustrators*, group show, New York · 2008, *Creative Art Session*, group show, Kawasaki City Museum

Selected Publications

2013, *100 Illustrators*, TASCHEN, Germany · 2013, *New Illustrators File*, Art Box, Japan · 2013, *Alternative Movie Posters,* Schiffer Publishing, USA · 2011, *Illustration Now!*, TASCHEN, Germany · 2008, *Society of Illustrators Annual*, USA

opposite The Warriors – These Are the Armies of the Night, 2017 Limited-edition screen print; digital

Die Bith-Machine, 2015 Hero Complex Gallery, giclée print; digital

Death of a Man, 2014 Alex Nicholson, short movie poster; ink, digital; handwriting: Futoshi Yoshizawa

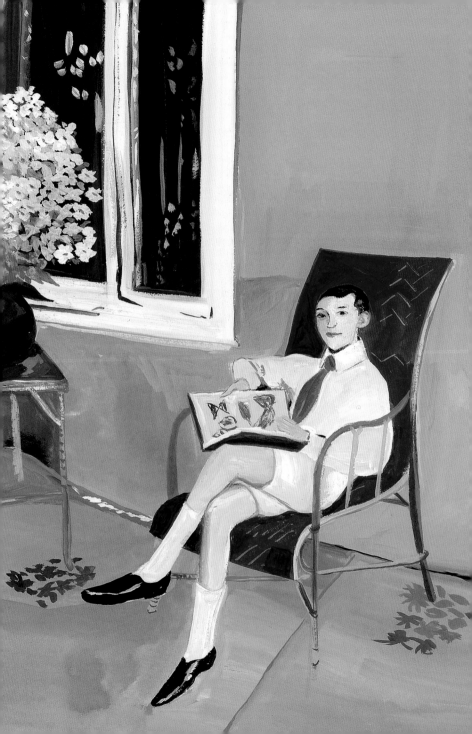

"I think I'm incredibly lucky because I had the patience and perseverance and single-mindedness to believe that I belonged in that world."

for *The Great Discontent*

MAIRA KALMAN

Maira Kalman is an Israeli-born American illustrator based in Manhattan. Her quirky, idiosyncratic vision of the modern world marries observational wit with an equal measure of irreverence. Born in Tel Aviv in 1949 to Russian-Jewish parents, Kalman moved to the Bronx in New York with her family when she was four. After studying art at the High School of Music & Art, she met her future husband, graphic designer Tibor Kalman, with whom she would collaborate closely under the auspices of their graphic and product design company M&Co. The firm became noted for its eclectic portfolio, including work for magazines such as Interview, bands like Talking Heads, and title sequences for Jonathan Demme's blockbuster movie *The Silence of the Lambs* (1991). Kalman is particularly well regarded for her children's books, the first of which, *Stay Up Late* (1987), illustrated the lyrics of David Byrne. As well as being a regular contributor to *The New Yorker*, designing fabrics for Isaac Mizrahi, and sets for the Mark Morris Dance Group, Kalman's diverse illustrational output has been showcased in numerous exhibitions, including the 2010 retrospective *Maira Kalman: Various Illuminations (of a Crazy World)* at the Institute of Contemporary Art in Philadelphia. Her two monthly online columns for *The New York Times*, "The Principles of Uncertainty" (2006–07), a narrative journal of her life, followed by "And The Pursuit of Happiness" (2009), a year-long historical investigation into American democracy, have been amalgamated into book form.

Selected Exhibitions
2019, *Maira Kalman*, solo show,
Julie Saul Gallery, New York · 2017,
Sara Berman's Closet, solo show,
Metropolitan Museum of Art,
New York · 2014, *Maira Kalman:
Selects*, solo show, Cooper Hewitt,
New York · 2010, *Maira Kalman:
Various Illuminations*, solo show,
ICA, Philadelphia

Selected Publications
2007, *The Principles of Uncertainty*,
Penguin Press, USA · 2005, *The
Elements of Style*, Penguin Press, USA

p. 284 Vladimir Nabokov
as a Young Boy, 2007
The Principles of Uncertainty,
The New York Times, newspaper;
gouache on paper

Candy Store in Rome, 2014
My Favorite Things, Harper Design;
gouache on paper

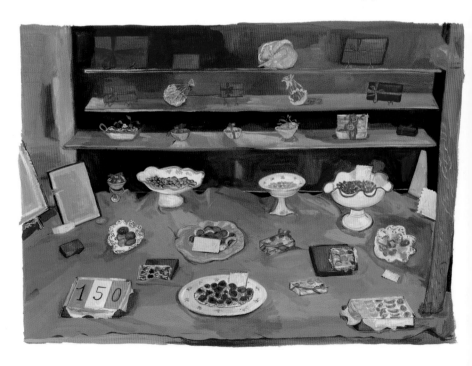

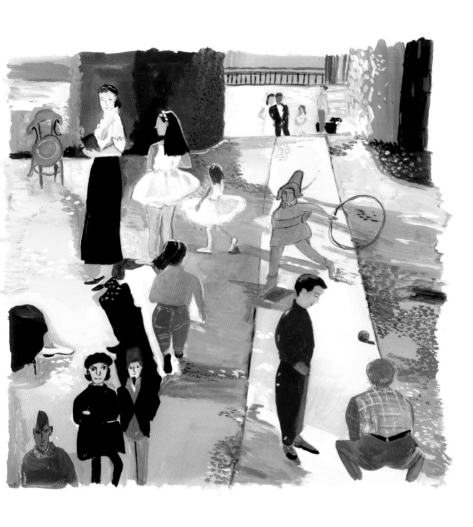

Afternoon in the Park, 2007
The Principles of Uncertainty,
The New York Times, newspaper;
gouache on paper

pp. 288/289
Gertrude and Alice, 2019
The Autobiography of Alice B. Toklas,
Gertrude Stein, book, Penguin Press
2020; gouache on paper

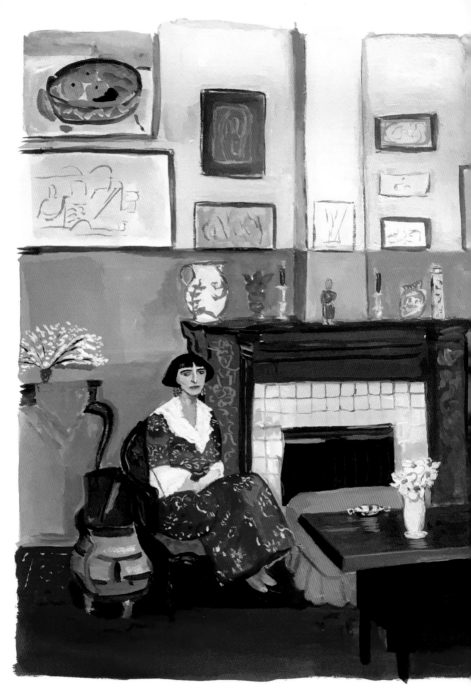

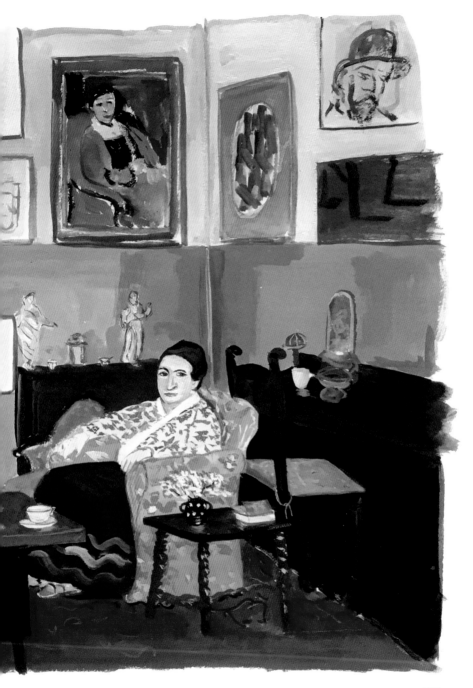

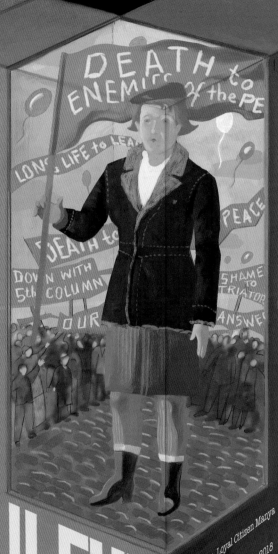

DEATH to
ENEMIES of the PE
LONG LIFE to LEA
PEACE
DEATH to
DOWN WITH
5th COLUMN
SHAME
TO
TRIATOR
OUR
ANSWER

GULAG

Action Figure Loyal Citizen Manya
For ages 5 and up
Item # 1918 1937 1948 1964 2018
Made in Russian Federation 2018

> "One day, I realized that simple ink lines and brushstrokes are doing exactly what I want them to; they are projections of my emotional state and thought processes. This was the beginning of my own visual story."

IGOR KARASH

Born in 1960, Igor Karash grew up in Baku, the capital of the former Soviet Republic of Azerbaijan. After studying architecture, he attended the Kharkov State Academy of Design and Arts in Ukraine, gaining an MA in Graphic Arts and Illustration in 1988. He immigrated to the United States in 1993, initially living in Houston, and later settling in St. Louis, where he lives and works today. The breadth of his practice can be gauged by his numerous projects in book and editorial illustration, graphic design, theater and film set design, as well as teaching. Karash works in a variety of traditional media, including pencil or gouache on paper, and ink on cardboard, though he sometimes experiments with digital tools. Imbued with a dark mysticism and deep sense of nostalgia, his personal work explores the political grotesque. Referencing the Bolshevik coup of 1917, his conceptual project *The Red Series* (2018) examines the power of the state over the creative process through a personal exploration of his native country's past as "a purely artistic reflection in the form of intimate graphic narratives that border on the absurd." A constant innovator, his ability to strike a fine balance between the familiar and the novel has earned him the highest critical regard. In 2012, he won the Book Illustration Competition run in partnership by The House of Illustration and The Folio Society for reimagining Angela Carter's *The Bloody Chamber and Other Stories*. This led to one of his most notable projects to date when, in 2014, he was commissioned by The Folio Society to illustrate a limited two-volume edition of Leo Tolstoy's epic novel *War and Peace*. Karash has twice been honored as one of *Lürzer's Archive's* "200 Best Illustrators Worldwide."

Selected Exhibitions:
2019, *Society of Illustrators*, group show, Museum of Illustration, New York · 2018, *Gulag Posters*, group show, Gulag Museum, Moscow · 2018, *In Red & Black*, solo show, Russian Cultural Center, Houston · 2016, *Telling Tales*, group show, British Academy, London · 2016, *Illustrating War & Peace*, solo show, Modern Graphic History Library, Saint Louis

Selected Publications:
2019, *Daily Heller: Dramatic Life, Dramatic Art, Print* magazine, USA · 2018, *Golden Bee Biennale Catalogue,* Russia · 2018, *Drawn,* Capsule Books, Australia · 2017, *200 Best Illustrators Worldwide, Lürzer's Archive*, Austria · 2017, *Design Annual,* Graphis, USA

p. 290 Loyal Citizen Manya, Gulag Action Figures, 2018
Personal work, competition entry for the Golden Bee International Poster Biennial, Moscow; digital

A Day of the Dictator, 2018
Personal work; pencil, digital

opposite Bolshevik Icon, One Page Comic, 2018
Personal work, print; pencil, digital

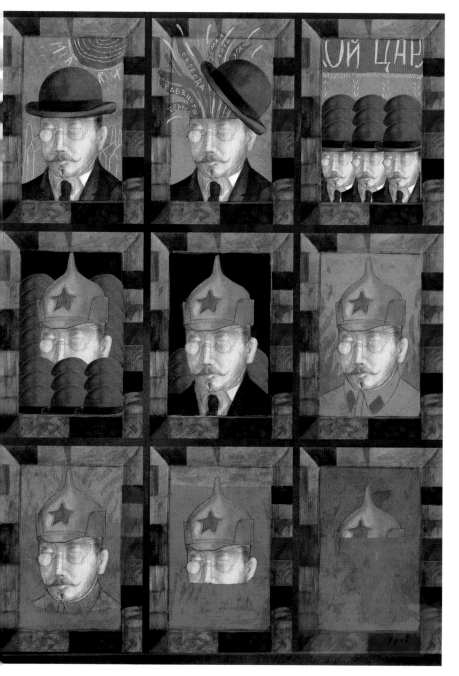

Dirty Pond or the
Day Before the Battle, 2014
War & Peace, by Leo Tolstoy,
book, the Folio Society;
gouache on Arches paper;
art direction: Sheri Gee

Swine Lake, Grand Finale, 2018
Personal work; digital

opposite *Warlight*, Michael
Ondaatje, 2017
Oprah magazine, book review;
digital; art direction: Jill Armus

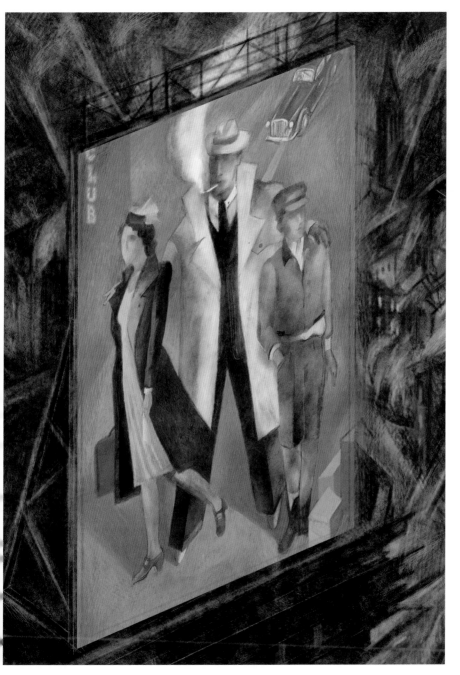

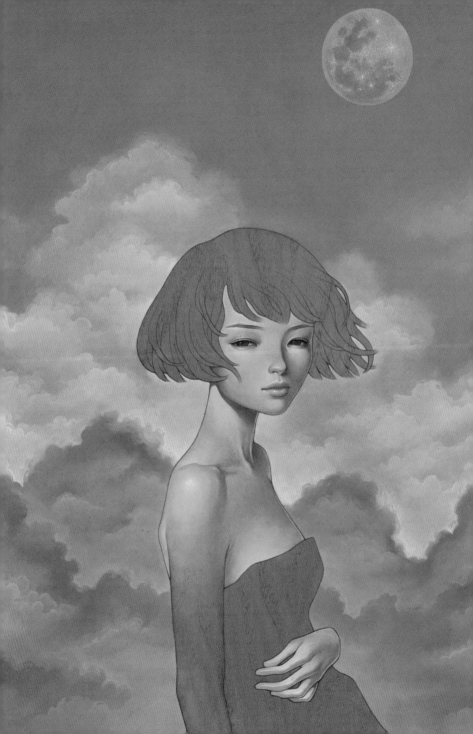

> "The main focus of my work is the face and the subtleties of capturing a certain feel and expression. Sometimes my subject's gaze is away from the viewer in a contemplative, self-reflecting way, but often I confront the viewer with a direct stare or glance, as if to say, 'I see you. I am here. I exist.'" *for Prohbtd*

AUDREY KAWASAKI

Audrey Kawasaki, a Japanese-American artist, was born in Los Angeles in 1982. As a child with a bicultural upbringing, she immersed herself in Japanese TV, food, and manga comics. An introduction to fine art classes at the Mission: Renaissance Fine Art Studio led her to enrol in the Pratt Institute in New York. However, Kawasaki left the painting course after two years, citing discouragement of her style by her faculty professors and a personal disconnection with the New York conceptual art scene. Returning to Los Angeles in the mid-2000s, Kawasaki soon emerged on the art scene, creating her own identifiable style of oil on wood panel. Her work explores the enigmatic qualities of female sensuality through innocent yet uninhibited young women—primarily focusing on the face, often looking directly at the viewer—posing in ethereal or sometimes ornate backgrounds. Blending influences from Art Nouveau and manga, her precision lines on natural grain evoke both grace and eroticism in her subjects. Kawasaki's artworks have appeared in art magazines such as *Hi-Fructose* and *Juxtapoz*. In 2011, her painting *My Dishonest Heart* was tattooed on singer Christina Perri by Kat Von D on an episode of reality TV show *LA Ink*.

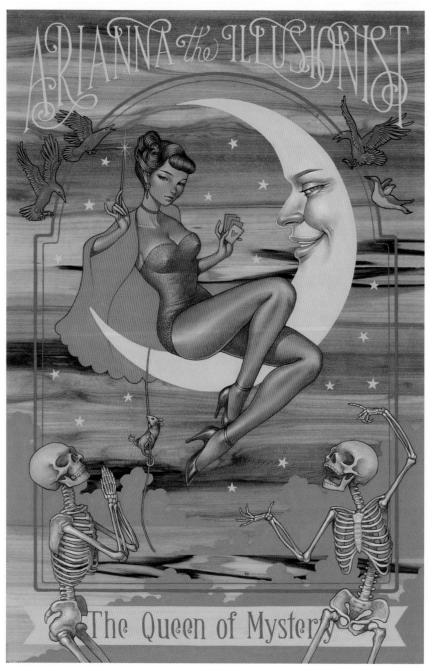

ARIANNA the ILLUSIONIST

The Queen of Mystery

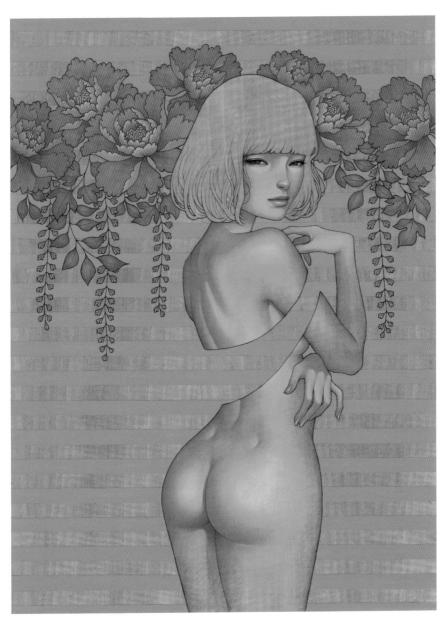

p. 296 Nocturne, 2016
Interlude, solo show, Thinkspace
Gallery, Los Angeles; graphite,
acrylic, and oil on wood panel

opposite Arianna, 2017
Thinkspace Gallery, Moniker
Art Fair, London; graphite,
and acrylic on wood panel

Charmer, 2016
Interlude, solo show, Thinkspace
Gallery, Los Angeles; graphite,
acrylic, and oil on wood panel

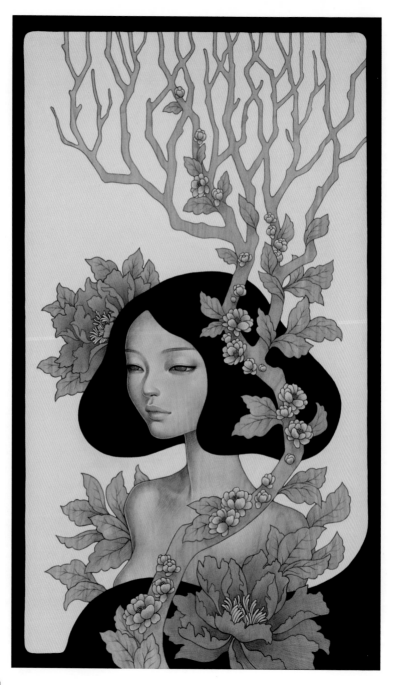

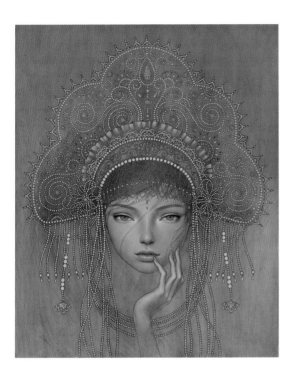

opposite Ponderer, 2013
Thinkspace Gallery, Scope
Miami Art Fair; graphite, acrylic,
and oil on wood panel

Charlotta, 2017
Gilded Horizons, solo show,
KP Projects Gallery, Los Angeles;
graphite, acrylic, and oil on wood

It Was You, 2014
Hirari Hirari, group show,
KP Projects Gallery,
Los Angeles; graphite, acrylic,
and oil on wood panel

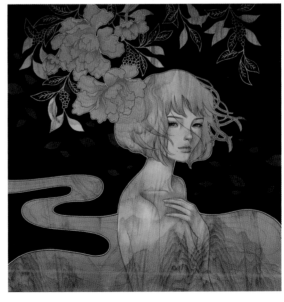

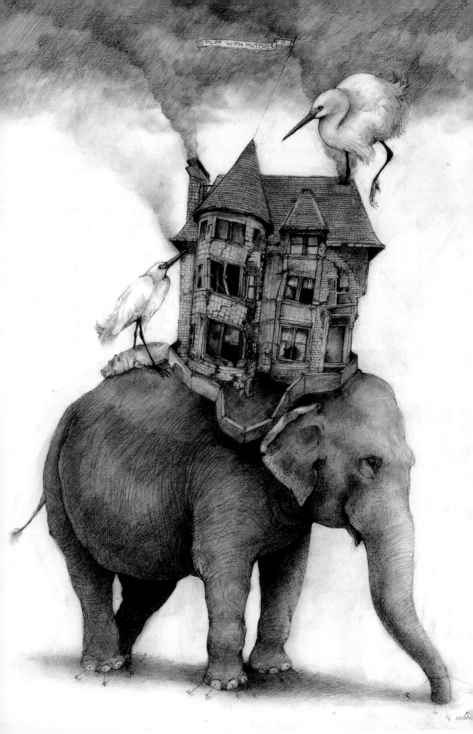

> "If something is so strong within you that you're incomplete without it, I would say give yourself permission. Because that's all you need in the end anyway."
>
> for *Your Creative Push*

ADONNA KHARE

Adonna Khare is recognized for her large-scale carbon pencil drawings on paper. Born in Glendale, California, in 1980, she received both her BA in Art (2003) and MFA (2007) from California State University, Long Beach. Her playful, anthropomorphic studies of the natural world are metaphorical reflections on the human condition. Rendered in a photorealist style, Khare's animals inhabit a surreal, almost fairytale-esque environment. References stream from Dürer to Darwin to Disney. She takes the viewer on a journey through the looking glass, where scales are subverted in a twist on the origin of species. In real life the size of her works ranges from eight-feet by ten-feet drawings to wall-size murals. Her work has featured in the *Los Angeles Times*, *American Art Collector*, and *The Huffington Post*, and has captivated audiences online and in galleries across the United States. In 2012, Khare was selected from over 1,500 artists around the world as winner of ArtPrize, the world's largest art competition. Her works can also be found in the permanent collections of the Long Beach Museum of Art, Grand Rapids Art Museum, and Crystal Bridges Art Museum. Khare is a member of The Drawing Center in New York.

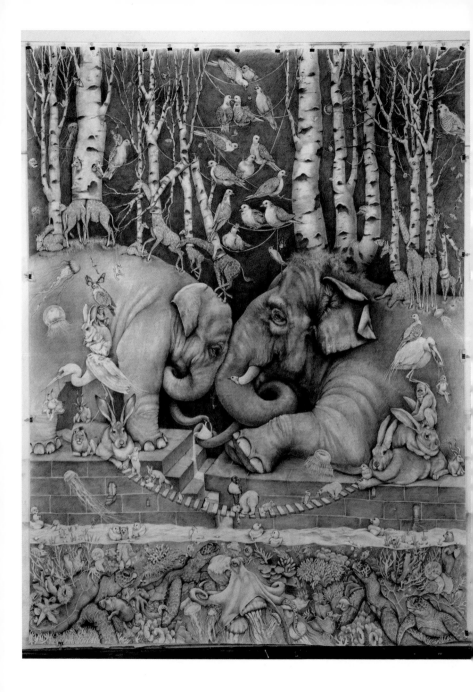

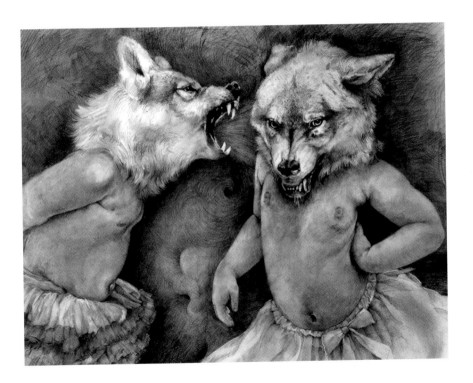

p. 302 Elephant House Birds, 2015
Personal work;
carbon pencil on paper

opposite Elephants, 2012
Personal work;
carbon pencil on paper

Screaming Wolves, 2014
Personal work;
carbon pencil on paper

"I enjoy subtracting the noise from the unnecessary information to be as simple as possible. It's a hard process because you have to take away things that are dear to you. You have to kill your darlings."

for *Design Indaba*

MAX KISMAN

Max Kisman is a Dutch graphic designer and illustrator based in Amsterdam. Born in Doetinchem in 1953, he studied graphic design, illustration and animation at the Academy of Art and Industry in Enschede before graduating from the Gerrit Rietveld Academy in 1977 and starting his own studio. An early adopter of digital technology, he created computer-aided type designs and illustrations for *Language Technology* and *Vinyl Music*. In 1986, he co-founded the magazine *TYP/Typografisch Papier*, and designed postage stamps for the Dutch Postal Service. With an editor's brain, Kisman's pictographic style is concerned with simplifying concepts to the bare essentials or, as he terms it, "subtracting the noise"— a process that is evident in his striking poster work. In 1989, he received a grant from the Netherlands Foundation for Visual Arts, Design and Architecture to explore aspects of his personal visual graphic symbolism and iconography. A move into television in the early 1990s saw a new direction in his career and practice. As chief graphic designer for VPRO in the Netherlands he began to shift his focus to their interactive media arm VPRO-digital. He designed icons for the pioneering web magazine *HotWired* before moving to San Francisco to work for Wired Television. In 2002, he became a member of the Alliance Graphique Internationale. During his illustrious career, Kisman has taught in institutions throughout Holland and in San Francisco, and has designed typefaces for FontShop International, Fuse, and his own Holland Fonts foundry.

Selected Exhibitions

2018, *Tolerance Poster Show*, group show, traveling exhibition · 2018, *Sex Only*, solo show, Museum Meermanno, The Hague · 2017, *17for17*, group show, Palais de Tokyo (Paris), Dutch Parliament (The Hague) · 2016, *Voor Altijd Jong. Max Kisman en Fiep Westendorp*, solo show, WG Kunst, Amsterdam · 2013, *Max Kisman Beeld Taal*, solo show, Gr-id Museum, Groningen

Selected Publications

2018, *Sex Only, Max Kisman Diary Documents 1987–2017*, Sub Q Amsterdam, The Netherlands · 2018, *#Geni #Taal #XXX*, Drukwerk in de Marge, By Kisman, The Netherlands · 2017, *Fukt #16 Dirty Drawings. The Sex Issue, Fukt Magazine*, Germany · 2016, *Vlinder wijst de weg*, By Kisman, The Netherlands · 2014, *I Am a Slave of Your Freedom*, By Kisman, The Netherlands

p. 306 Indonesian DNA, 2014 CODA Museum, Apeldoorn, poster; analog sketching, digital

Du bist mein Geheimnis, 2018 Paradiso, poster; analog sketching, digital, screen print

The Year of Space, 2015
S+RO magazine;
analog sketching, digital

opposite Ancestors, 2014
Tablecloth; analog sketching, digital,
Jacquard weaving

No Poverty, 2017
Chora Connection, Alliance
Graphique Internationale, poster;
analog sketching, digital

#Metoo, A Year Later, 2018
NRC, newspaper; analog sketching,
digital

"Work hard. Draw every day. Draw what is around you. People, places, objects… everything." for *AI-AP*

OLIVIER KUGLER

German-born Olivier Kugler's reportage illustrations display an extraordinary skill-set for storytelling through graphics and words. From reporting on a veterinarian's work with elephants in the illegal logging industry in Laos, to documenting the remarkable story of a truck driver's journey from Turkey to Iran—which won him a V&A Illustration Award in 2011—Kugler's work has taken him far afield. He documents his subjects first-hand, drawing on location, or from his own photographs, and coloring on his laptop. The resulting panels are loaded with details, prompting the viewer to eye-track a scene. He also produces graphic novels: *Escaping Wars and Waves: Encounters with Syrian Refugees* was first published in 2018. Born in Stuttgart in 1970, Kugler grew up reading Tintin books in Simmozheim, a small village in the Black Forest. After military service in the Navy, he received a diploma in visual communication from the Hochschule Pforzheim before working as an agency designer in Karlsruhe. An opportunity came when he was offered a scholarship to do an MA in Illustration at the School of Visual Arts in New York. Since graduating in 2002, Kugler has specialized in documentary illustration, gaining early support from *The Guardian*, with later commissions from Médecins Sans Frontières, *Harper's Magazine*, and French quarterly *Revue XXI*. He lives and works in London.

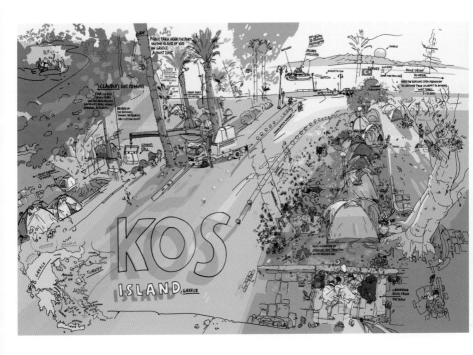

p. 312 Mit dem Elefantendoktor in Laos, Edition Moderne, 2013; first published as "Le Docteur Elephants", *Revue XXI* magazine, 2012; pencil drawing, colored digitally

Kos, *Escaping Wars and Waves*, Myriad Editions (UK), Penn State University Press (USA), 2018; first published by *Harper's* magazine, USA, 2014; pencil drawing, colored digitally

opposite Habib, *Escaping Wars and Waves*, Myriad Editions (UK), Penn State University Press (USA), 2018; first published by *Harper's* magazine, USA, 2014; pencil drawing, colored digitally

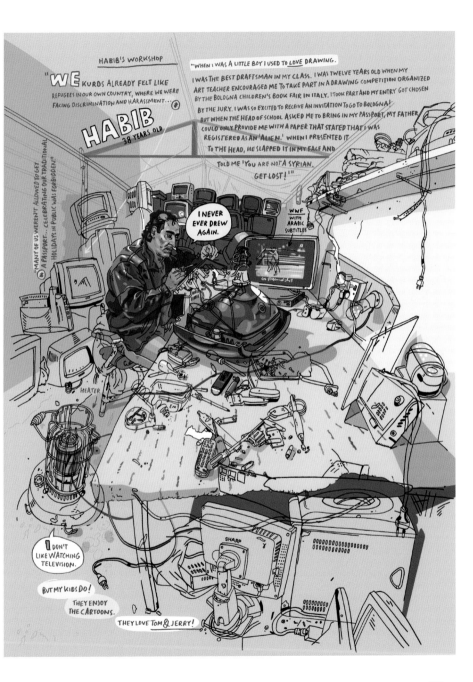

315

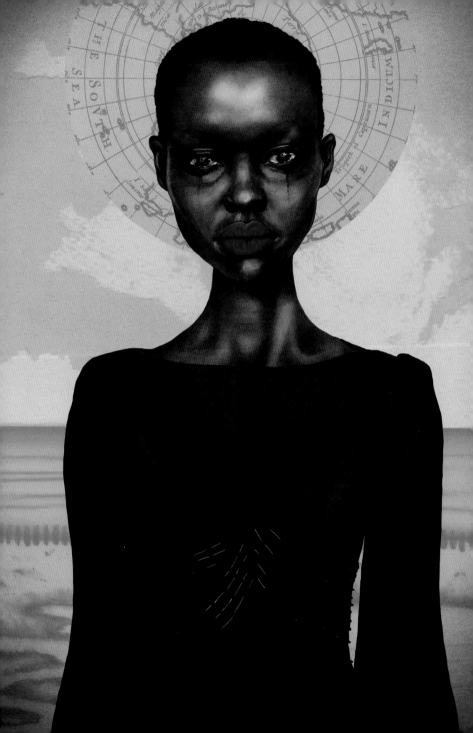

> "I'm very interested in the beauty that lies beneath the surface. That's why there's always something in my drawings that distracts the viewer's eye, like bugs or the skeleton of an ostrich." *for Lagom*

KATARINA KÜHL

Born in 1985, Katarina Kühl is a German freelance illustrator based in her home city of Hamburg, where she graduated in illustration and design at Bildkunst Akademie in 2014. The focal point in much of Kühl's work is the human face in all its myriad expressions, often embellished with her signature circled cheeks. Hints of John Tenniell, Tim Burton, and *commedia dell'arte* bubble up in her slightly caricatured features, inviting the viewer to look beneath the surface. She creates her works directly from the source of inspiration, seldom sketching beforehand. An idea can come from a book or from characters in a film, whether real or fictitious. After responding to a creative brief, her depiction of Cate Blanchett for the 2015 film *Carol* was hand-picked by film director Todd Haynes to appear in the cinema magazine *Little White Lies*. Kühl's personal career highlights include illustrating a book about baking entitled *Die drei Damen auf Café-Fahrt* and entering an online competition by Draw A Dot, in which she illustrated her vision of fashion designer Giambattista Valli (who subsequently began to follow her on Instagram).

Selected Exhibition
2012, *Liebeserklärungen an ein Hotel*, group show, Hotel Wedina, Hamburg

Selected Publications
2018, *Die drei Herren und das mysteriöse Fischbrötchen*, Wölfchen Verlag, Germany · 2016, *Threaded* magazine, Threaded Media Ltd, New Zealand · 2016, *Rosegarden* magazine, Rosegarden Verlag, Germany · 2015, *Die drei Damen auf Café-Fahrt*, Wölfchen Verlag, Germany · 2013, *GEOmini*, Gruner & Jahr, Germany

p. 316 Halo, 2018
Personal work, fine art print; pencil,
chalk, digital, collage with
photograph, map, and drawing;
dress: Zac Posen

opposite Diamonds, 2018
Personal work, fine art
print; pencil, chalk, digital;
dress: Gucci

Lady Gwendoline, 2017
Personal work, fine art print; pencil,
chalk, digital; model: Gwendoline
Christie; dress: Giambattista Valli

Stranger Things, 2016
Personal work, fine art print;
pencil, chalk, digital

opposite Inspired by
British *Vogue*, 2018
Personal work, fine art print;
pencil, chalk, digital; model:
Cara Delevingne; hat: Noel Stewart

"I am a witness to the world around me, and my visual comments are reactions to these events. In every case, there is a fluidity, a desired response, though of course I cannot control that response; in some ways, what I really do is try and encourage thoughtful participation in the cultural moment."

ANITA KUNZ

Anita Kunz is one of the most established voices in contemporary illustration. Born in Toronto in 1956, she grew up in a German household in Kitchener, Ontario reading dark children's tales like *Der Struwwelpeter* and *Max und Moritz*. After returning to her native city, she received her degree from Ontario College of Art in 1978. Throughout an illustrious career spanning four decades, Kunz's work has graced the covers of over fifty books and accompanied the editorials of some of the world's leading print magazines, from *Rolling Stone* and *The New Yorker* to *Variety*. A noted speaker, she has lectured on her craft at TED and the Smithsonian, and has also led workshops at the Illustration Academy in Sarasota, Florida and at Syracuse University in New York. Her paintings are in the permanent collections of several important institutions, including the Library of Congress and the Canadian Archives in Ottawa. In 2017, she was inducted to the Museum of American Illustration Hall of Fame in New York. Often irreverent, sometimes haunting, Kunz's handcrafted style is steeped in references to art history, from the Flemish Masters to Surrealism. Her process involves collecting reference material and doodling on paper. She usually paints on board, gradually layering with watercolors and gouache.

Selected Exhibitions
2017, *Anita Kunz*, solo show, Ro2
Gallery, Dallas · 2015, *Serious Wit*,
solo show, Massachusetts College
of Art, Boston · 2008, *Satirical
Conclusions*, solo show, Laguna
Beach College, California · 2003,
Point Counterpoint, solo show,
Swann Gallery, Library of Congress,
Washington, D.C. · 2000,
Retrospective, solo show, Museum of
American Illustration, New York

Selected Publications
2014, *The 100 Best Illustrators
Worldwide, Lürzer's Archive*, Austria ·
2012, *Blown Covers, The New Yorker*,
USA · 2008, *Illustration Now!*,
TASCHEN, Germany · 2002,
Art and Evolution, Nuvo magazine,
Canada · 2000, *Rolling Stone:
The Illustrated Portraits*, Chronicle
Books, USA

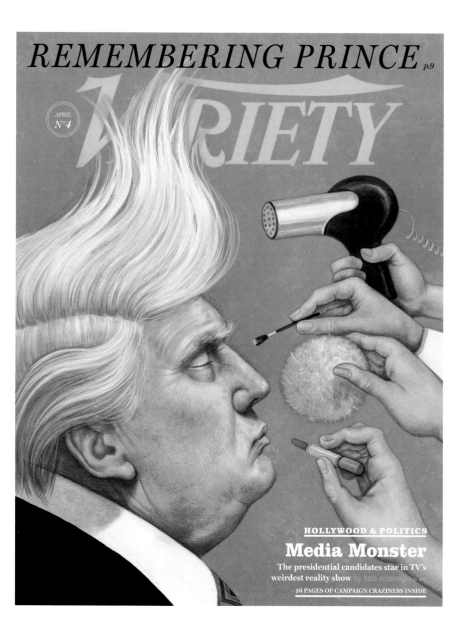

REMEMBERING PRINCE *p.9*

APRIL
Nº 4

VARIETY

HOLLYWOOD & POLITICS

Media Monster

The presidential candidates star in TV's
weirdest reality show By TED JOHNSON

26 PAGES OF CAMPAIGN CRAZINESS INSIDE

p 322 Raphael redux, 2018
Personal work; acrylic on board

opposite Dangerous Toys, 2015
The New Yorker, magazine
cover; acrylic; art direction:
Françoise Mouly

Media Monster, 2015
Variety, magazine cover; acrylic;
art direction: Chuck Kerr

Magritte Redux, 2018
Personal work; acrylic on board

opposite top Belushi, 2015
Rolling Stone, magazine, acrylic;
art direction: Joe Hutchinson

opposite bottom
Matisse Redux, 2018
Personal work; acrylic on board

"It always happens that the illustration moves in a direction of its own during the process. The less control I have over it, the better it becomes. The more I start to analyze and think, the worse it gets."

for *Beretkah*

LAURA LAINE

Born in Helsinki in 1983, Laura Laine belongs to a new wave of gifted Scandinavian artist-illustrators. After specializing in fashion illustration at the University of Art and Design in Helsinki, where she now teaches, Laine embarked on a solo career as a freelancer. Her favored muses, beautifully rendered in pencil and pen, are mainly elongated catwalk models or "twisted-bodied girls with a melancholy attitude," which have made her a sought-after creative talent in the high-end fashion world. Her stylized vision and collaborative approach—working with designers, art directors, stylists, and photographers—has resulted in ad commissions for such clients as Gap, Tommy Hilfiger, Iben Høj, and *Vogue Japan*. In 2011, Laine received the Design Forum Finland's Young Designer of the Year award with fashion designer Heikki Salonen. Outside of her native Helsinki, she has exhibited her work in the Netherlands, New York, London, and Los Angeles. In 2013, Laine forayed into glass art, participating in a group show at the National Glass Museum of Holland in Leerdam. Her interest developed into a solo exhibition at the Design Museum, Helsinki in 2015.

p. 328 Lotta Volkova, 2016
Marie Claire, magazine;
pencil and markers on paper

opposite Viktor & Rolf, 2017
Personal work; pencil and markers
on paper

Girl #1, 2018
Personal work, video art;
pencil on paper

Girl #2, 2018
Personal work, video art;
mixed media on paper

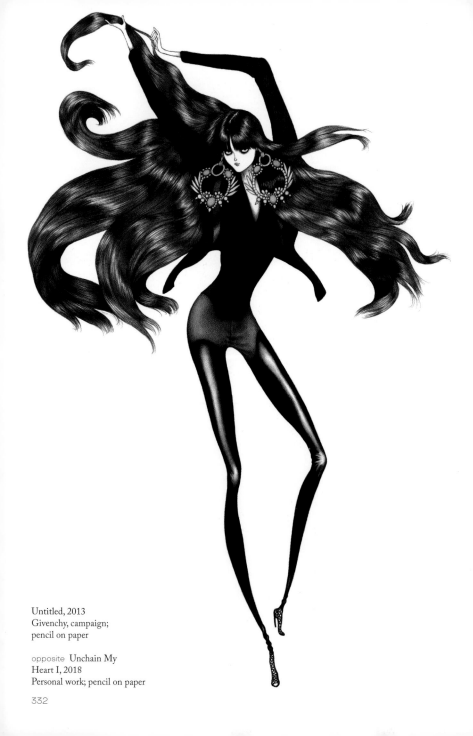

Untitled, 2013
Givenchy, campaign;
pencil on paper

opposite Unchain My
Heart I, 2018
Personal work; pencil on paper

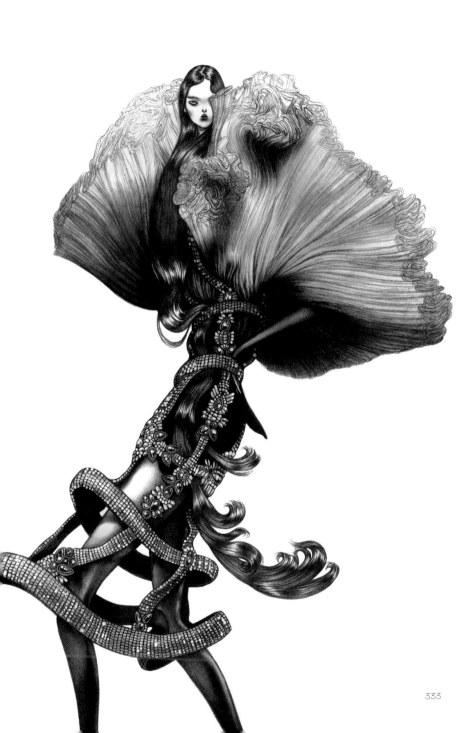

> "Possessing a dark and theatrical style, influenced by the likes of Alexander McQueen and Gareth Pugh, Connie's work lends itself well to the sinister trappings of gaming equipment." *for Schön! Magazine*

CONNIE LIM

Connie Lim is an American illustrator with Korean heritage. Born in Los Angeles in 1986, she was bitten by the drawing bug at an early age. Whilst attending Art-Center College of Design in Pasadena, her penchant for fashion design and illustration developed. This guided her to Central St Martins in London, where she graduated with a BA in Fashion Design and Marketing in 2013. During this period she began honing her craft in the industry—taking on freelance commissions, doing an internship with British designer Giles Deacon, and featuring her work in *Dazed and Confused* and fashion art books such as *The Beautiful: Illustrations for Fashion and Style* (2010). With a style occupying a realm somewhere along the border of 1960s spy comic books (Modesty Blaise) with traces of Art Nouveau (Alphonse Mucha), Lim's fantasy graphic world is inhabited by a host of mysterious, gothic-tinged women, often inked or rendered in Polychromos color pencil on moleskin paper. In 2014, following a successful crowdfunding campaign, she realized a long-term personal project of creating a signature set of 54 hand-drawn and beautifully packaged playing cards. Dividing her time between London, New York, and Los Angeles, Lim has taught at the University for Creative Arts in Rochester (UK), and guest-lectured at London College of Fashion. Her list of clients includes Bulgari, Guerlain, and Maybelline.

Selected Exhibitions

2017, *Fashion Illustration Gallery*,
group show, Bluebird Chelsea,
London · 2017, *SHOWStudio*, group
show, Floral Street Gallery, London ·
2016, *Fashion Illustration Gallery*,
group show, Bluebird Chelsea,
London · 2016, *SHOWStudio,
Lifedrawing*, group show, Sunbeam
Studios, London · 2016, *Connected
Lines*, group show, Oxo Gallery,
London

Selected Publications

2010, *The Beautiful: Illustrations for
Fashion*, Gestalten, Germany · 2010,
Curvy, 6th edition, Brio Group,
USA · 2007, *Great Big Book of
Fashion Illustration*, Batsford, USA

p. 334 Smoke, 2016
Personal work; goauche
on sketchbook paper

opposite Roses, 2017
Personal work; gouache
and watercolor on
Bockingford paper

Charme Lipstick #3, 2017
Louboutin, website;
gouache on sketchbook paper

Maison Margiela,
Fall/Winter 2016
Show Studio; gouache
on sketchbook paper

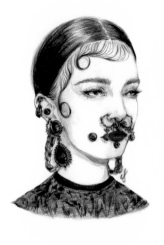
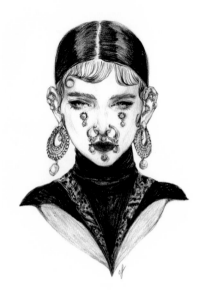
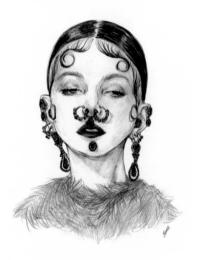
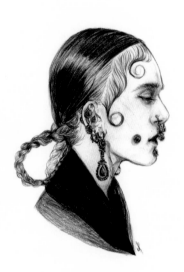

338

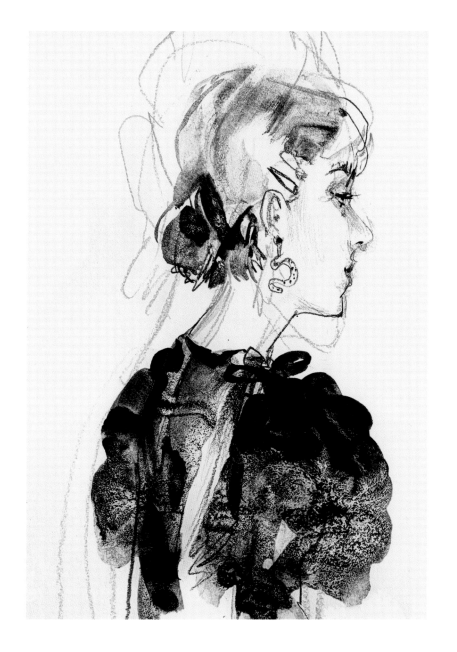

opposite Givenchy Fall/
Winter 2015
Personal work; pencil, gouache

Elizabeth in Pink #2, 2018
Personal work; pencil, ink

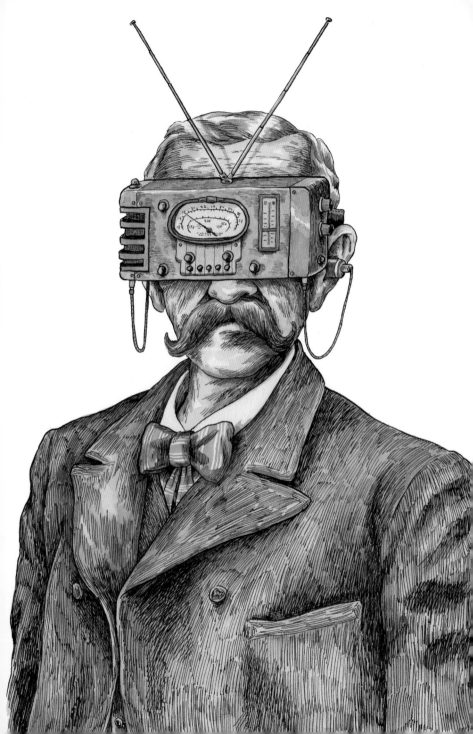

> "I am just this big salad full of different ingredients. And I generally don't think it's very nice when an artist tries to go, 'Hey, I just appeared out of nowhere! I am such an original.' I mean, say thanks, man!" *for Alt.Latino*

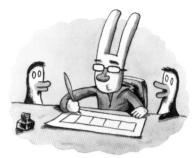

LINIERS

Ricardo Siri likes inappropriate names, and this is reflected in his choice of pseudonym—his namesake ancestor, Liniers, was a French viceroy in Buenos Aires who met his fate via a firing squad. Born in the Argentine capital in 1973, Liniers drew *Star Wars* scenes as a child, so that he could take them home from the cinema. A passion for comics grew. After studying advertising, Liniers began illustrating for fanzines, and soon progressed to magazines and newspapers. A wealth of inspirations abound in Liniers' panels, from Hergé (*Tintin*) to Charles Schulz (*Peanuts*) and Bill Watterson (*Calvin & Hobbes*). His highly popular comic strip Macanudo has been published in Argentine daily *La Nación* since 2002, and has now been translated into English and widely syndicated. Liniers has published over 30 books, including *Rabbit on the Road* (2008), a series of illustrated travelogs with his alter ego as a bespectacled bunny. As well as his meta-humor cartoon strips, Liniers has endeared himself to younger readers with his easy-to-read children's stories, such as *The Big Wet Balloon* (2013), and the wonderful *Written and Drawn by Henrietta* (2015), which charts the process of a young girl as she creates her own color-pencilled world with the help of her cat. In 2018, his book *Good Night, Planet* won the Eisner Award for Best Publication for Early Readers. Liniers' work has graced several covers for *The New Yorker*. He currently lives in Vermont, where he was a fellow at the Center for Cartoon Studies (2016–17).

2018, *Art by Liniers*, solo show, The Society of Illustrators, New York · 2016, *Todo es Macanudo*, solo show, Centro Cultural Borges, Buenos Aires · 2016, *Pensemos bien con Liniers*, solo show, Museo de Arte Contemporáneo, Lima · 2015, *Macanudismo, Quadrinhos, Desenhos e Pinturas de Liniers*, solo show, Centro Cultural dos Correios, São Paulo · 2014, *Cosas que te pasan si estás vivo, exposición de tiras de Liniers*, solo show, Casa Tinta, Bogotá

Good Night, Planet, 2017
Toon Books, book

p 340 Old school future,
Personal work

Art by Liniers, 2018
Society of Illustrators, poster

pp. 344/345 *El Macanudo
Universal 2*, 2015 Editorial Común,
book cover

Nueve cabezas, 2009
Personal work, acrylic on canvas

opposite Relatos Salvajes, 2014
Warner Bros. Pictures, movie poster

WARNER BROS. PICTURES PRESENTA

UNA PRODUCCIÓN DE KRAMER & SIGMAN FILMS Y EL DESEO CON EL APOYO DEL INCAA ICAA EN CO-PRODUCCIÓN CON TELEFE PRODUCTORA ASOCIADA CORNER PRODUCCIONES
"RELATOS SALVAJES" CON RICARDO DARÍN OSCAR MARTÍNEZ LEONARDO SBARAGLIA ÉRICA RIVAS RITA CORTESE JULIETA ZYLBERBERG Y DARÍO GRANDINETTI
MÚSICA ORIGINAL GUSTAVO SANTAOLALLA DIRECCIÓN DE FOTOGRAFÍA JAVIER JULIÁ DIRECCIÓN DE SONIDO JOSÉ LUIS DÍAZ DIRECCIÓN DE ARTE CLARA NOTARI VESTUARIO RUTH FISCHERMAN CASTING JAVIER BRAIER VILLEGAS BROS.
MONTAJE DAMIÁN SZIFRON PABLO BARBIERI COORDINACIÓN DE POST PRODUCCIÓN EZEQUIEL ROSSI PRODUCTORES ASOCIADOS CLAUDIO F. BELOCOPITT GERARDO ROZÍN CO-PRODUCTOR AXEL KUSCHEVATZKY
PRODUCCIÓN EJECUTIVA POLA ZITO LETICIA CRISTI PRODUCIDA POR HUGO SIGMAN AGUSTÍN ALMODÓVAR PEDRO ALMODÓVAR MATÍAS MOSTEIRIN ESTHER GARCÍA ESCRITA Y DIRIGIDA POR DAMIÁN SZIFRON

347

> "Basically I create eye-roll-inducing art that makes me laugh. Often there are subtle hints of more serious themes, like when I'm walking the streets and find discarded items in trash." *for Widewalls*

ADAM LUCAS

Through his delightfully irreverent take on celebritydom, advertising, and consumerism, the artist known as Hanksy (b. Adam Lucas, 1986) has contributed his own humorous voice to street art culture. In 2011, the struggling young creative—recently transplanted to New York from Chicago, and just laid off from work—decided to make a joke piece. Hybridizing Banksy's famous rat with the cartoon head of actor Tom Hanks, he wheatpasted it onto a wall in NoLita, and a new art meme was born. Someone posted it online and it went viral. Propelled by the online sensation (Tom Hanks even tweeted about it), Hanksy embarked on a full-time practice of light-hearted visual spoofing with satirical epigrams. Sold-out exhibitions and interactive installations followed (*Surplus Candy*, 2014, and *Best of the Worst*, 2015). More icons were mashed up, from the waggish Homer Simpson as an "avoca'doh" to the acerbic "Dump Trump"—the latter depicting the presidential candidate as a poop emoji. Unlike his namesake inspiration, in 2016 the artist behind Hanksy decided to reveal his true identity and rebrand himself as Adam Lucas. Signaling a more informed departure from his street-art parody, his inaugural exhibition *Some Grow Up, Others Grow Down* was the result of a long period of isolationist gestation. Comprising a series of multicolored mural panels in a style the artist has dubbed "Synthetic Cubism," Lucas's work addresses cultural coding by mixing text within an abstract pop context. He works from his studio in Chinatown.

Selected Exhibitions
2018, *Public Display No. 2*, group
show, Galerie du jour Agnés B.,
New York · 2017, *Some Grow Up,
Others Grow Down*, solo show,
New York

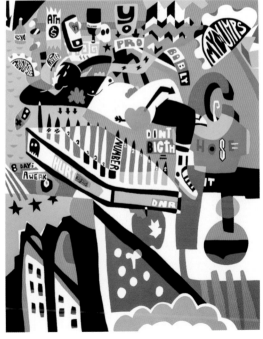

opposite Floor & Wall
Pattern #2, 2018
1800 Tequila, in-store activation;
hand drawing, vector

Dont Hassle Me, 2017
Personal work; hand drawing,
acrylic on canvas

You Probably Chose It, 2017
Personal work; hand drawing,
acrylic on panel

> "I always knew that I wanted to do digital art, but it was ridiculous. It was like saying I wanted to be a professional pogoist. When I started, there was nothing: almost no blogs, no tutorials, barely any magazines. Saying you wanted to do that professionally was ludicrous."
>
> for *The Great Discontent*

JUSTIN MALLER

Justin Maller is a freelance digital artist and art director based in Los Angeles. Born in Melbourne in 1983, he studied creative arts at the University of Melbourne, which he found "thoroughly un-useful." In 1998, a friend gave Maller a copy of Photoshop 4, and from that moment he was hooked. Within a few years he was creating digital art and immersing himself in the DeviantArt community. In 2002, he co-founded the Depthcore Collective, an international modern digital art collective of which he is also Creative Director. After some years working for various companies, followed by a move to New York, he went solo in 2007, steadily building an enviable client base, which includes such major brands as Verizon, Google, Nike, Jordan, ESPN, and Ministry of Sound. Maller's style has shifted from displaced hyperrealities to portraits and animals rendered as 3D geometric abstractions. He rarely uses stock imagery, preferring his own photography or collaborative contributions for original source material. In 2013, he set himself the challenge of producing a new work of art each day for 365 days. The resulting project, titled *Facets*, gained him much kudos on social media.

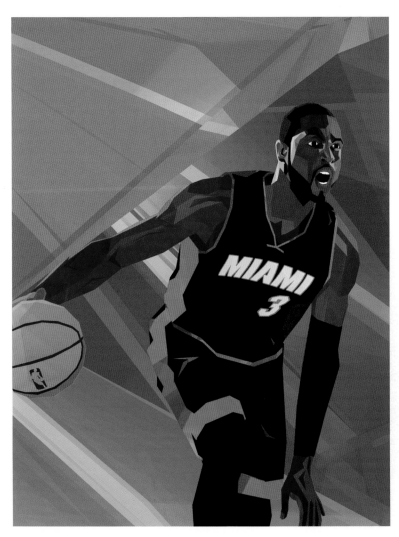

Apple Dreams, 2017
Unico; digital

Candy Dreams, 2017
Unico; digital

> "The light is like 'knowledge,'
> the perfect moment in
> an encounter with nature.
> Great balance could be represented
> with a near-death experience."
>
> for *Odalisque Magazine*

MARCO MAZZONI

Born in 1982 in Tortona, in the Piedmont region of Italy, Marco Mazzoni discovered drawing at 14 when he created an album cover for some friends' punk band. Local gig posters soon followed and the artist's passion was sparked. Later, Mazzoni studied painting at the Brera Academy in Milan, receiving his bachelor's degree in 2007. Working almost exclusively with colored pencil—a fine line between portraiture and still life—his work is a contemplation on nature and mysticism. Recurring subjects are young women: herbalists from 16th- to 18th-century Sardinian folklore, *Cogas* (faeries) and *Janas* (vampiric witches) that cure and curse. Their eyes are often obscured by shadow or light, or covered with ornate flora and fauna or animal life, as if personifying the mystical properties of their medicines. Fish shoal in clusters, birds and mammals entangle in nests, oozing mucousy sap. His moleskin sketchbooks almost become diptychs, taking on the appearance of the ancient books of remedies themselves. There is an uncanny embodiment of the physical in Mazzoni's practice. He remains somewhat aloof online, letting his work speak for itself to hundreds of thousands of followers. Mazzoni has exhibited in Europe and the United States. In 2016, his series titled *The Illustrated Encyclopedia of Mental Diseases* featured in the group exhibition Cluster at the Jonathan LeVine Gallery in New York. The following year saw the launch of a successful Kickstarter campaign to produce his first high-quality, limited-edition hardback book titled *Drawings + Sketches 2012/2017* in collaboration with Satellite Press, a small publishing house dedicated to the Italian underground scene. He lives and works in Milan.

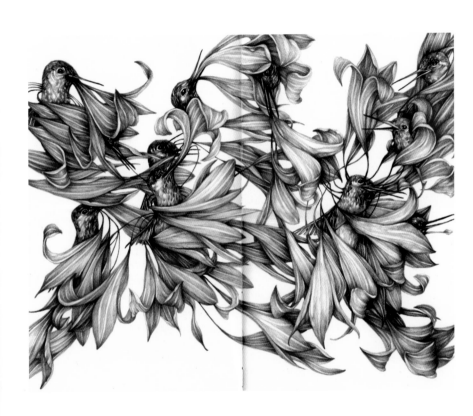

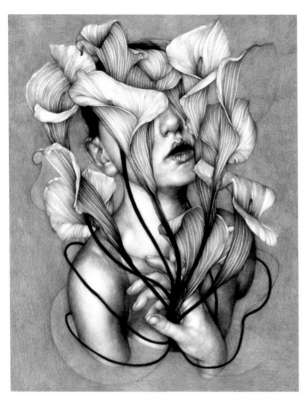

p. 358 Dance, Weep, Dance, 2017
Personal work; hand drawing;
Galleria Giovanni Bonelli

opposite Prom, 2017
Ltdedn (This is a Limited Edition);
hand drawing

Insecurity, 2017
Personal work; hand drawing;
Thinkspace Gallery

Aphonia, 2015
Personal work; hand drawing;
Galleri Benoni

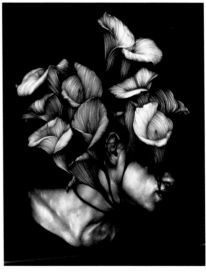

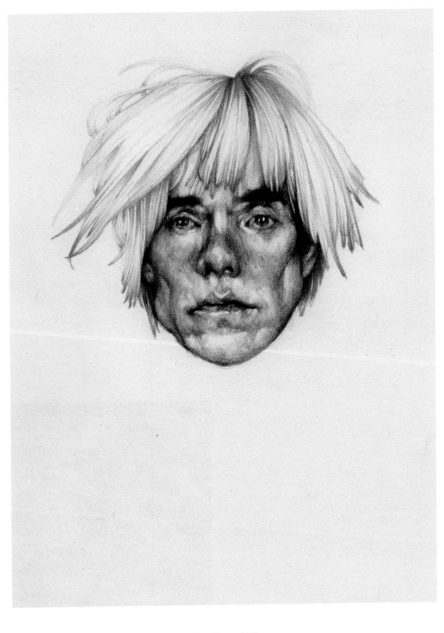

Andy, 2017
Dondup, magazine;
hand drawing

opposite Sketch #01, 2017
Satellite Press, book;
hand drawing

Selected Exhibitions

2018, *The Moleskine Project VII*, group show, Spoke Art Gallery, New York · 2018, *Imago, a History of Portraits*, group show, Muca Museum, Munich · 2017, *Dear Collapse*, solo show, Thinkspace Gallery, Los Angeles · 2016, *Turn the Page, the First Ten Years of Hi-Fructose*, group show, Virginia Museum of Contemporary Art · 2016, *Monism*, solo show, Galleri Benoni, Copenhagen

Selected Publications

2018, *Imago, a History of Portraits,* Muca Books, Germany · 2018, *Poucette,* Albin Michel Jeunesse, France · 2017, *The Moleskine Project Volume One of Hi-Fructose,* Paragon Press, USA · 2017, *Vision of the Dark Side: the Best of Dark Illustration,* DPI, Taiwan · 2017, *Turn The Page: the First Ten Years of Hi-Fructose,* Baby Tattoo Books, USA

"I create images that are thought-provoking and seductive. People and their relationships are a central theme throughout my work. Creating art about people and their odd ways, my characters seem to exude an idealized innocence with a glimpse of hard-earned wisdom in their eyes."

TARA McPHERSON

Born in San Francisco in 1976, Tara McPherson grew up in Los Angeles. In 2001, she graduated with a BFA (Hons) in Illustration from ArtCenter College of Design in Pasadena. Whilst still a student she interned at Rough Draft Studios working on Matt Groening's animated series *Futurama*. A move to New York proved pivotal in kickstarting her freelance career. She soon found herself creating gig posters for the Knitting Factory and bands on the alternative scene, including Death Cab for Cutie and Queens of the Stone Age. McPherson's otherworldly imagination harbors a myriad of influences from comic books to science to European folklore. She has described her style as somewhere between "rendered and flat, sweet and creepy, illustrative and figurative." Candy-colored science-fiction girls in space helmets with carved-out hearts float in an abyss with luminous sea creatures or are lifted by strange cartoon-eyed balloons. Loaded with symbols, these surreal depictions give the viewer a kaleidoscopic glimpse into the human psyche. Her art migrates from paintings to murals, posters, comics, books, and toy figures. McPherson lectures around the world and is a former faculty member of Parsons School of Design. Her work is in the permanent collection of the Rock and Roll Hall of Fame. In 2012, her "Lilitu" figure produced by Kidrobot won "Toy of the Year" at the Designer Toy Awards.

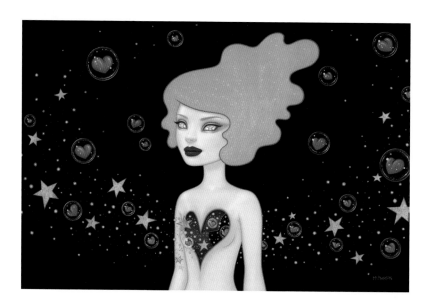

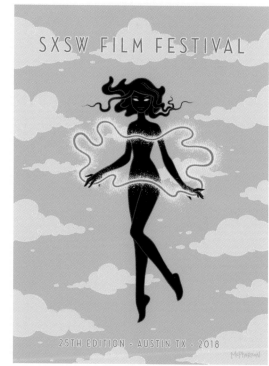

p. 364 Stellar Revolution, 2017
Designer Con, booklet cover;
graphite, ink, digital

opposite Eyes On You, 2017
Personal work, website; oil

Supernova, 2014
Personal work, exhibition; oil

SXSW Film Festival, 2018
Promotional poster;
graphite, digital

Selected Exhibitions
2015, *I Know it by Heart*, solo show,
Dorothy Circus Gallery, Rome ·
2014, *Supernova*, group show, Merry
Karnowsky Gallery, Los Angeles ·
2013, *Wandering Luminations*, solo
show, Jonathan LeVine Gallery,
New York · 2010, *Bunny in the
Moon*, solo show, Jonathan LeVine
Gallery, New York · 2009, *Fractal
Lake*, group show, Choque Cultural,
São Paulo

Selected Publications
2017, *Hi-Fructose Volume 42*, Ouch
Factory Yum Club, USA · 2013,
*Bunny in the Moon: The Art of
Tara McPherson Volume 3*, Dark
Horse Books, USA · 2009,
*Lost Constellations: The Art of Tara
McPherson Volume 2*, Dark Horse
Books, USA · 2006, *Lonely Heart:
The Art of Tara McPherson Volume 1*,
Dark Horse Books, USA · 2006,
Illustration Now!, TASCHEN,
Germany

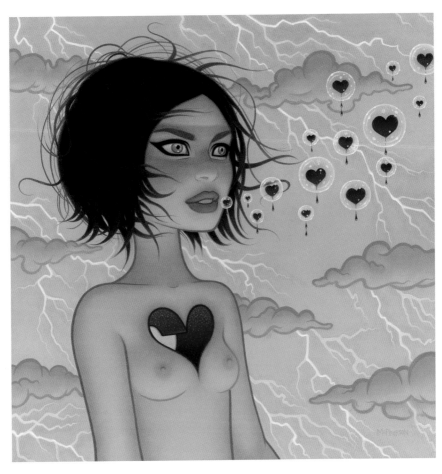

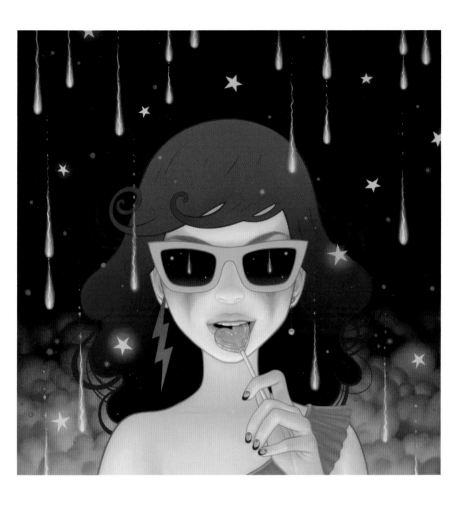

opposite *Storm Queen*, 2016
Kevin Cardani, commission; oil

Electric Lola, 2015
Natalia Garcez, album cover; oil

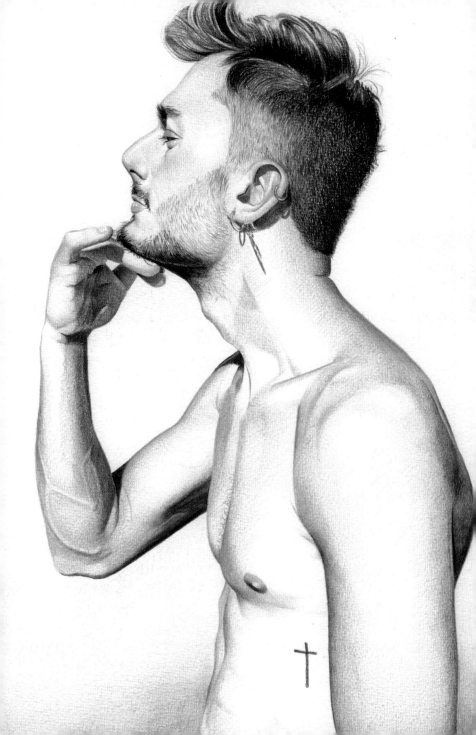

GILDO MEDINA

Gildo Medina's nomadic career has imbued him with a world vision and level of cultural and academic sophistication that has translated into his own distinctive visual mark. Medina's multidisciplinary practice spans painting, film, photography, graphic and interior design. He was born in Mexico City in 1980, where he would later study visual arts at the San Carlos Academy and graduate with a degree in graphic design from the Ibero-American University in 1997. He also studied internationally at the Academy of Fine Arts in Florence and Central St Martins in London. Whether creating in pencil or paint, Medina's work marries the figurative with the surreal and the erotic to create art-design pieces that evoke a sense of aged beauty with a contemporary feel. This approach has attracted a sophisticated clientele, from wealthy collectors in Monaco to restaurateurs in Australia. He has collaborated on Parfums de Voyage, a range of home fragrance products with New York-based luxury lifestyle brand L'Objet, and has illustrated art furniture for Hong Kong luxury fashion retailer Lane Crawford. In 2016, he presented a to-date retrospective at the Cultural Institute of the Mexican Embassy in Paris titled *Couronnes* (Crowns).

Selected Exhibitions

2016, *Couronnes*, solo show, Mexican Cultural Institute, Paris · 2016, *Fluctuat nec mergitur*, solo show, Galerie Detais, Paris · 2016, *TechDreamers*, solo show, LuisaVia Roma, Florence · 2016, *Nomadism in Art*, solo show, Appart Paris, Galerie fait maison, Dubai · 2015, *L'objet, Perfum de Voyage*, solo show, Lane Crawford, Hong Kong

Selected Publications

2016, *Hair,* Assouline, USA · 2013, *100 Illustrators*, TASCHEN, Germany · 2011, *Illustration Now! Portraits,* TASCHEN, Germany · 2010, *The Beautiful. Illustrations for Fashion & Style,* Gestalten, Germany · 2009, *Illustration Now! Vol.3,* TASCHEN, Germany

p. 370 Gesti italiani. Non me ne frega niente, 2017 Personal work; colored pencil on cotton paper

D'ici à l'infini!, 2016 Personal work; ballpoint pen on leather

opposite Couronnes, 2017 Personal work; acrylic on leather

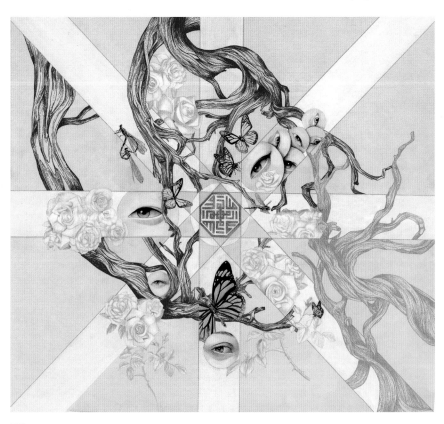

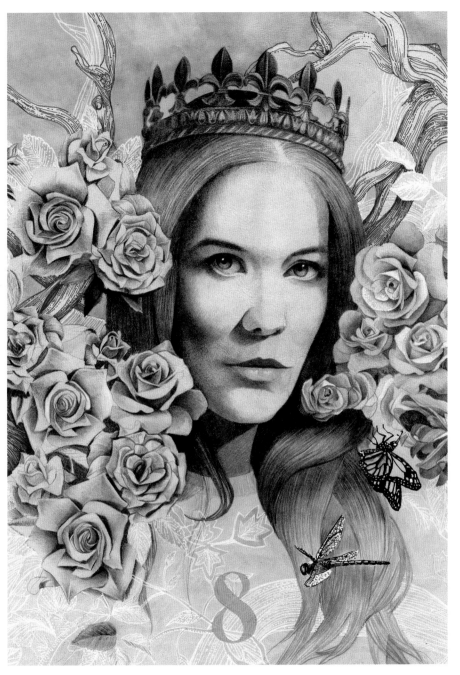

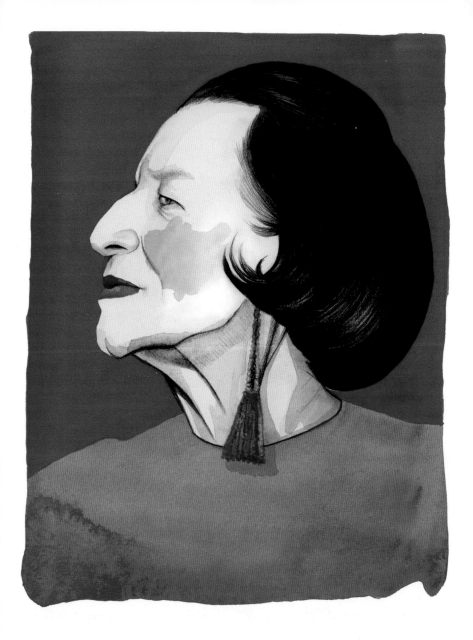

Ms.Vreeland, 2015
Harper's Bazaar, magazine;
charcoal and watercolor on
cotton paper

opposite top
Voyage Voyage, 2018
Louis Vuitton; hand painting

opposite bottom
Korinther 13, 2015
Personal work; pencil
on cotton paper

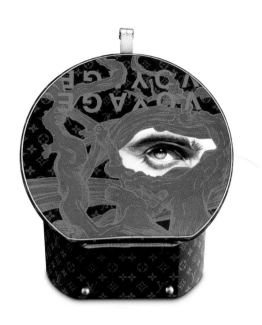

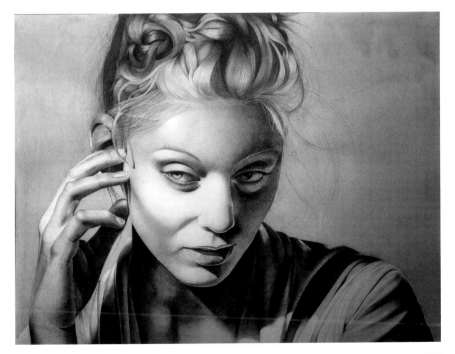

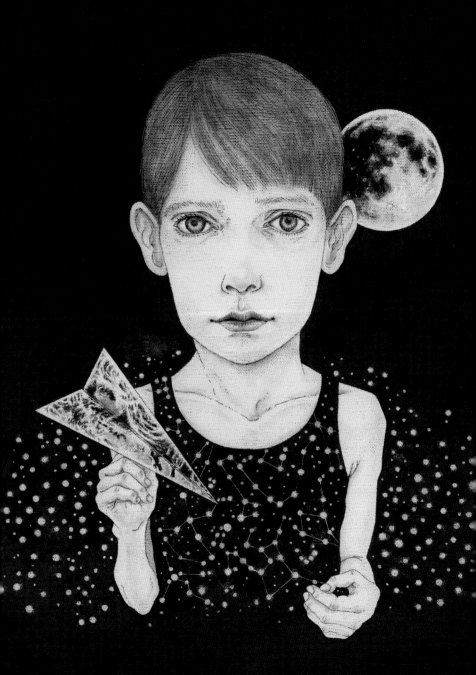

"I always try to make humor, irony, and hope coincide with a little melancholy in my work. And I try to find the elements of universality that exist in individuals to free us from possessiveness."

MARI MITSUMI

Mari Mitsumi was born in Yokohama, Japan, in 1967. After attending the Toyo Eiwa Jogakuin Junior College in Tokyo, she worked in publishing as an editor in the early 1990s before shifting her focus to illustration at the prestigious Setsu Mode Seminar. Since graduating in 1996, Mitsumi has undertaken a plethora of freelance commissions for advertising, books, and editorial—All Nippon Airways, Columbia Music Entertainment, *GQ Japan*, Nikkei Business, and Volvo are among her clients. Concept and texture play equal roles in her visual exploration. Working in a variety of media, from acrylic and digital painting to aquatint and etching with letterpress printing, Mitsumi renders her subjects, mostly expressionless portraits of ordinary people with oversized heads, in a style that sits somewhere between graphic novel realism and caricature. Her work has featured in numerous Japanese publications, including *Croissant* and *Illustration File 2018*. She has been recognized by *American Illustration*, *Communication Arts*, and *3x3 Magazine*, and has participated in several group and solo exhibitions in her native country.

p. 378 *Love & Systems*, 2012,
Book by Taiko Nakajima, book
cover, Gentosha; acrylic on canvas

opposite *This is the Life*, 2014,
Book by Alex Shearer, book cover,
Kyuryudo; acrylic on canvas

Abe's Peanut, 2013
Postcards; hand drawing, digital
author: Daniel Handler

Blind Moon, 2012
Personal work, *We'll Be Your Mirrors*,
solo show; acrylic on canvas

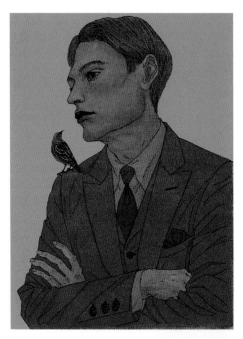

Selected Exhibitions
2015, *Une marge laissee de l'estampe*, group show, Museum of Onomichi City University, Hiroshima · 2014, *Eden*, solo show, Galerie Malle, Tokyo · 2012, *We'll Be Your Mirrors*, solo show, Galerie Malle, Tokyo · 2008, *Tangible*, solo show, Galerie Malle, Tokyo · 2002, *Bird on the Wire*, solo show, HB Gallery, Tokyo

Selected Publications
2013, *Abe's Peanut*, USA · 2011, *3x3 Magazine*, USA · 2011, *Illustration Now! Portraits*, TASCHEN, Germany · 2011, *1000 Ideas by 100 Manga Artists*, Rockport Publishers, USA · 2005, *Illustration Now! Vol.1*, TASCHEN, Germany

Romance, 2013
by Koji Yanagi, book cover,
Bungeishunju; hand drawing, digital

All I Know, 2014
Personal work, *Eden*, solo show;
acrylic on canvas

opposite *The Tin Horse*, 2015
by Janice Steinberg, book cover,
Hayakawa Publishing; etching,
Ganpishi Japanese paper, digital

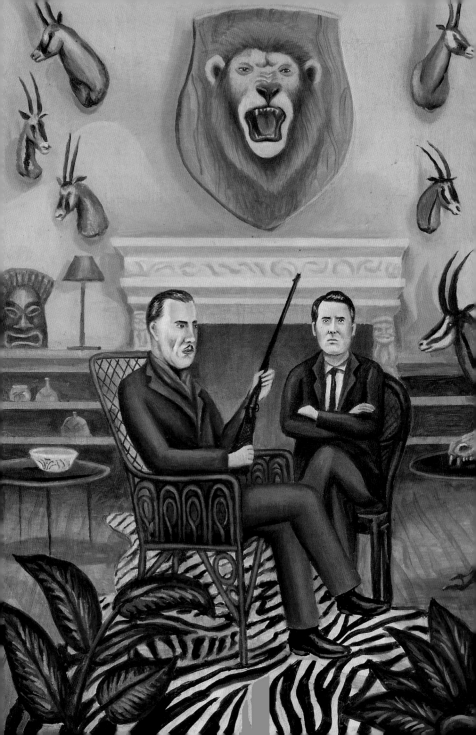

> "I like strange cocktails. To combine things that wouldn't normally fit."

SERGIO MORA

Sergio Mora (aka Magicomora) is a Spanish artist-illustrator whose identifiable style of imagery has adorned murals in swimming pools as well as packaging and licensed products, such as tableware, apparel, and wallpaper. He was born in Barcelona in 1975. After studying illustration at the Llotja Barcelona Arts and Crafts School in the late 1990s, Mora struggled to find work. His style was deemed too arty for the illustration business and too illustrational for the art gallery world—a dichotomy he would soon dispel by fusing a magical narrative with an otherworldly abstraction to create delightful, funny, eerie, and nostalgic images. Mora's pop surrealist universe with its 1950s sci-fi references, TV characters, iconic logos, and folkloric symbolism has mesmerized vaiewers around the globe through exhibitions, posters, set designs, and hospitality branding. In 2016, he was awarded a Latin Grammy in the Best Recording Package category for *El Poeta Halley* by Love of Lesbian. The following year, he joined forces with Philippe Starck to illustrate chef José Andrés' Bazaar Mar restaurant in Miami. Mora's murals were hand-painted on 6,000 tiles to visualize Starck's surrealist, nautical theme.

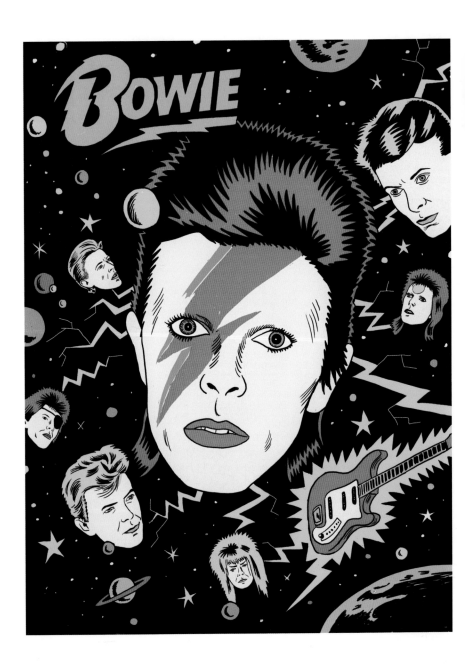

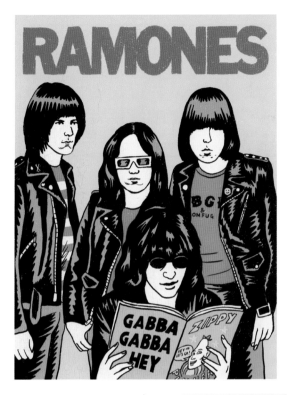

p. 382 *El mundo perdido*, 2018
Book by Arthur Conan Doyle,
Random House; oil on canvas

opposite and above *Cuentos para
niños Rockeros*, 2019
Book by Mario Vaquerizo,
Planeta de libros; digital

Monster Rock 'n' Roll, 2018
Motorzombis, album cover,
Rock Estatal Records; digital

SPACE HULA YOGASAN अंतरिक्ष ह्यूला योगासन	बंधा पद्मासन	त्रिकोणासन	दंडयमान धनुरासन
त्रिभुज	गोमुखासन	देवी मुद्रा	पद्मासन
पद्मासन	यूटिटा त्रिकोणासन बी	शीर्षासन	पूर्वजों पर आसन
दंडयमान धनुरासन	पद्मासन	पूर्वजों पर आसन	धनुरासन
पद्मासन	पक्षीय मरने	अर्धमत्स्येन्द्रासन	शीर्षासन

opposite Space Hula
Yogashan, 2018
Personal work, poster;
oil on paper, digital

El hambre invisible, 2018
Book by Santi Balmes,
Planeta de libros; digital

p. 388 top *El mundo perdido*, 2018
Book by Arthur Conan Doyle,
Random House; oil on canvas

pp. 388/389 bottom Mercado
Little Spain, New York, 2019
Think Food Group, chef José
Andrés, mural; oil on canvas, digital

387

Selected Exhibitions
2018, *El poeta Halley*, solo show, Galería Senda, Barcelona · 2011, *25 Years*, group show, La Luz de Jesus Gallery, Los Angeles · 2011, *Piñatarama*, group show, Museo de Arte Moderno de México · 2011, *Grafika*, group show, traveling exhibition, Instituto Cervantes · 2004, *Comida para tu alma*, solo show, Iguapop Gallery, Barcelona

Selected Publications
2019, *Las legendarias aventuras de Chiquito*, Temas de Hoy, Spain · 2018, *Moraland*, Norma Editorial, Spain · 2013, *Typical Spanglish*, La Cúpula, Spain · 2014, *El niño Rock*, Lunwerg Editores, Spain · 2009, *Papá tatuado*, A Buen Paso, Spain

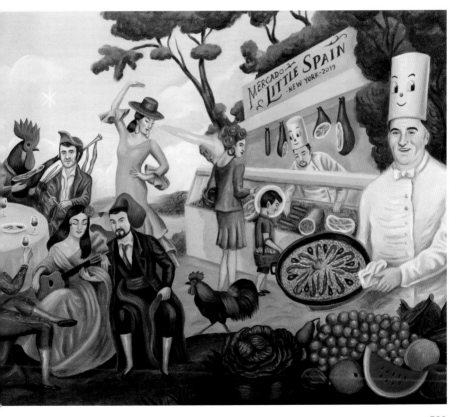

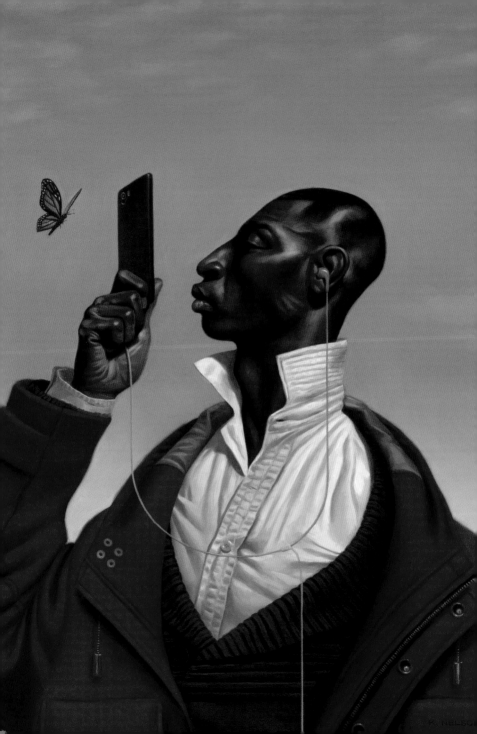

> "Many of us are getting on in years and feel it's time to make some things known before they are gone for good." *for CNN*

KADIR NELSON

Kadir Nelson is one of the most respected contemporary illustrators documenting and celebrating the black American story. Richly expressive, his figurative paintings make up an extensive body of work, from commercial and private commissions to personal works of fine art. Born in Washington, D.C., in 1974, Nelson was drawing by the age of three and painting at ten. After winning a scholarship to the Pratt Institute in Brooklyn, he received his BFA in 1996. His first job was with DreamWorks SKG, where he was lead development artist on Steven Spielberg's Oscar-nominated feature film *Amistad* (1997). He attracted attention for his illustrated book *We Are the Ship: The Story of Negro League Baseball* (2008); images from the series were also used as commemorative stamps for the US Postal Service. In addition to clients like Coca-Cola and *Sports Illustrated*, Nelson's work has adorned record sleeves for Michael Jackson's posthumously released album *Michael* (2010), and singer-rapper Drake's LP *Nothing Was The Same* (2013). Whether depicting baseball legend Andrew "Rube" Foster or Nelson Mandela, Nelson approaches his subjects with an affinity and integrity that captures an essence of their narrative. Other works have addressed race through the reinterpretation of cultural icons, such as his version of Grant Wood's 1930 painting *American Gothic* for a 2017 cover of *Ebony* magazine, or transforming *The New Yorker's* mascot Eustace Tilley into a black dandy. Nelson has also authored and illustrated children's books, and is the recipient of Caldecott and Coretta Scott King awards. His paintings are in the permanent collections of the International Olympic Committee and the US House of Representatives. He is based in Los Angeles.

Selected Exhibitions
2017, *The HeLa Project*, group show,
traveling exhibition, USA · 2011,
We are the Ship, solo show, traveling
exhibition, USA · 2005, *All the
Stories Are True*, group show,
Smithsonian Anacostia Museum,
Anacostia · 2005, *Ellington Was
Not a Street*, solo show, Muskegon
Museum of Art, Michigan · 2001,
Black Romantic, group show, Studio
Museum in Harlem, New York

Selected Publications
2018, *Famed for "Immortal Cells…"*,
Smithsonian, USA · 2014, *Sweet
Land of Liberty, The New York Times*,
USA · 2008, *Stepping Up to the
Plate, Los Angeles Times*, USA ·
2008, *Pride of the Game, Sports
Illustrated*, USA · 2003, *Nurturing
Romance of Sport, International
Review of African American Art*, USA

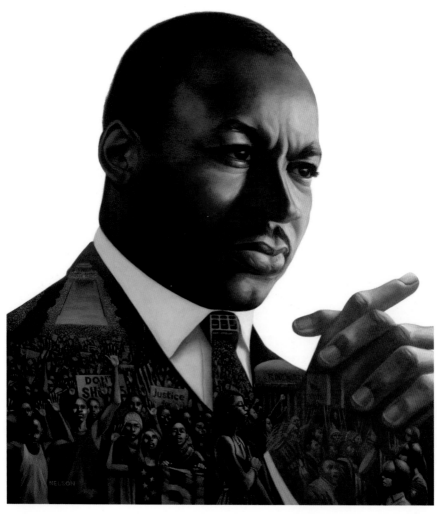

p. 390 Eustace Negro, 2015
The New Yorker, magazine cover;
oil on panel; art director:
Françoise Mouly

opposite Dr. MLK, Jr.,
A Dream Deferred, 2017
The New Yorker, magazine cover;
oil on canvas; art director:
Françoise Mouly

Forbidden Fruit, 2014
Personal work; oil on canvas

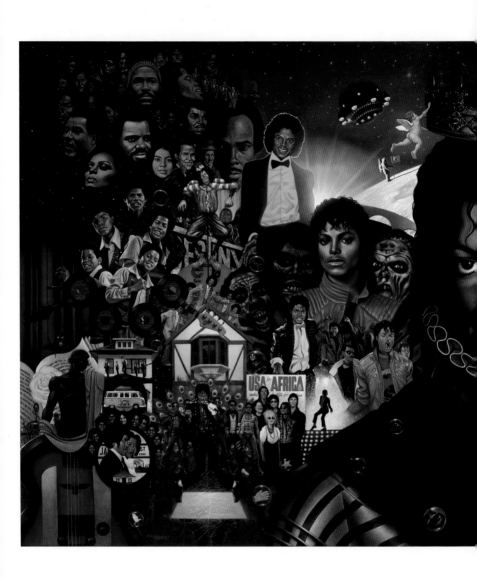

Michael Jackson,
The King of Pop, 2010
Sony Music, album cover;
oil on canvas

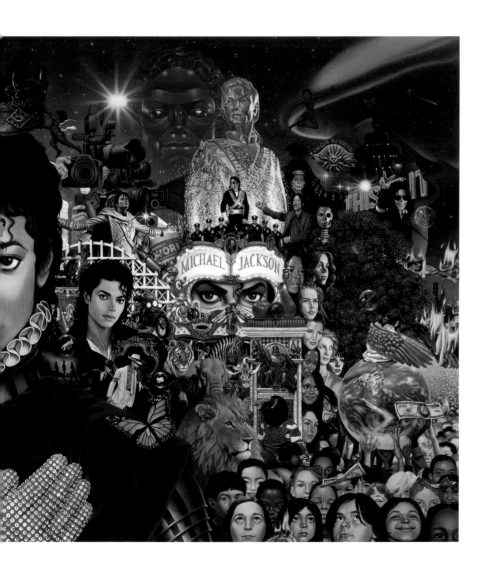

Bright Star, 2017
The New Yorker, magazine
cover; oil on canvas; art director:
Françoise Mouly

opposite A Hole in the Roof, 2014
Personal work; oil on canvas

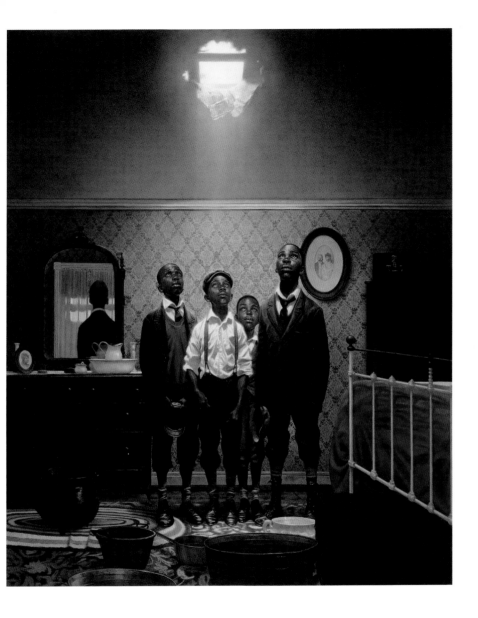

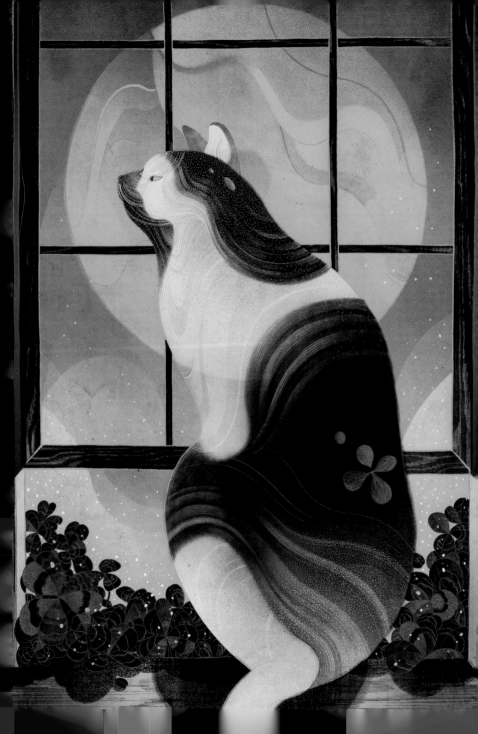

"I like to understand something and then forget about it for a while. Usually when I least expect it, something will pop into mind."

VICTO NGAI

A sense of wonder and displacement informs Victo (a nickname derived from Victoria) Ngai's visual perspective, reflecting her own personal migration and her exposure to different cultures and illustration styles. Born in Guangdong Province, China, in 1988, Ngai grew up in Hong Kong, where her early influences included Chinese art and craft styles, such as *nianhua, gongbi hua*, and *lianhuanhua*. In 2006, she gained a place at Rhode Island School of Design, where she developed an interest in Japanese *ukiyo-e*, Russian and Chinese poster art, and the Golden Age illustrators. After graduation in 2010, she moved to New York and began freelancing for *The New York Times* and *The New Yorker*. Ngai has since amassed a stellar list of clients, including Audible, HarperCollins, IMAX, Lufthansa, and *The Washington Post*, to name but a few. With meticulous attention to detail, her process involves line work with ink pens, with background and fill textures created on paper in various media, before she colors digitally in Photoshop. From beautifully dense vistas in limited hues to figures in ornate textures—each work signed with a Chinese symbol that when turned counter-clockwise reads "Victo"—the breathtaking results evoke a visual confluence of her many inspirations. Ngai has received a slew of accolades, including being namechecked on *Forbes* magazine's "30 under 30" list in the category of Art and Style (2014), and receiving a 2018 *Spectrum Fantastic Arts* Gold Medal in Books. She also lectures widely, and has been a juror on such panels as the *Communication Arts Illustration Annual 59* (2018), and Society of Illustrators New York 57th Annual Exhibition (2015). Ngai currently lives in Los Angeles.

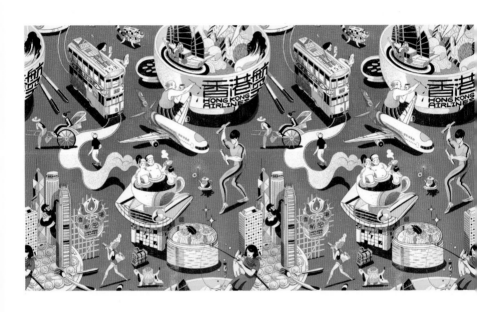

p. 398 Clover, 2016
Tor.com, website; hand drawing,
digital; story: Charlie Jane Anders;
art direction: Irene Gallo

Hong Kong Airlines, pattern, 2017
Branding, packaging design;
hand drawing, digital;
art direction: Mokit Fong

opposite Cocoon, 2016
Personal work, a tribute
to Alexander McQueen;
hand drawing, digital

Acquisition of a Wife, 2018
Folio Society, book, limited edition
of *The Kama Sutra of Vatsyayana*;
hand drawing, digital;
art direction: Sheri Gee

opposite Beyond and Above, 2015
Plansponsor, magazine;
hand drawing, digital;
art direction: SooJin Buzelli

Colorless Tsukuru Tazaki's
Years of Pilgrimage, 2015
The Boston Globe, magazine;
hand drawing, digital;
art direction: Kim Vu

Mixc Christmas Workshop, 2017
CRland, advertisement billboard;
hand drawing, digital;
project head: Bing Hou
art direction: Yong Liu

> "I try to base my illustrations on the idea, and then find an appropriate style to best support the concept."

CHRISTOPH NIEMANN

Christoph Niemann illustrates, designs, writes, and animates. He is a conceptualist with a peerless alacrity who turns convention on its head, creating imagery that can dumbfound the viewer with complexity or delight with staggering simplicity. He plays with abstraction and illusion. Physical objects placed on paper become part of the illustration: an ink bottle becomes a camera; an avocado becomes a catcher's glove. Niemann has sketched while running the New York Marathon and drawn live at the Venice Biennale. In 2013, two of his images were used as Google Doodles to celebrate the summer and winter solstices. An interest in technology platforms has led him into the world of interactive illustration. In 2016, he created "On the Go," the first 3D augmented-reality app for the covers of *The New Yorker*. Born in Waiblingen, Germany, in 1970, he attended the State Academy of Fine Arts in Stuttgart, under the tutelage of Heinz Edelmann. After receiving his master's degree in 1997, a move to New York proved timely in developing his career. Niemann made his name through editorials, with his work gracing covers from *Atlantic Monthly* to *The New York Times Magazine* and *Wired*. His innovative pictorial style has garnered him numerous accolades from the American Institute of Graphic Arts and American Illustration. In 2010, he was inducted into the Art Directors Club Hall of Fame.

PRICE $8.99

APRIL 2, 2018

THE NEW YORKER

p. 406 Observatory, 2018
Los Angeles (Hopes & Dreams)
series; silkscreen

opposite The Long Night, 2015
Newsweek, magazine; digital

Trompe-l'Oeil, 2018
The New Yorker, magazine
cover; digital

Mr. Know-It-All (Erase), 2016
Wired, magazine; digital

opposite top Offline, 2004
Personal work; digital

opposite bottom Design and
Violence Coffee (light gray), 2017
Personal work; silkscreen

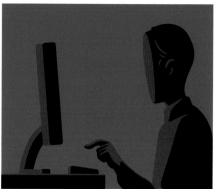
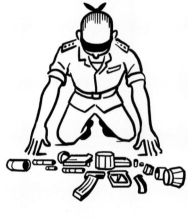
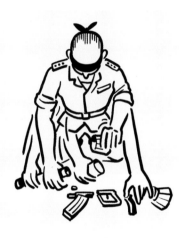
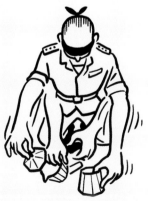

Cravings, 2018
Die Zeit, magazine cover;
mixed media

Vote!, 2018
Personal work; mixed media

opposite Hello Robot, 2017
Vitra Design Museum;
silkscreen

Selected Exhibitions
2018, *Im Auge des Betrachters*, solo show, Literaturhaus, Munich · 2017, *That's How!*, solo show, Cartoon Museum, Basel · 2017, *The Masters Series: Christoph Niemann*, solo show, School of Visual Arts Gallery, New York · 2017, *Talking Pictures*, group show, The Metropolitan Museum of Art, New York · 2016, *Unterm Strich*, solo show, Museum of Arts and Crafts (MKG), Hamburg

Selected Publications
2018, *Hopes and Dreams*, Abstractometer, Germany · 2017, *Souvenir*, Diogenes, Switzerland · 2016, *Words*, Greenwillow Books, USA · 2016, *Sunday Sketching*, Abrams Books, USA · 2012, *Abstract City*, Abrams Books (USA), Knesebeck (Germany)

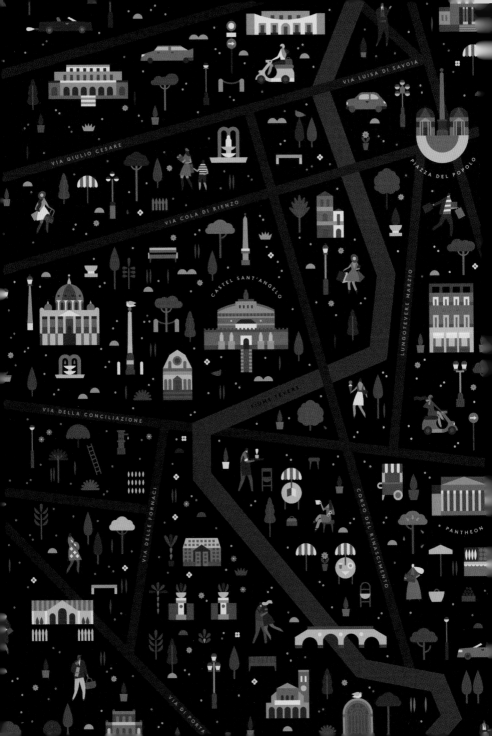

> "To me, style is an ever-evolving process. I think finding your own voice is important, but I've tried not to treat it as something that can never change. I think the evolution happens by itself, out of a natural yearning for change and looking for new challenges."
>
> for *Sense of Creativity*

LOTTA NIEMINEN

Bold and ambitious from an early age, Lotta Neiminen grew up wanting to be a famous movie director but her natural flair was for graphics. As a child she entered a drawing competition and won a computer. Born in Helsinki in 1986, Nieminen studied graphic design at Aalto University School of Arts, Design and Architecture before an exchange to the Rhode Island School of Design helped her fulfill her dream of seeing New York. After returning to her native Finland, she graduated in 2009 and began designing and art directing for Finnish fashion magazine *Trendi*. In 2010, she received the coveted Art Directors Club Young Guns award, and was featured in *Print* magazine's annual New Visual Artists review. Entrepreneurial and creative, Lotta Nieminen epitomizes the millennial approach, having amalgamated her skillset into a multifaceted creative practice that gives a~voice to her distinctive style and motivates her to push her own parameters when providing "holistic visual solutions for clients across disciplines." Based in Brooklyn, New York, since 2012 Lotta Nieminen Studio has provided art direction, design, and illustration services for a stellar roster, including Bulgari, Hermès, Google, Volkswagen, *Le Monde*, *Monocle*, and *Bloomberg Businessweek*. With attention to form, Nieminen's clear, colorful style, characterized by flat, slightly textured graphics and a penchant for patterning, lends itself it to any print, surface, or digital domain. She has been nominated for *Forbes* magazine's annual "30 under 30" list, and has given talks at conferences and educational institutions across the US and Europe.

Selected Exhibitions
2017, *Behance Pop-Up Gallery*, group show, Red Bull Arts New York, New York · 2013, *What's up North*, group show, Form/Design Center, Malmö · 2012, *Cityscapes*, solo show, Printa Gallery, Budapest · 2012, *Finished Final Def*, group show, GDFB 2012 Festival, Breda · 2012, *Agent Pekka*, group show, Guns & Butter Gallery, Amsterdam

Selected Publications
2018, *Upstart!*, Gestalten, Germany · 2014, *Pastel*, Victionary, Hong Kong · 2013, *A Map of the World*, Gestalten, Germany · 2012, *Breakthrough!*, Princeton Architectural Press, USA · 2011, *Visual Storytelling*, Gestalten, Germany

p. 414 **Bvlgari Summer** window displays, 2017 Phaidon, campaign; mixed media

opposite top and above Cityscapes poster series: *Lisbon*, *New York*, and *Global*, 2012 Personal work, solo show, Printa Gallery, Budapest; silkscreen posters

opposite bottom **Union Pearson Express** series, 2013 Branding illustration; mixed media; animation: Guru Studios; agency: Winkreative

> "I love interesting perspectives, a precise setting of light and shadow, and an interaction between illustration and typography."

ROBERT NIPPOLDT

Robert Nippoldt was born in Kranenburg, Germany, in 1977. He grew up drawing constantly, from caricatures of teachers at school to later stints as a court sketch artist (his father was a judge). Geared towards a career in law, he soon ditched the idea, enrolling instead on the graphic arts and illustration course at the University of Applied Sciences in Münster. Fortuitously, his final degree book project titled *Gangster: The Bosses of Chicago* went into print in 2005, winning a Red Dot Design Award and a German Designer Club Award. Two years later saw the release of *Jazz: The Roaring Twenties in New York*, which was selected as the most beautiful German book of 2007 by Stiftung Buchkunst. *Hollywood in the 1930s* (2010) completed his trilogy on America in the 1920s and 30s. Nippoldt's books have also been released with board games and limited-edition silkscreen prints; he even created and toured a stage show in which he drew live with a music band. Working from Studio Nippoldt in a converted freight yard in Münster, his sharp, high-contrast graphic style with its retro edge is a perfect match for his subjects and vintage milieu. Nippoldt's clients include *Le Monde*, *Die Zeit*, Mercedes-Benz, and *Time* magazine. 2017 saw the publication of his fourth book, *Night Falls on the Berlin of the Roaring Twenties*.

p. 418 Untergrund, 2017
*Night Falls on the Berlin
of the Roaring Twenties*, book,
TASCHEN; ink, digital

EU, 2015
Arte, magazine; ink, digital

opposite The Americans, 2014
The New Yorker, magazine;
ink, digital

opposite Pearls, 2017
*Night Falls on the Berlin
of the Roaring Twenties*, book,
TASCHEN; ink, digital

Marie & Jean Claude
Séférian, 2018
album cover; ink, digital

Love Song, 2015
Reader's Digest, magazine cover;
ink, digital

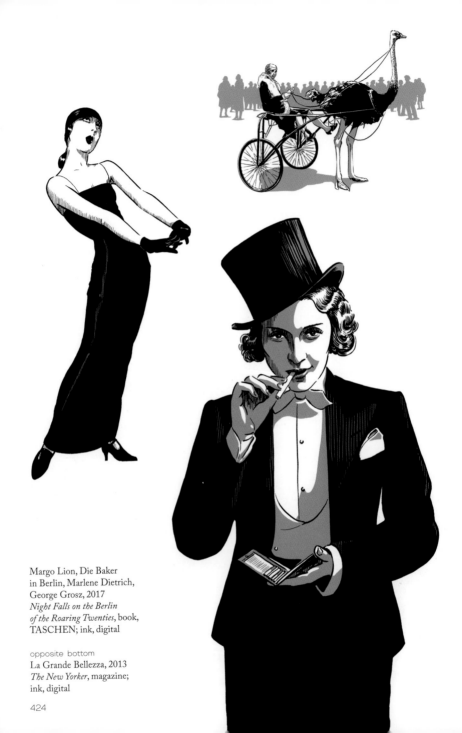

Margo Lion, Die Baker
in Berlin, Marlene Dietrich,
George Grosz, 2017
*Night Falls on the Berlin
of the Roaring Twenties*, book,
TASCHEN; ink, digital

opposite bottom
La Grande Bellezza, 2013
The New Yorker, magazine;
ink, digital

Selected Exhibitions
2018, *Night Falls on the Berlin of the Roaring Twenties*, solo show, TASCHEN Store, Cologne · 2018, *Ein Rätselhafter Schimmer*, solo show, TASCHEN Store, Hamburg · 2018, *Berlin 1912–1933*, group show, Royal Museums of Fine Arts of Belgium, Brussels · 2017, *Ein Rätselhafter Schimmer*, solo show, Galerie am Markt, Weimar · 2017, *Night Falls on the Berlin of the Roaring Twenties*, solo show, TASCHEN Store, Berlin

Selected Publication
2017, *Night Falls on the Berlin of the Roaring Twenties*, TASCHEN, Germany

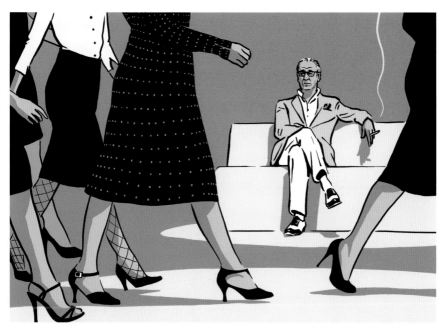

"So many ideas, I'm not quite certain where to start. I'd love to finish a few stories I'm writing. They are a little different from my illustration style so I'm not sure who will want to experience them, but they are the type of story I love, so I hope to do them justice." for *Freelance Wisdom*

MONICA OBAGA

From Kisii soapstone sculpture and Maasai beadwork to Kikuyu weaving and Swahili *leso* garments, Washington, D.C.-based graphic designer and illustrator Monica Obaga draws inspiration from her Kenyan roots and wider folk references from across Africa. Bold cut-out-style curves and geometric shapes create a liberating visual flow across a colorful palette. Born in Nairobi in 1983, Obaga grew up doodling her way through schoolbooks and dreaming of becoming a fashion designer until her high-school grades threatened to curb her ambitions. Instead, she discovered Instagram as an ideal platform to develop her creative pathways. A move to the United States in 2007 prompted a shift in focus to freelance illustration. Online collaborations soon led to commissions, and by the early 2010s she was instrumental in evolving the digital marketing of Buni.TV, turning it into one of Africa's leading video-on-demand channels. This foundation allowed Obaga to pool a broad set of creative, digital, and marketing skills. In 2016, to promote the launch of their new app, Airbnb selected 12 illustrators to create a travel poster for a world city. Obaga's vibrant vision of Nairobi was one of them. Her clients include Boost Mobile, Kenyan fashion guru Diana Opoti, sustainable fashion company Fauborg, and non-profit organization Girl Effect.

p. 426 Noirwave pattern, 2018
Products of Our Environment,
print; hand drawing, vector

Eartha Kitt, 2018
Boost Mobile, One Trick Pony,
video; hand drawing, vector

opposite Noirwave, 2018
Products of Our Environment, print;
hand drawing, vector

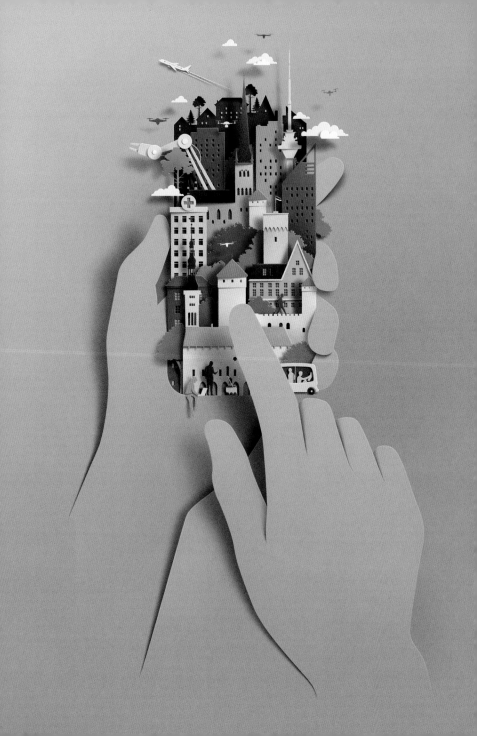

"I like to study the forms of shapes, and to work closely with light and shadow—keeping the illustrations minimal."

EIKO OJALA

All is not what it seems in the illustrated world of Eiko Ojala. At first glance one would be forgiven for mistaking his work for the hand-crafted mastery of a paper-cut artist. In fact he is, though not in the traditional sense. While Ojala draws his illusory landscapes and figures by hand to look like paper cuts, the technical wizardry occurs in Photoshop, where he sometimes incorporates photographed and scanned elements of real paper. His style is minimal and sharp and can be provocative and humorous. The overall raised effect lies in his meticulous attention to detail and skill in rendering shadow and light—he shuns the use of 3D software. Born in Tallinn, Estonia, in 1982, Ojala briefly studied interior design at the EuroAcademy before turning to illustration. A break came in 2013 when his artwork *Vertical Landscapes* went viral on social media. Commissions soon began to flood in: HBO, *National Geographic Traveler*, the Victoria and Albert Museum, and Wellington City Council are among the many clients on his roster. Participation in shows such as *Art Kaohsiung in Taiwan* (2016) and *Silence & Distance* at London's Pocko Gallery (2018) have pinned Ojala's world exhibition map, while accolades like an Art Directors Club Estonia Gold for "Tallinn Bicycle Week" 2015, and a New Zealand Best Design Awards 2016 Bronze for "Wellington Summer City" have added to his tally. Ojala travels and works between Estonia and New Zealand.

Selected Exhibitions
2018, *Silence & Distance*, group show, Pocko Gallery, London · 2017, *Endless Summer*, group show, Atelier Meraki, Paris · 2017, *Six Impossible Wishes*, group show, Wisedog, Larisa · 2016, *Op-Ed Art*, group show, Pelham Art Center, New York · 2016, *Art Kaoshung*, group show, Kaoshung, Taiwan

Selected Publications
2018, *Dadventures*, HarperCollins Publishers, United Kingdom · 2016, *All Year Round*, Scholastic, USA · 2016, *Directory of Illustration*, USA · 2016, *Contemporary Art of Excellence vol.2*, Global Art Agency, United Kingdom · 2016, *Creative Pool Annual*, United Kingdom

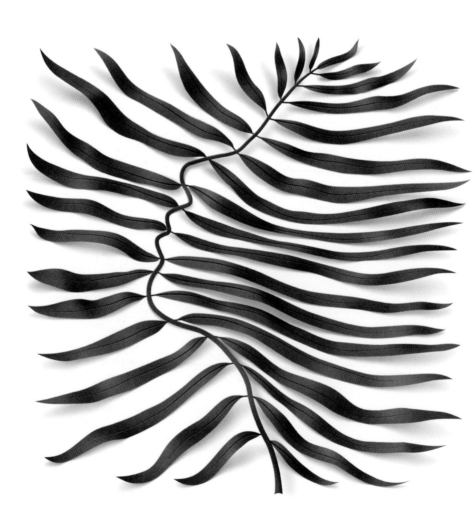

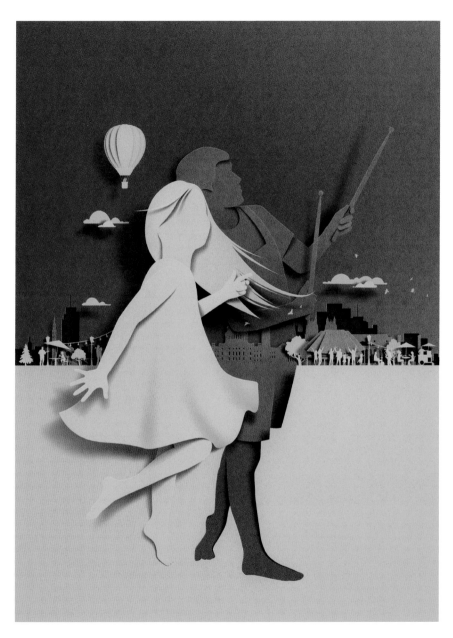

Endless Summer, 2017
Personal work, print;
paper cut, digital

Landscape, 2016
Personal work, print;
paper cut, digital

opposite Myth #3, 2016
Personal work, print;
paper cut, digital

434

Dreamer, 2017
Personal work, print;
paper cut, digital

opposite Earth, 2017
The New York Times,
newspaper; paper cut, digital

Selected Exhibitions
2018, *Silence & Distance*, group show, Pocko Gallery, London · 2017, *Endless Summer*, group show, Atelier Meraki, Paris · 2017, *Six Impossible Wishes*, group show, Wisedog, Larisa · 2016, *Op-Ed Art*, group show, Pelham Art Center, New York · 2016, *Art Kaoshung*, group show, Kaoshung, Taiwan

Selected Publications
2018, *Dadventures,* HarperCollins Publishers, United Kingdom · 2016, *All Year Round,* Scholastic, USA · 2016, *Directory of Illustration,* USA · 2016, *Contemporary Art of Excellence vol.2,* Global Art Agency, United Kingdom · 2016, *Creative Pool Annual,* United Kingdom

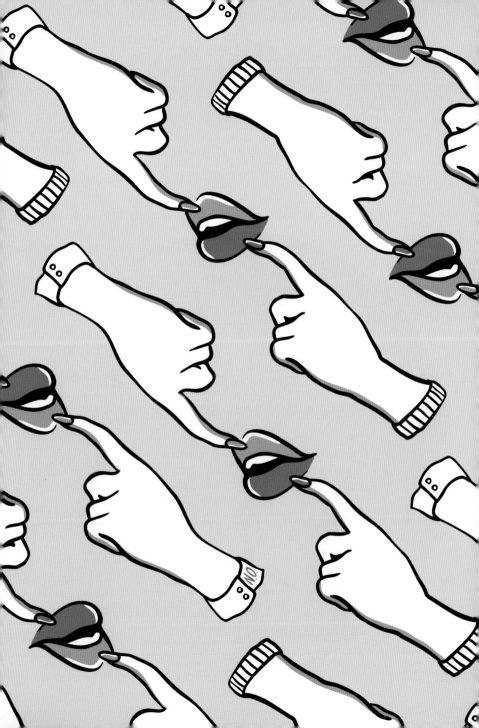

NAOMI OTSU

Naomi Otsu conjures up words, phrases, and images in a compositional style that mixes doodling and lettering. Her work appears on advertising, pin badges, T-shirts, posters, and food infographics. Her unique take on visual communication stems from her diverse background. Half Korean and half Japanese, she was born in Mount Vernon, New York, in 1987, and raised in Tokyo before moving back to the US, where she received her BFA in Illustration and Communication Design from Parsons School of Design in 2010. She started out working for apparel brand and retailer Opening Ceremony, progressing to senior graphic designer. Following a brief stint at creative agency Laird+Partners, Otsu decided to go solo in 2014. Stimulated by her Brooklyn milieu, and equipped with a foundation in producing visual designs across the board, Otsu embarked on her freelance journey with an eclectic lexicon of referents to pool. She has created posters for Red Bull Sound Select and Ms. Lauryn Hill's "Diaspora Calling!" 2016 tour, spot Illustrations for *i-D* magazine online, and a host of menu cards for local eateries. Her love of food and drawing is showcased on We8that, a visual blog she created with her sister. Otsu lives and works in Brooklyn.

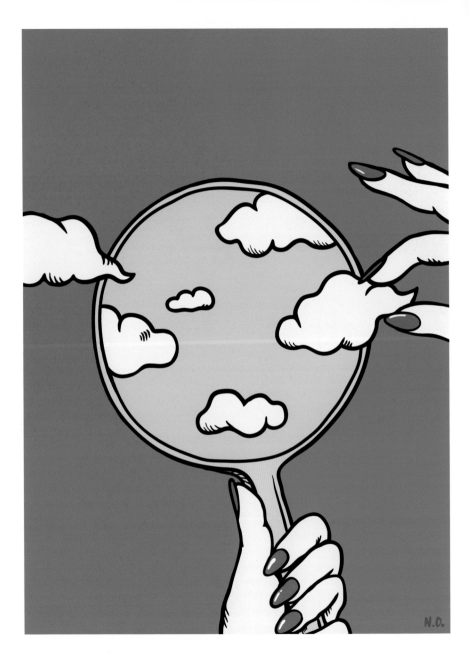

p. 438 Spill the Beans, 2016
Personal work; digital

Mirror in the Sky, 2015
Personal work; digital

opposite Chain Reaction, 2017
Versace, sneaker; digital

440

441

Kindness, 2017
Kindness Cleaning; digital

opposite Recommended Diet
for July 4th, 2015
Personal work; digital

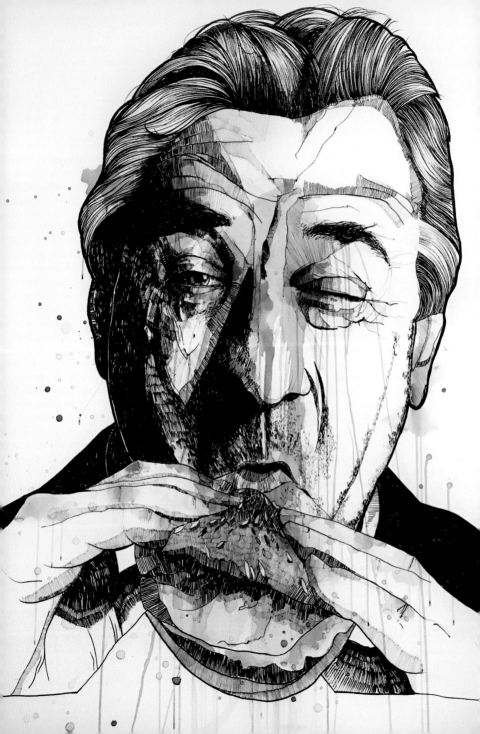

> "Practice your passion, with dedication, love, and commitment." for *Multiverso da Arte*

SARA PAGLIA

Italian illustrator Sara Paglia marries crisp ink lines, hatches, and random Ecoline watercolor marks with digital techniques that result in evocative images that hold the eye. Her portraits of famous faces, from Jimi Hendrix and Amy Winehouse to Nelson Mandela and Italian musicians like Rino Gaetano and Davide "Boosta" Dileo, burst with character and expression. Her work has featured in *Rolling Stone Italia* and the ClioMakeUp blog. Born in Rome in 1984, Paglia studied illustration at the European Institute of Design, receiving her bachelor's degree in 2006. After nearly a decade as a graphic designer for an international sports company, she took a leap of faith into the world of freelance illustration. As well as portraits, she creates murals for restaurants and salons, tattoo art, and sells her own line of merchandise. Like so many of her contemporaries, Paglia has harnessed the power of social media, through which she regularly engages with her thousands of followers. In 2018, she participated in the *Binario18: Itineraries in Visual Communication* platform at Rome's Officine Farneto.

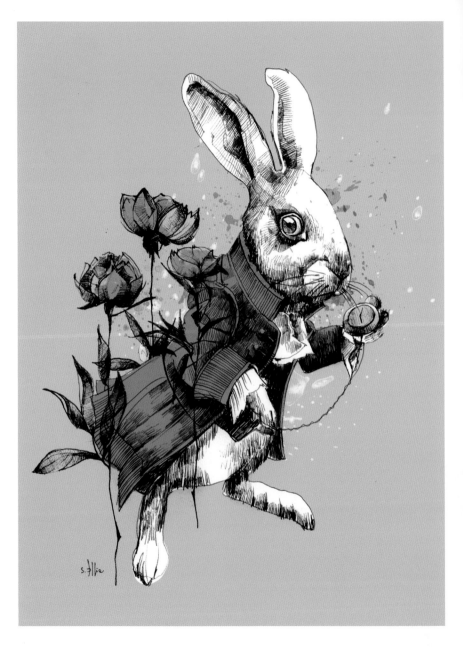

p. 444 Robert De Niro, 2018
Galo Restaurant; ink, ecoline

How Long is Forever?, 2018
Personal work; ink, digital

opposite Lentamente muore, 2018
Galo Restaurant, mural; ink, digital

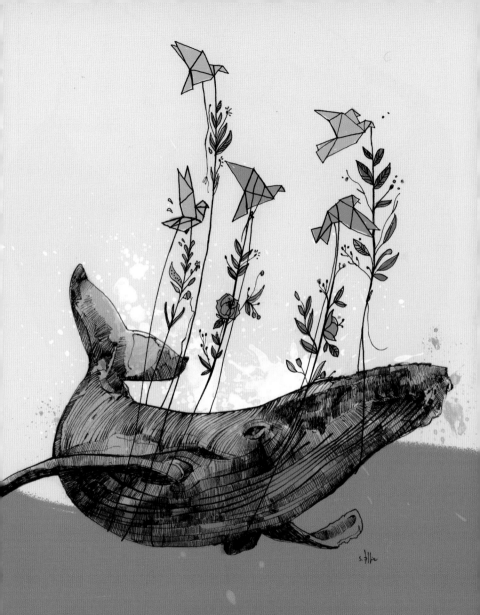

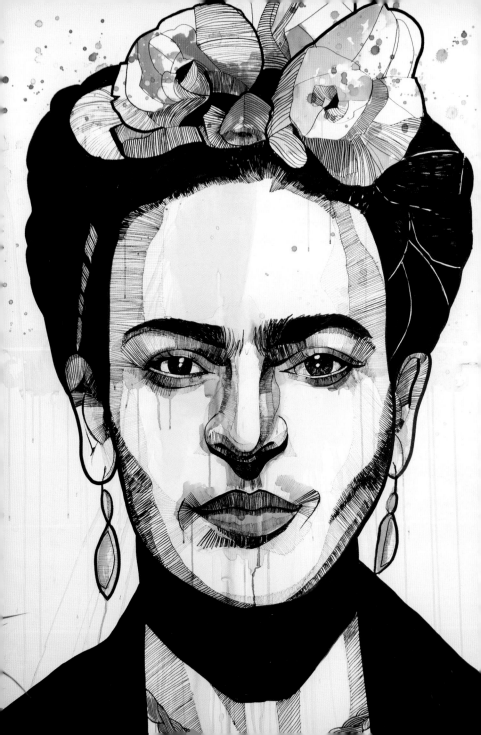

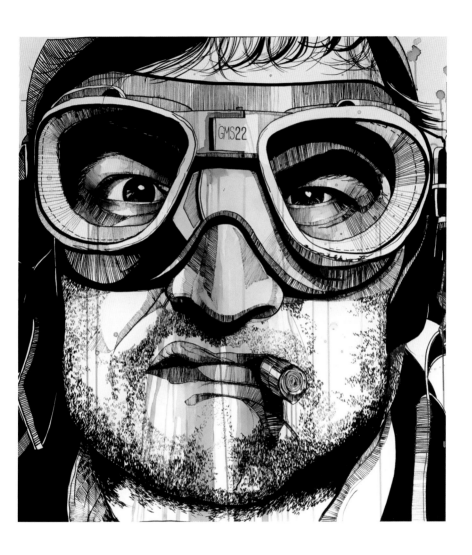

opposite Frida Kahlo, 2018
Frida Beauty Lab, beauty shop;
ink, ecoline

John Belushi, 2018
Personal work; ink, ecoline

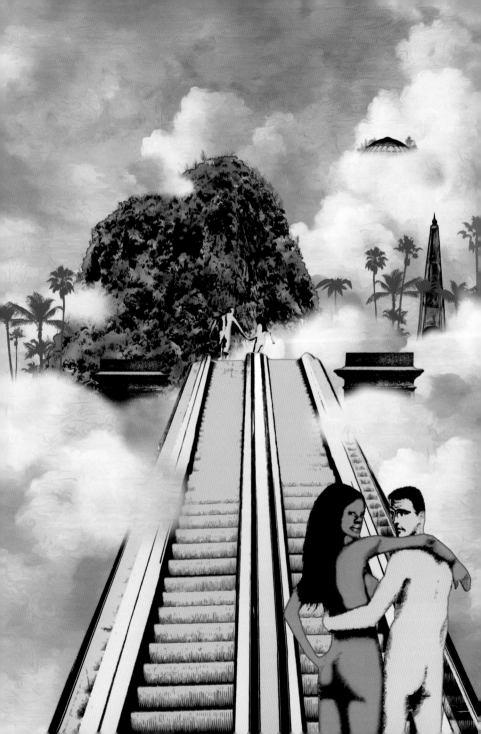

> "Keeping the passion alive is easy when you love what you do, and this helps inspiration. Inspiration is a mystery; the best inspiration comes as you breathe." for *Dressed and Naked*

PIERRE-PAUL PARISEAU

Montreal-based Pierre-Paul Pariseau (b. 1958) is an internationally acclaimed mixed-media illustrator. Entirely self-taught, he started out creating manual-cut and paste works before discovering the wonders of Photoshop. For source material he trawls through boxes of print media cut-outs amassed over the years in his studio, which he appropriates into his collage-based universe. There are obvious nods to Pop Art and the anti-Nazi photomontages of John Heartfield, along with the absurd visual antics of Monty Python's Terry Gilliam in his work, yet Pariseau has a distinctively personal voice that elicits an emotional and intellectual response. Embedded within his saturated montages are signifiers that prompt the viewer to construct their own narrative. Pariseau's surreal visualizations have featured in magazines, on book covers, posters, and album sleeves. His clients include Random House, the *British Medical Journal*, and *The Wall Street Journal*, to name but a few. Pariseau has exhibited internationally and received recognition as one of "200 Best Illustrators Worldwide" published by *Lürzer's Archive*. In 2017, he was selected a winner of the Hiii Illustration International Competition sponsored by Hiiibrand, Nanjing, China. He has been a jury member of the 11th Annual Stereohype Button Badge Design Competition (UK, 2015), and the Alberta Magazine Awards (Canada, 2017–19).

p. 450 Refuge, 2018
Personal work, *Ciudad Persona,*
group show, La Nave, Madrid;
collage and digital

Ready to Ware, 2017
Commercial Observer, magazine;
collage and digital; art direction:
Jeff Cuyubamba

opposite The Euro and the
Battle of Ideas, 2017
The Milken Institute Review,
magazine; collage and digital;
art direction: Joannah Ralston

453

The Great Bee Die-off, 2016
Foreign Policy, magazine;
collage and digital;
art director: Margaret Swart

Selected Exhibitions
2018, *Art and (H)Aktivism*, group
show, Ugly Duck Creative, London ·
2018, *Artbox Project New York 1.0*,
group show, Stricoff Gallery,
New York · 2016, *Superfine Art
Fair*, group show, Miami · 2015,
Fuorisalone, group show, Milan
Design Week · 2014, *The
Metamorphosis of Appearances*, solo
show, Cultural House, Montreal

Selected Publications
2019, *200 Best Illustrators Worldwide*,
Lürzer's Archive, Austria ·
2018, *Pictoria,* vol.2, Capsules
Books, Australia · 2014, *Freistil:
The Best Illustrators,* Germany ·
2014, *Directory of Illustration, 3X3
Magazine*, USA · 2012, *Illustration
2,* Zeixs, Germany

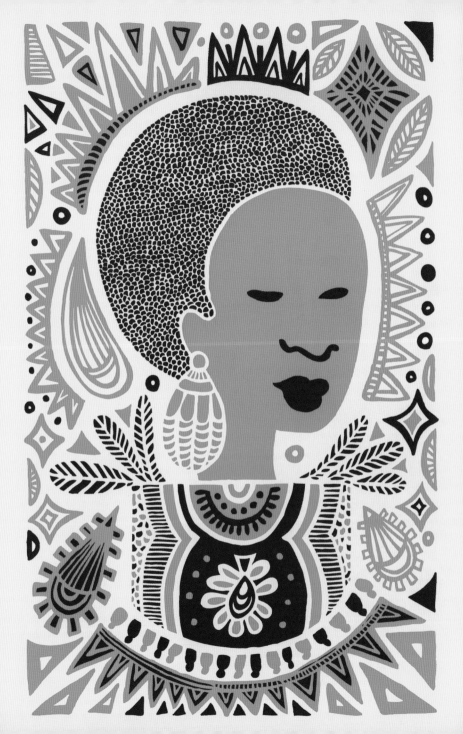

> "The beauty, though, is that we live in a time when the tools to create images and tell stories are readily available." for *Thandie Kay*

ANDREA PIPPINS

Born in Washington, D.C., in 1979, Andrea Pippins spent her early childhood in a garment studio with her Brazilian mother. She drew while her mother sewed. This instilled in her a love of textiles, patterns, and color. Another epiphany occurred while watching Halle Berry play an art director in the film *Boomerang* (1992), when she was inspired to see a woman of color in a creative profession. In the period between receiving her BFA and MFA in Graphic and Interactive Design at Tyler School of Art at Temple University, Philadelphia, she worked for Hallmark Cards and TV Land/Nick at Nite. Following a period of teaching she took the plunge and became a full-time freelancer, gradually shifting her focus from graphic design to illustration. With a style that moves from delicate pen and ink doodles to bright, flat, and colorful compositions, Pippins draws upon media and memory to create imagery that is both affirmational and relatable. An advocate of creativity as a means of self-empowerment, Pippins uses her books and design blog "Fly" as platforms to inspire young women of color to celebrate their creativity and self-expression. Since publishing *I Love My Hair* (2015), an adult coloring book celebrating the diversity of hair through styles and accessories, Pippins has produced several other titles, including *Becoming Me* (2016), an illustrated activity journal, and *Young Gifted and Black: Meet 52 Black Heroes from Past and Present* (2018), a collaboration with author Jamia Wilson. Pippins' clients include the BlackStar Film Festival, Bloomberg, *Essence Magazine*, *The New York Times*, *O: The Oprah Magazine*, and the National Museum of African American History and Culture. She lives in Stockholm.

p. 456 Afro Blue, 2013
Personal work, limited-edition
screen print

Break the Silence, 2015
The Association for Women's
Rights in Development, website;
hand drawing, digital

opposite Black Star Film Festival,
poster, 2013; hand drawing, digital

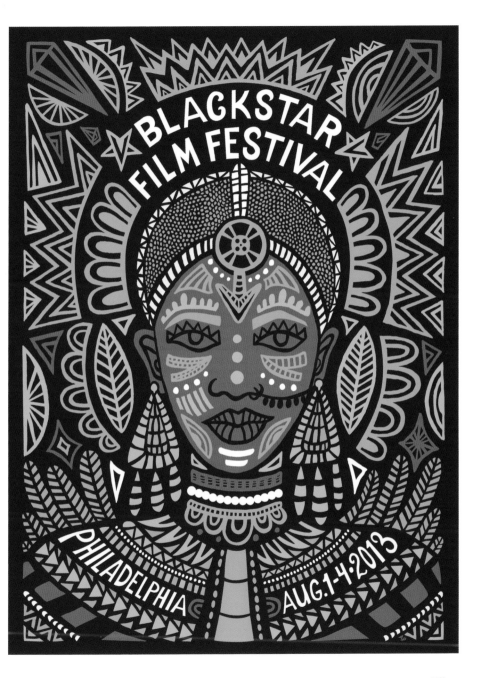

459

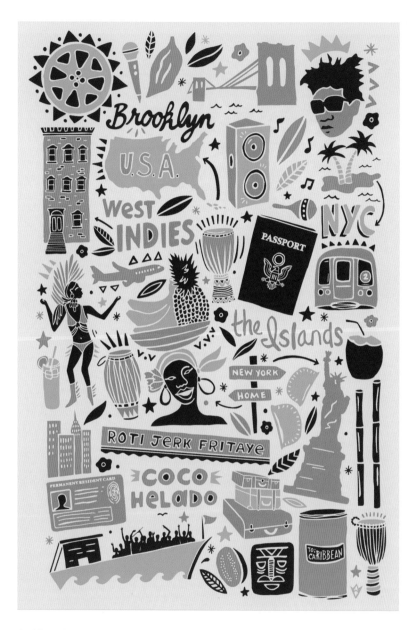

CaribBeing Doodles, 2015
Lincoln Center Out of Doors
Summer Festival promotional
material; hand drawing, digital

opposite top Untitled, 2017
Scoop, magazine cover;
hand drawing, digital

opposite bottom *Young Gifted and
Black: Muhammad Ali*, 2017
Quarto Knows/Wide Eyed, book;
hand drawing, digital

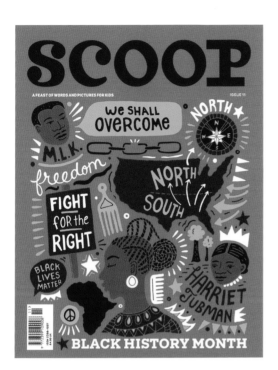

Selected Exhibitions
2014, *The Art of Blackness*, group
show, NYCH/Robotic Minds
Gallery, Chicago · 2013, *Product
Lines*, group show, Case[werks],
Baltimore

Selected Publications:
2019, *Step Into Your Power,* Quarto
Knows/Wide Eye, United Kingdom
· 2018, *Young Gifted and Black,*
Quarto Knows/Wide Eye, United
Kingdom · 2018, *We Inspire Me,*
Chronicle Books, USA · 2016,
Becoming Me, Schwartz & Wade,
USA · 2015, *I Love My Hair,*
Schwartz & Wade, USA

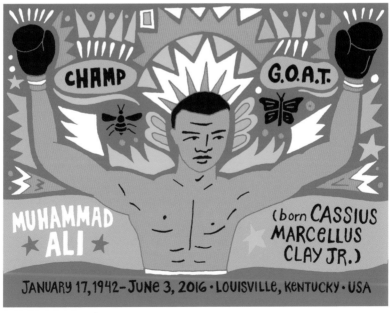

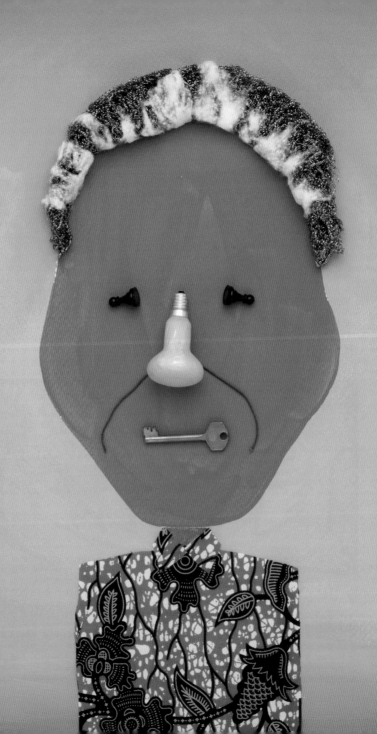

"I like to think of my illustrations as puzzles that need to be solved within a certain amount of time."

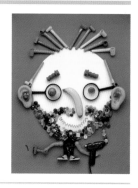

HANOCH PIVEN

Hanoch Piven is an artist and editorial caricaturist who creates collage illustrations with found objects and materials. His witty portraits and caricatures of celebrities and icons have appeared in countless editorials, from *Rolling Stone* and *The Times* to *Die WeltWoche* and *Der Spiegel*. Born in Montevideo in 1963, Piven moved to Israel at the age of 11, where he grew up in Ramat Gan. After graduating from the School of Visual Arts in New York in 1992, he returned home where he began his long association with Israeli newspaper *Haaretz*. Piven's playful and abstract approach elicits an immediacy of response, prompting the viewer to examine the objects he arranges so carefully to make up a subject's features. Piven is the author of children's books including *My Best Friend is as Sharp as a Pencil* (2010), and he has also developed a series of face-making apps for the iPad. A passionate educator, he has inspired both children and adults alike through his regular creative workshops and animations for TV. Piven has also lectured at several institutions, from the China Academy of Fine Arts in Beijing and Sheridan College in Toronto to the Instituto Europeo di Design in Rome and Bezalel Academy of Arts and Design in Israel. Among his awards, Piven is the recipient of a Gold Medal from the Society of Illustrators of New York (1994). His book *What Presidents Are Made Of* was chosen as one of the "10 Best Children's Books of 2004" by *Time* magazine. He lives between Tel Aviv and Barcelona.

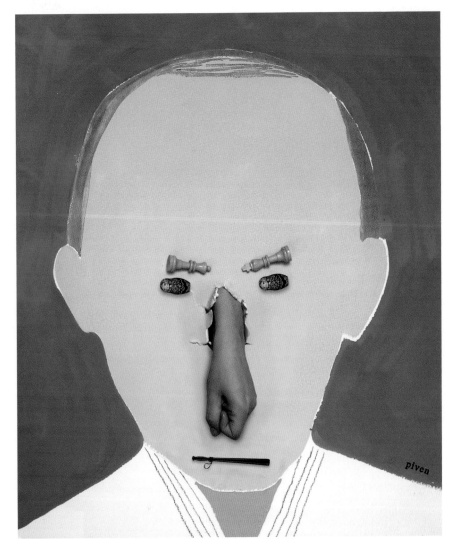

plven

464

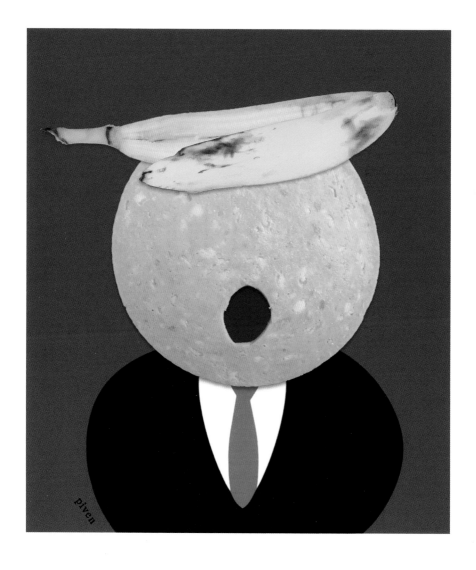

p. 462 Nelson Mandela, 2016
King David School, Johannesburg;
photographed 3D collage

opposite Vladimir Putin, 2018
Am Oved Books, book cover;
photographed 3D collage

Donald Trump, 2016
Personal work; digital collage

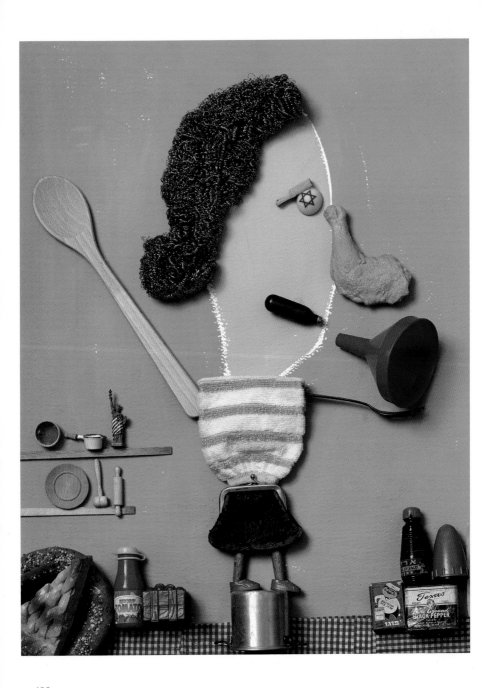

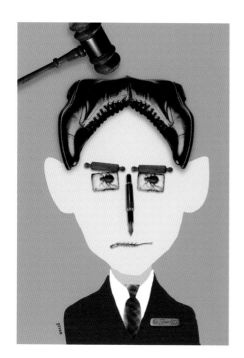

Selected Exhibitions

2018, *Pivenworld*, solo show, Sefika Kutluer Festival, Ankara · 2014, *Pivenworld*, solo show, Bangkok National Art Gallery, Bangkok · 2011, *Making Faces*, solo show, Czech Cultural Center, Prague · 2010, *Pivenworld*, solo show, Skirball Cultural Center, Los Angeles

Selected Publications

2017, *The Art of Living*, Romania · 2017, *The Straight Times*, Singapore · 2016, *IRB Barcelona*, Spain · 2012, *La Vanguardia*, Spain · 2017, *The Romania Journal*, Romania

opposite Golda Meir, 2018
What Are Prime Ministers Made Of,
Kinneret Publishers, book cover;
photographed 3D collage

Franz Kafka, 2017
Jewish Soul, by Hanoch Daum
and Ariel Hirschfeld, book,
Yediot Books; digital collage

Willem Dafoe, 2018
Hemispheres, magazine, United
Airlines; photographed 3D collage;
art director: Rickard Westin

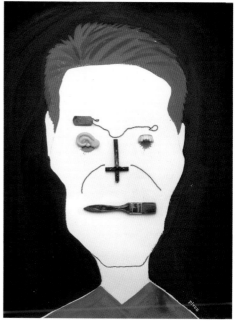

> "I try always to plan and think about the next thing I want to make by surrounding myself with creative people. That's what always gets me motivated and reminds me how much I love to make art."

GEFFEN REFAELI

Born in Tel Aviv in 1984, Geffen Refaeli began drawing around the age of five, producing weird, dark, and humorous illustrations. Upon reflection, Refaeli confesses that she grew up refusing to let go of her childhood universe, choosing to inhabit a solitary world of memories through her practice. Her love of animals, combined with a desire to escape her life of seclusion, nearly led her to become a veterinarian, but in the end she could not forego her passion for drawing. Since graduating from the Bezalel Academy of Arts and Design in Jerusalem with a bachelor of design in 2010, she has undertaken various freelance illustration commissions and projects. In May 2012, Refaeli launched her "DailyDoodleGram" project on Instagram. Initially she created illustrations of her friends, but the project evolved into an obsessive everyday practice with tens of thousands of followers eagerly awaiting her next creation. Scrolling through her Instagram photostream, she selects elements from random photos that catch her eye, combining them to create playful, surreal doodles. Pencil sketches manifest into sharp, black India-ink illustrations, sometimes embellished with digital color overlays. Users whose photos she has referenced are then tagged, allowing them and others to click and view both artwork and original image.

Selected Exhibitions

2017, *Dailydoodlegram*, solo show, Fumetto Comics and Illustration Festival, Lucerne · 2017, *With Just One Pearl*, solo show, Kandinof Gallery, Jaffa · 2016, *From Instagram to the Museum and Back*, solo show, Israel Museum, Illustration Library, Jerusalem 2016, *Dailydoodlegram*, group show, Lustre Festival, Prague · 2013, *DailyDoodlegram*, solo show, Urban Spree, Berlin

Selected Publications

2018, *The Elementary Particle*, Israel · 2018, *Why Do You Speak So Vaguely?*, Humdrum collective, Israel · 2017, *Children's Health Guide*, Israel · 2017, *Yolanda De Meow*, Kibuz-Poalim, Israel · 2016, *Ink*, Victionary, China

p. 468 and opposite
Why Do You Speak So Vaguely?, 2018
Hideout, Humdrum Collective;
ink and watercolors on paper

Pupikus Volcanus, 2017
Children's Health Guide,
self-published 2017;
ink and watercolors on paper

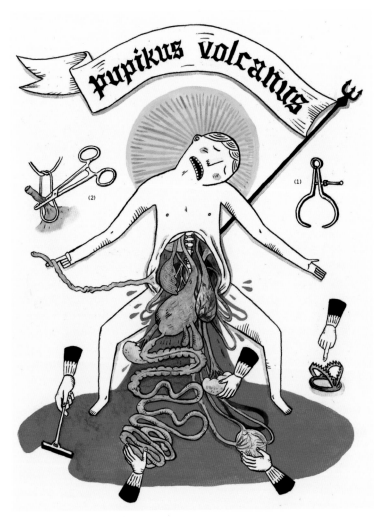

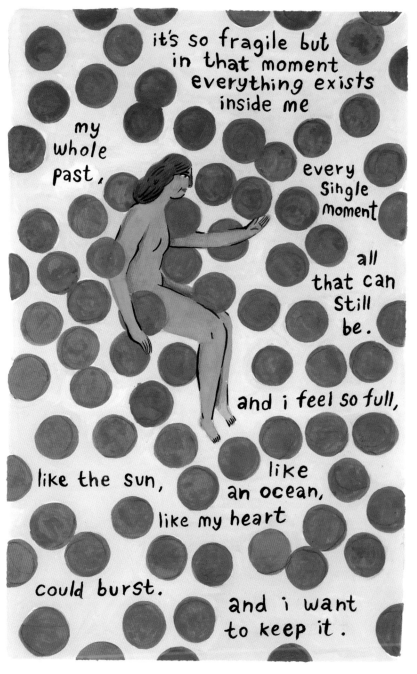

it's so fragile but
in that moment
everything exists
inside me

my
whole
past,

every
single
moment

all
that can
still
be.

and i feel so full,

like the sun,

like
an ocean,

like my heart

could burst.

and i want
to keep it.

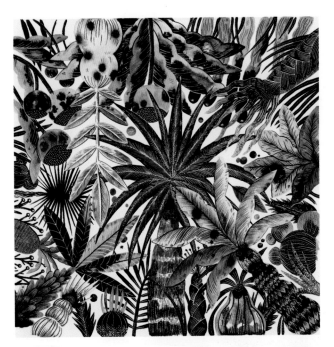

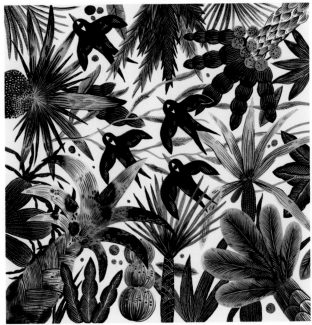

opposite Plantation & Birds, 2017
Shufff silk scarves, print design;
ink on paper

Untitled, 2015–2018
Personal work, Dailydoodlegram;
ink on paper

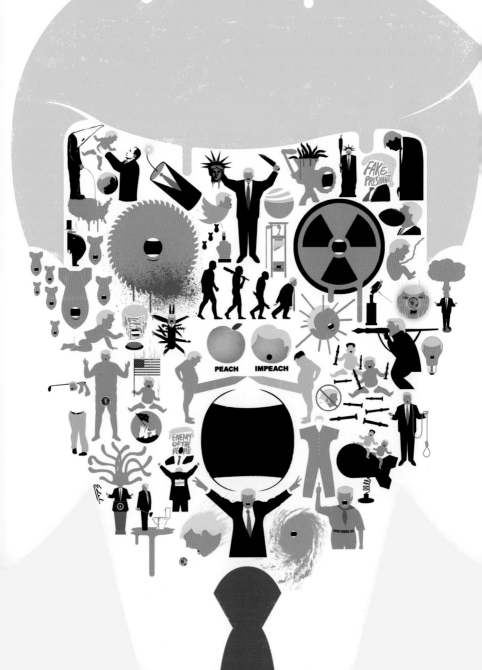

> "I try to get at the essence of the subject in a clear and concise manner and often include biographical details that help inform the viewer."

EDEL RODRIGUEZ

Born in Havana in 1971, Edel Rodriguez grew up in rural Cuba amid fields of tobacco and sugar cane. In 1980, he and his family emigrated to Miami as political refugees. In 1994, Rodriguez received an honors degree in painting from the Pratt Institute in Brooklyn. After graduating, he followed up on a lead to join *Time* magazine as a temp, and soon became the youngest art director of the publication's Canadian and Latin American editions at 26. He enrolled on a master's course at Hunter College in Manhattan, graduating in 1998. The same year, his work appeared in *Print* magazine's *New Visual Artists Annual*. Rodriguez has since accumulated numerous awards from the likes of *Communication Arts* and the Society of Publication Designers. His distinctive visual language stems from his direct personal experiences dealing with political repression, cultural identity, and displacement. Employing a limited palette of acrylics, his saturated images are laden with references from politics and religion to island life and urban pop. A pivotal moment came in 2016–17, when Rodriguez's controversial visual reductions of Donald Trump for *Time* and *Der Spiegel* went viral around the globe. His personal art contains bold, conceptual portraits and landscapes. Notable examples include his series painted directly on cigar boxes, diptychs that load his visualizations into an almost tangible cultural artefact. His art has been exhibited in Los Angeles, Toronto, New York, Dallas, Philadelphia, and Spain.

Selected Exhibitions
2018, *Fault Lines*, group show, Paul Roosen Contemporary, Hamburg · 2018, *Freedumb*, solo show, Ministerium für Illustration, Berlin · 2018, *Agent Orange*, solo show, Wieden+Kennedy, Portland · 2013, *Dystopia*, solo show, Curly Tale Fine Art, Chicago · 2010, *Here There*, solo show, Nucleus Gallery, Los Angeles

Selected Publications
2018, *The History of Graphic Design: 1960–Today,* TASCHEN, Germany · 2018, *Printed Pages,* It's Nice That, United Kingdom · 2018, *De Volkskrant,* De Persgroep, The Netherlands · 2017, *Americas Quarterly,* Council of the Americas, USA · 2017, *The Design of Dissent,* Rockport, USA

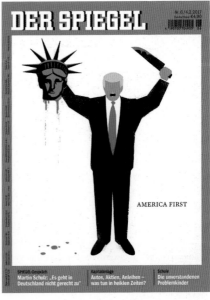

Meltdown, 2016
Time, magazine cover; mixed media, acrylic on paper, digital

America First, 2017
Der Spiegel, magazine cover; mixed media, acrylic on paper, digital

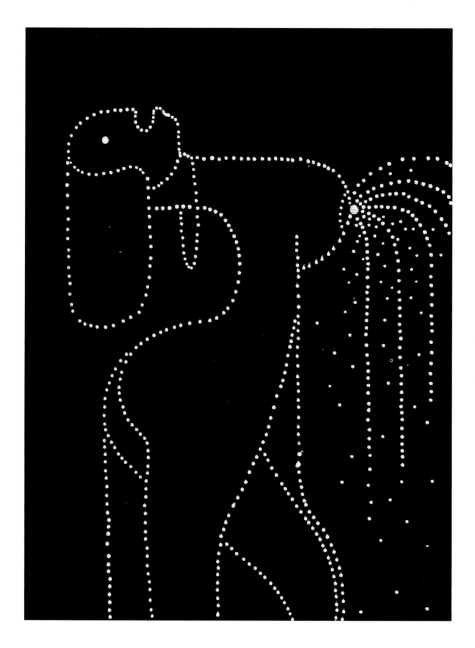

p. 474 Agent Orange, 2017
Personal work, poster; mixed media,
acrylic on paper, digital

Lights, 2016
Personal work; acrylic on paper

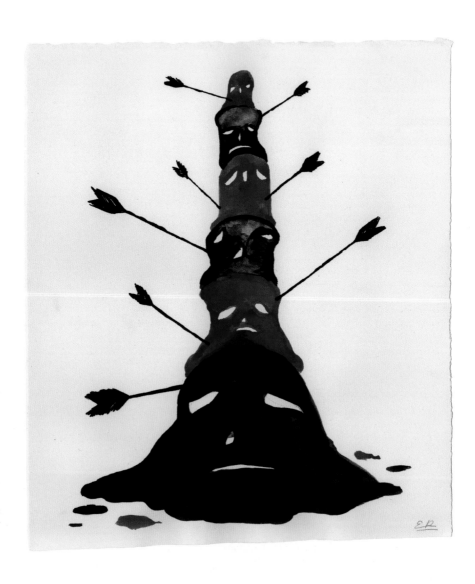

Totem, 2017
Personal work; ink on paper

opposite Stage, 2013
Personal work; acrylic on canvas

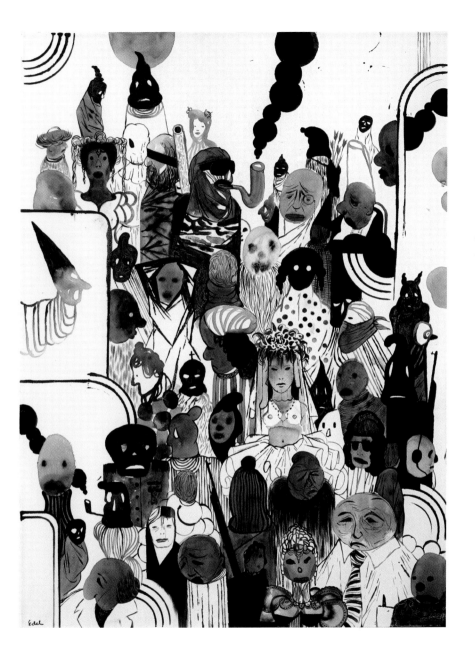

Edel

480

opposite Rise Up!, 2017
School of Visual Arts, poster; mixed
media, acrylic on paper and digital

Father and Son, 2014
Personal work; ink and spray paint
on paper

A Planet for Rent, 2015
Restless Books, book cover;
mixed media, acrylic and ink
on paper and digital

> "I really like to walk around and look (if I can force myself to detach from my iPhone), and I take pictures of things I find interesting on the way—people, places, or situations that I can afterwards draw."
>
> for *Culture Trip*

BRUNO SANTÍN

Bruno Santín is a freelance illustrator who lives and works in Ponferrada, Spain, where he was born in 1972. He studied textile design at the School of Applied Arts in León, where he worked in glass, sculpture, and fabric design. Upon graduating with distinction in 1999 he began defining his peculiar illustrational voice, which is characterized by a penchant for bearded men and accentuated by a distinct palette of reds and pinks. His fashion portraits often merge into wonderful abstract compositions: floral garlands, butterflies, jellyfish, or a fusion of technology. Santín creates imagery that absorbs both the folkloric and psychedelic. His practice involves creating multiple drawings simultaneously with pencil and paper. His work has appeared in numerous fashion and lifestyle publications, including *The Evening Standard Magazine* (London), *IF Magazine* (Chile), and *Prizm*, Ohio's LGBTQ community magazine. With group and solo exhibitions to his name in his native Spain, Santín's growing portfolio and following can also be found on Istahu, Pinterest, and Instagram.

"Gucci"
Bruno Martin '18

Prada Fall 2015.
Bruno Santi

p.482 and opposite Gucci, 2018
Personal work; hand drawing, ink,
pen, pencil

Prada, Fall 2015
Personal work; hand drawing,
ink, pen, pencil

Selected Exhibitions
2018, *Cuatro Años/Four Years*, solo
show, Fabero Exhibition Center,
León · 2017, *Pulse: Acts of Love and
Kindness*, group show, Fort Mason
Center, San Francisco · 2016,
Barbitour, solo show, Museo
Arqueológico de Cacabelos, León ·
2016, *Bearded Men, Mermaids &
Sailors*, solo show, La Doce Gallery,
A Coruña · 2013, *Stone, Paper,
Scissors, and Polaroids*, solo show,
La Casona Fundación, León

Selected Publications
2018, *Shangay* magazine, Editorial
Imani, Spain · 2018, *Dear* magazine,
Influencer Press & EdM Revistas,
Spain · 2018, *If* magazine, Aly
Bonilla, Chile · 2018, *Prizm*
magazine, Carol Zimmer Clark,
USA · 2017, *Mitologia. Rafa Spunky*,
DK Records, Spain

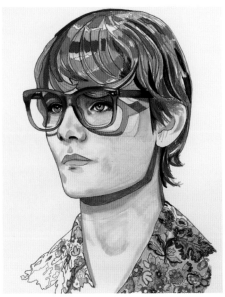

Gucci, 2017
If, online magazine;
hand drawing, ink pen, pencil

Gucci, Fall 2016
Personal work; hand drawing, ink,
pen, pencil

opposite Gucci, 2018
Personal work; hand drawing, ink,
pen, pencil

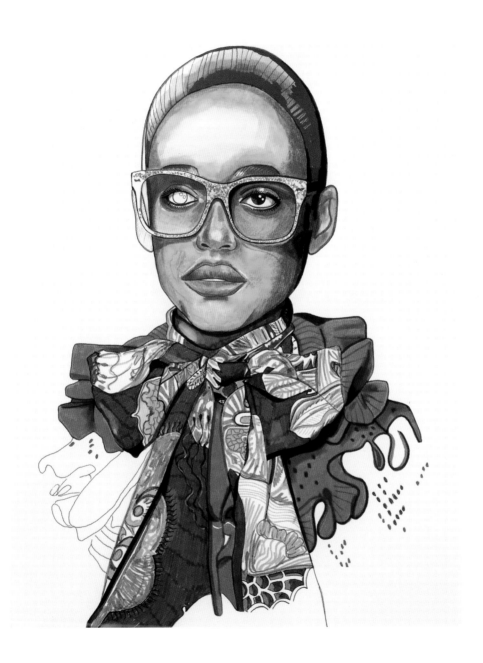

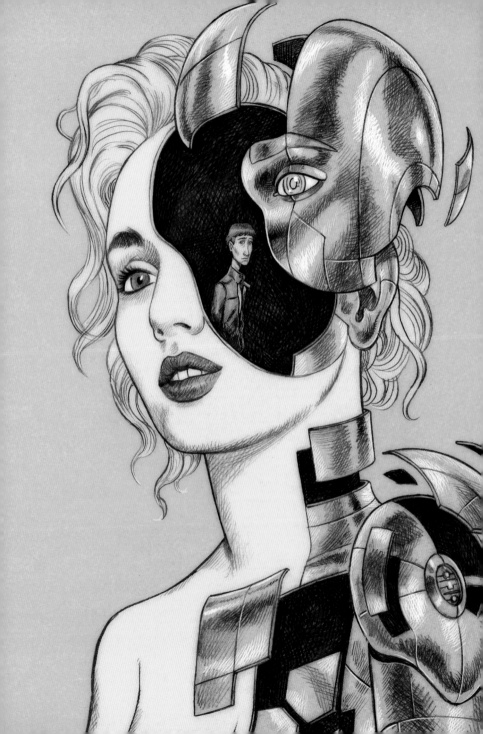

> "In my work I try to put the same emphasis on the visual landscape as I do on the conceptual elements, which together comprise the whole."

KOREN SHADMI

Born in Kfar Saba, Israel, in 1981, Koren Shadmi is an Israeli-American illustrator and cartoonist. He enrolled in a comics course at the age of nine, then his first graphic novel *Profile 107* was released in Israel at the age of 17, produced in collaboration with his mentor, the famed cartoonist, Uri Fink. In 2002, after completing his military service, Shadmi moved to New York and attained a bachelor's degree in illustration at the School of Visual Arts in 2006, where he now teaches the subject. His style traverses from simple to detailed, while sustaining a minimal quality. A unique palette of color gradients and background textures gives his pictures an uncanny, tonal light. This otherworldly quality has appeared on numerous captivating covers and editorials for such publications as *The New York Times*, *The Wall Street Journal*, *Spin*, and *Popular Mechanics*. In addition, Shadmi's graphic books and short stories—exploring themes of love, relationships, and death—have featured in various anthologies; one example is the short story "Antoinette" in *Best American Comics 2009*, taken from his first graphic novel *In the Flesh*. Amongst other accolades, his distinctive style has earned him a Society of Illustrators Albert Dorne Medal and a Rudolph Dirks Award at the German Comic Con.

p. 488 Bionic, 2018
Personal work, book cover; digital

opposite Streetwear Woman, 2018
Women's World Daily, magazine;
digital

Chop & Change, 2017
Newsweek, magazine cover; digital

The Last Words, 2016
Hadassah Magazine; digital

opposite Sanctuary, 2017
Personal work, poster; digital

Selected Exhibitions
2010, *Society of Illustrators*, group
show, New York · 2009, *Comics &*
Paintings, solo show, BilBalBul
Festival, Bologna · 2009, *Artists*
Against the War, group show, Society
of Illustrators, New York

Selected Publications
2013, *Tribute to Robert Crumb,*
Edition 52, Germany · 2010, *Society*
of Illustrators, USA · 2009, *Best*
American Comics, Houghton Mifflin,
USA · 2008, *Communication Arts,*
USA

> "I think in illustration, you have to start with a certain style, even if it's not as concrete as it will be ten years later on. My ultimate goal is to be respected by my peers and people I respect." *for Adobe*

YUKO SHIMIZU

Yuko Shimizu was born in Tokyo in 1963. She spent her early teens living in New York before returning to Japan. After receiving a degree in marketing and advertising at Waseda University she worked in corporate PR for over a decade before abandoning her career to follow her true path. In 1999, she arrived back in New York, where she enrolled in the School of Visual Art's "Illustration as Visual Essay" program. Soon after completing an MFA in 2003, she gained her first commission for *The Village Voice*, and has since developed a highly successful career as a visual artist. Referencing both traditional and contemporary Japanese culture—from traditional woodblock printing to manga graphic novels—Shimizu's style reflects her background viewed with a Western eye. Her process is labored and meticulous. Working with ink on paper and only coloring in Photoshop, Shimizu creates imagery that is dreamlike, sometimes erotic, and always beautiful. The breadth of her output is evidenced by her client list, which includes Apple, Adobe, the Library of Congress, MTV, and Nike. Shimizu produced 70 covers for the DC Comics series *Unwritten*. In 2009, she collaborated on an 11-panel mural project in Brooklyn with graphic designer Stefan Sagmeister as part of the Robin Hood Foundation Library Initiative, and produced limited-edition T-shirts for Gap's AIDS charity line Product RED. The same year, Shimizu was listed in *Newsweek Japan* as one of "100 Japanese People The World Respects." In 2018, she won the prestigious Society of Illustrators Hamilton King Award. Shimizu lives and works in midtown Manhattan and also teaches at her alma mater.

p. 494 Untitled, 2017
Fully Booked, cover;
ink drawing, digital;
art direction: Jaime Daez

Through the Water Curtain, 2018
Japanese Tales, The Folio Society,
book; ink drawing, digital;
art direction: Raquel Leis Allion

opposite Deka vs. Deka, 2015
Maximum the Hormone, DVD
sleeve; ink drawing, digital; art
direction: Maximum the Ryo-kun,
Keiichi Iwata (7 Stars Design)

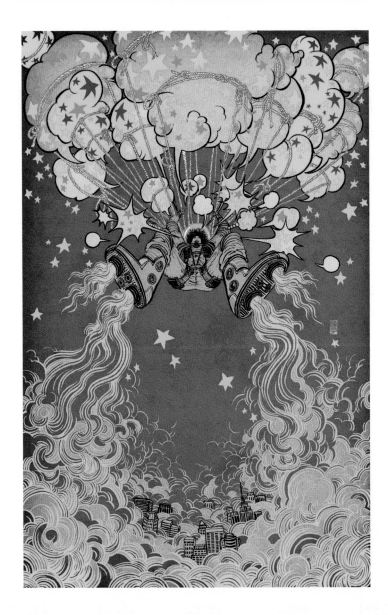

Fly Higher, 2016
School of Visual Arts, poster;
ink drawing, digital;
supervision: Anthony Rhodes,
art direction: Gail Anderson,
design: Ryan Durinick

opposite Camp Festival, 2015
Poster and key graphic;
ink drawing, digital;
art direction: Bram Timmer

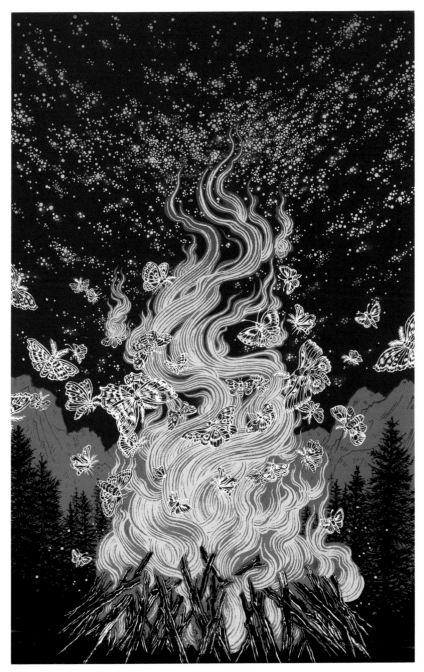

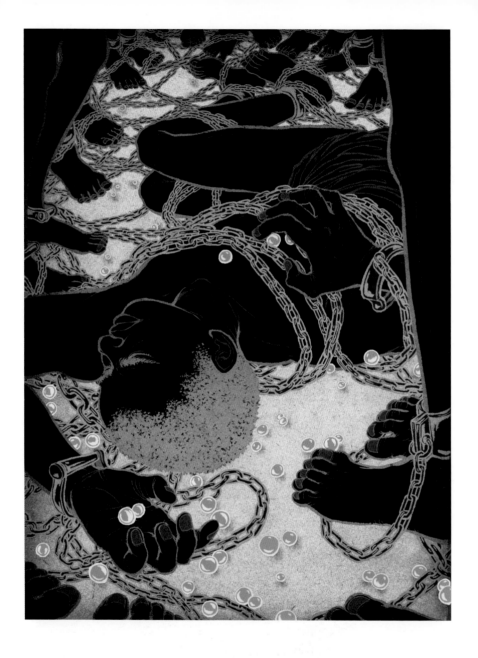

Selected Exhibitions
2018, *Art as Witness Political Graphics 2016–2018*, group show, SVA Chelsea Gallery, New York · 2015, *Wrath of the Gods*, group show, Philadelphia Museum of Art · 2015, *Samurai by Giant Robot*, group show, Worcester Art Museum, Massachusetts · 2013, *Sketchtravel*, group show, Kyoto International Manga Museum · 2011, *Rolling Stone and the Art of the Record Review*, group show, Society of Illustrators, New York

Selected Publications
2016, *Living with Yuko Shimizu,* Roads, Ireland · 2014, *Fifty Years of Illustration,* Laurence King Publishing, United Kingdom · 2011, *Yuko Shimizu,* Gestalten, Germany · 2008, *Things I have Learned in Life So Far,* Abrams, USA · 2008, *Illustration: A Visual History,* Abrams, USA

opposite and below
The Young King, 2018
Oscar Wilde Fairytales, book, Beehive Books; ink drawing, digital; art direction: Josh O'Neill

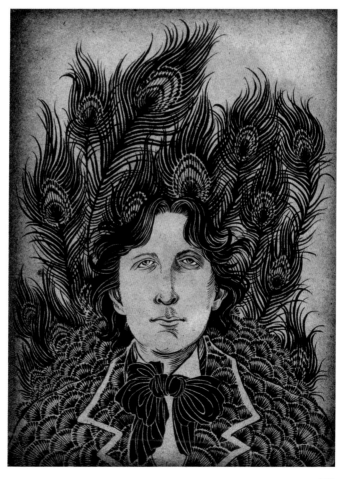

"My graphic approach to illustration has been inspired by some of the great poster artists of the first half of the 20th century. Those who have influenced me the most have done so because of their simplicity and directness."

LAURA SMITH

Through her eclectic, revivalist style, Laura Smith harks back to a bygone era of advertising illustration—an era of Art Deco travel ads and post-war baby boomers. Minimal graphic forms are married with American folk or 1950s–60s typography, which add to the endearing sense of retro-pastiche. Born in Texas, Smith grew up in a mid-century modern house on Manhattan Beach in Southern California. A sense of color, light, and nostalgia would leave an indelible imprint on her creative mind. An early inspiration was the work of Donald "Putt" Putnam, her best friend's father—an artist and instructor at Pasadena's ArtCenter College of Design, which Smith would later attend. After graduating she moved to New York, where she spent more than a decade evolving her distinct visual voice before returning to the West Coast, and eventually settling in Hollywood with her husband, the renowned font designer Michael Doret—with whom she has collaborated. From advertising billboards to magazine covers, Smith's illustrations have been commissioned for a stream of major clients, including *Businessweek*, Ferrari, HBO, Macy's Thanksgiving Parade, the New York Knicks, the World Series, and The Walt Disney Company. To boot, her work has been recognized in such leading publications as *Illustration* and *Communication Arts*, with posters in the permanent collections of the Museum of Modern Art (MoMA), the Smithsonian Institution, and the Victoria and Albert Museum.

p. 502 Solpuri Furniture, 2017,
brochure; digital; art direction:
Roland Althammer

opposite Falcon Diner, 2005
Ameristar Casino, poster; acrylic

Highland Village-Housewares, 2007
Lamp post poster; acrylic;
art direction: Chris Hill

opposite The Future is Now, 2017
American Public Works
Association, poster; digital;
art direction: Jon Dilly

Graphic Artists Guild Handbook,
2014, book cover; acrylic;
art direction: Sarah Love

Strongman, 2017
Personal work; digital

> "I'm not trying to fit into any scene, I'm just trying to create work that I'm proud of. My work gets grouped in with the underground artists—graffiti, illustration, hot rod, skate, comics, etc.—and I know many of these people so maybe I am part of the movement. I'll let someone else decide." *for Webesteem*

JEFF SOTO

Born in Fullerton, Orange Co., California, in 1975, Jeff Soto grew up in a family of outdoor enthusiasts. Getting his first skateboard at the age of nine introduced him to the world of graffiti and illegal street art, whilst a staple diet of film and television—the likes of *Star Wars* and *Robotech*—further fed into his visual language. In high school he formed a graffiti crew with a friend and began stencilling his signature "Sotofish." Under the aliases of "Kilo" and "Trek" he began to "bomb," "tag," and create "pieces," eventually teaming up with artist Maxx242, with whom he would form Bashers Crew on the Los Angeles scene. A decade-long hiatus followed in 1999 after Soto received an associate degree in arts from Riverside City College. He then majored in illustration at ArtCenter College of Design in Pasadena, earning a BFA with distinction in 2002. When he channeled his concepts into commercial illustration, Soto's highly detailed, colorful style, which connects pop surrealism with street art, soon began to reel in prized commissions for the likes of United Airlines, Disney, and rock bands like Pearl Jam and Soundgarden. In 2010, Sota returned to graffiti (though he considers himself a "muralist") and has since created pieces around the world. Soto exhibits regularly in galleries and museums as well as urban, public spaces. His work has been showcased in two monographs, *Potato Stamp Dreams* (2005) and *Storm Clouds* (2009). He lives and works in Riverside, where he continues to instruct at his alma mater.

p. 508 Winter Nights, 2016
Personal work;
acrylic on wood

opposite Night Walkers, 2015
Personal work;
acrylic on wood

The Cat, 2015
Personal work;
acrylic on wood

Night Flight, 2015
Personal work;
acrylic on wood

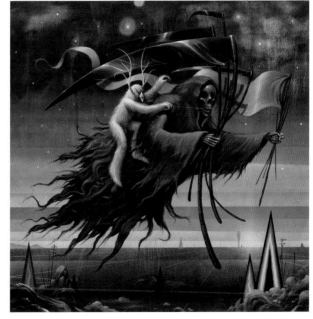

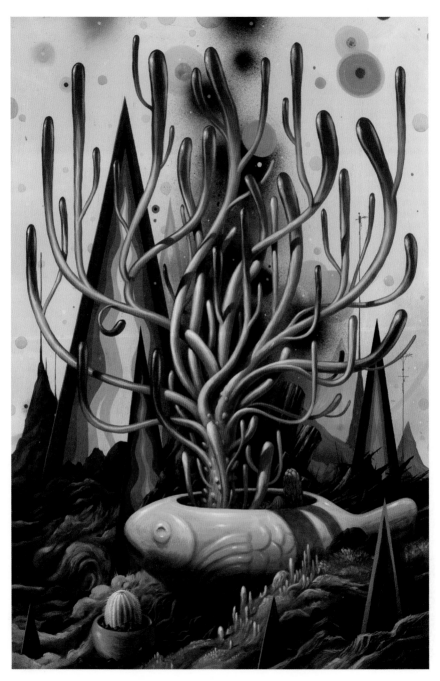

Selected Exhibitions

2017, *The Sotofish Society*, solo show, Jonathan LeVine Projects, New York · 2015, *Nightgardens*, solo show, Merry Karnowsky Gallery, Los Angeles · 2013, *Fire Within*, solo show, Bunsen Goetz Gallerie, Nuremberg · 2009, *Inland Empire*, solo show, Stolen Space Gallery, London · 2001, *Potato Stamp*, solo show, New Image Art, Los Angeles

Selected Publications

2019, *Staf Magazine*, Staf Malaga, Spain · 2015, *Very Nearly Almost*, magazine, VNA London, United Kingdom · 2009, *Stormclouds: Jeff Soto*, Murphy Books, USA · 2009, *Juxtapoz*, High Speed Publications, USA · 2005, *Potato Stamp Dreams: Jeff Soto*, Murphy Books, USA

opposite Tree of Love, 2015
Personal work; acrylic on wood

Red Terrarium Keeper, 2016
Personal work; acrylic on wood

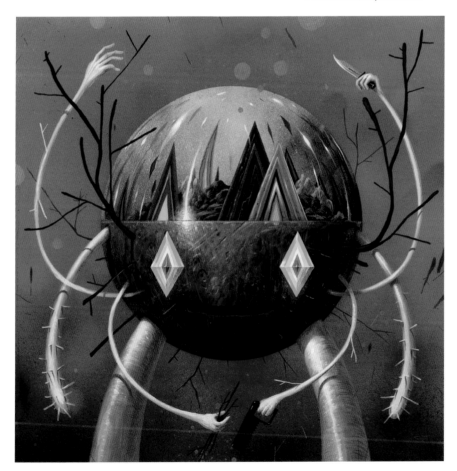

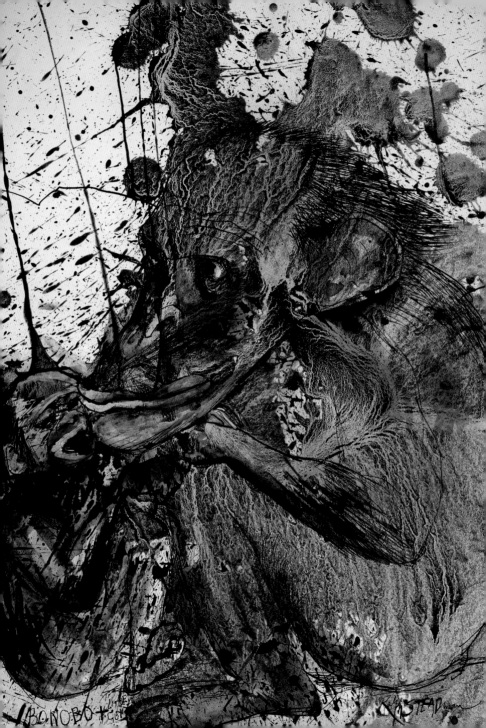

BONOBO little... KOSTABI...

> "I suppose what I'm actually on is a frightening, paranoiac fear of life, and I exorcise that fear by drawing."
>
> for *The Independent*

RALPH STEADMAN

Renowned for his trademark slash and splatter technique, British artist Ralph Steadman is one of the most imitated illustrators and political caricaturists today. With a style that blends the Abstract Expressionism of Jackson Pollock with the grotesque figures of Francis Bacon, Steadman exaggerates his subjects using a sardonic detonation of humor that reveals the absurdity and psychosis of the human condition. Born in Wallasey, in 1936, and raised in North Wales, Steadman attended East Ham Technical College and the London College of Printing in the 1960s. During this period he began garnering attention for his contributions to the satirical magazines *Punch* and *Private Eye*, and to newspapers like *The Daily Telegraph* and *The New York Times*. Steadman is most recognized for his long association with American journalist and writer Hunter S. Thompson, for whom he illustrated several articles and books, most notably the 1971 roman à clef *Fear and Loathing in Las Vegas: A Savage Journey to the Heart of the American Dream*. His erratic visual style complemented the savage wit and high-octane gonzo journalism of Thompson. Throughout his career, Steadman has visually reinterpreted several literary classics, from Lewis Carroll's *Alice in Wonderland* to Ray Bradbury's *Fahrenheit 451*. A wine lover, he traveled extensively during the 1990s creating illustrations for Oddbins alcohol retail chain, and he subsequently produced three travel books: *The Grapes of Ralph* (1992), *Still Life with Bottle* (1994), and *Untrodden Grapes* (2005). His numerous accolades include the 1979 American Institute of Graphic Arts Illustrator of the Year award, a BBC Design Award, and a number of D&AD mentions. In 2012, Steadman was the subject of a documentary *For No Good Reason*, directed by Charlie Paul, which premiered that year at the London Film Festival. He lives and works in the village of Loose in Kent.

p. 514 Bonobo and Little Guy, 2018
Critical Critters, book by
Ceri Levy; Indian ink, dirty water

The Invention of the Wheel, 1987
The Big I Am, book; Indian ink,
pen, atomizer

opposite American
Swamp Pet, 2018
Rolling Stone, magazine;
Indian ink, acrylic, dirty water

AMERICAN SWAMP PET
MESSES WITH STARS & STRIPES
RalSTEAD

TIPPING AT WILLMILLS

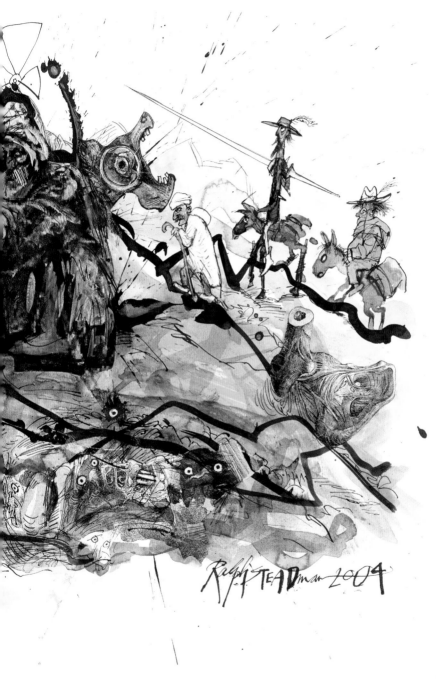

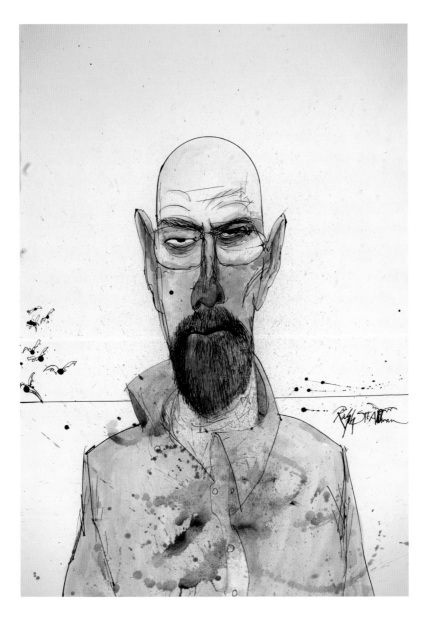

pp. 518/519 Tipping at
Willmills, 2004
The Independent, magazine,
psychogeography series;
Indian ink, collage

Walter White, 2014
Sony Television, DVD collectors'
sleeve; Indian ink, dirty water

opposite Frenchman on Bike, 1987
Oddbins Wine Merchants,
The Grapes of Ralph, catalogue
cover; Indian ink, dirty water

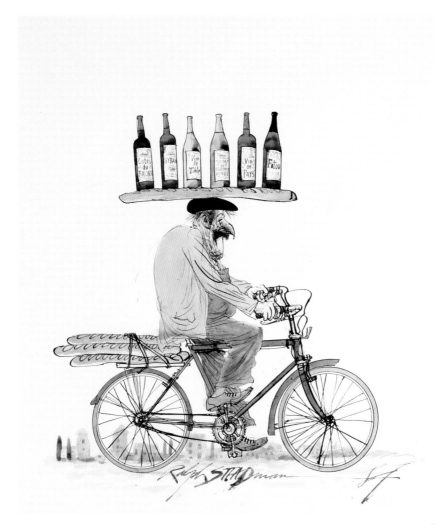

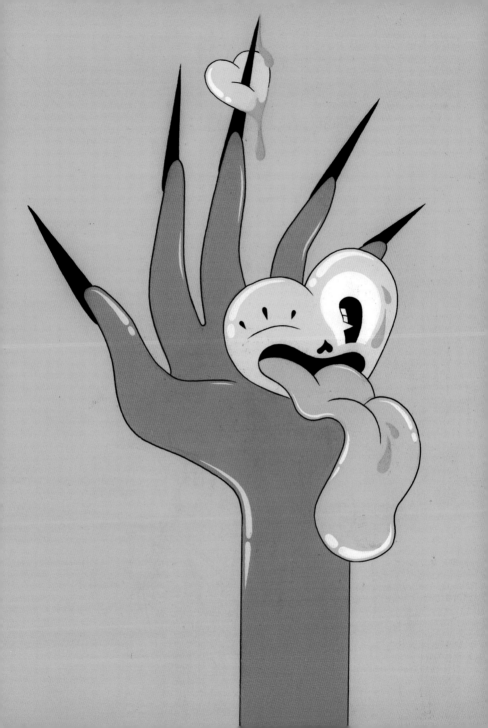

"Predominantly, I'm an illustrator—but then I work in so many different fields as well, [including] photography and fashion, and I also consider myself an artist."

for *Digital Arts*

HATTIE STEWART

In an era of Internet memes, London-based artist and illustrator Hattie Stewart has received attention for her "doodle-bombing," a technique she coined for customizing photographs and images with an array of bright, primary-colored characters and icons. Stewart's collection of cartoonish marks, characterized by wide eyes, love hearts, and bubblegum-pink lips, play on a lexicon of graphic references from the early animations of Disney and Max Fleischer to 1970s decals, 80s typefaces, slot-machine cherries, and Mexican Day of the Dead designs. Her implements of choice are Posca pens. Stewart's anthropomorphisms have appeared in art and fashion mags from *Interview* to *Vogue*, for brands like Urban Outfitters and Marc by Marc Jacobs, and animated title cards for movies such as Charlie Lyne's film essay *Beyond Clueless* (2014). Her tongue-in-cheek characters have also featured in a pull-out book, *Living With: Hattie Stewart* (2016). The same year, she was invited to illustrate over a series of photographs of various performing artists, including Pharrell Williams, Katy Perry, and Queens of the Stone Age, to celebrate the tenth annual Apple Music Festival. Born into a creative family in Colchester, England, in 1988, she studied illustration at Kingston University and graduated in 2010. Stewart has exhibited her work in Los Angeles, Miami, New York, and Berlin.

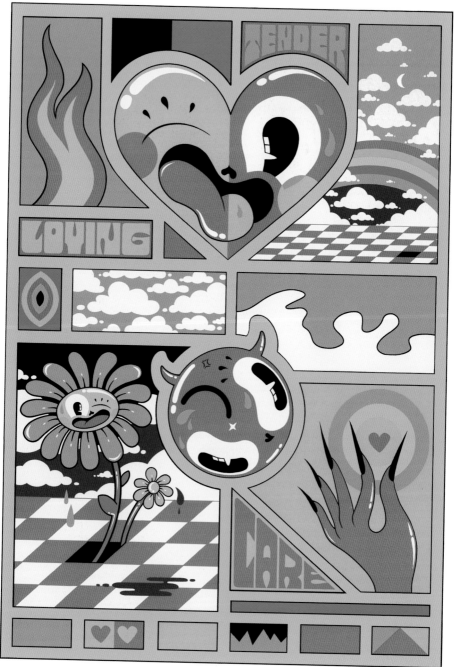

p. 522 Ouch, 2017
Personal work; hand drawing

opposite Tender Loving Care, 2018
Personal work; digital

Checkerboard, 2018
Personal work, postcard; digital

MAC Cosmetics, 2016
Advertisement; digital illustration
over photography

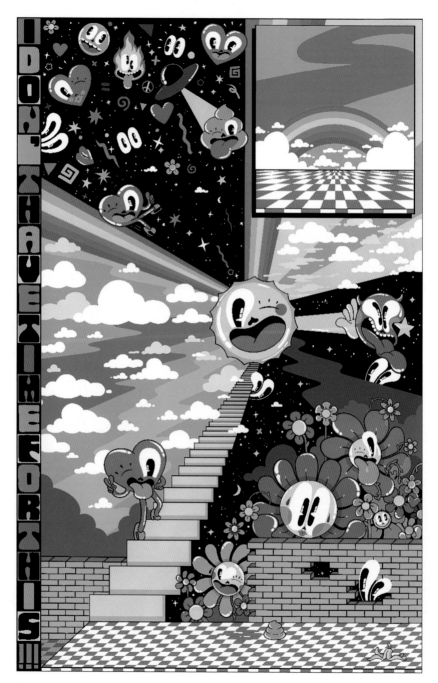

opposite I Don't Have Time
For This, 2018
Now Gallery; digital file which was
recreated into a painted installation

Squish, 2018
Personal work; hand drawing

Selected Exhibitions
2018, *I Don't Have Time for This*,
solo show, Now Gallery, London ·
2016, *Untitled, Artist Rooms*, solo
show, Firstsite Contemporary
Gallery, Colchester · 2015,
Adversary, solo show, House of
Illustration, London · 2015, *Pattern/
Shape/Fluidity/Versions*, solo show,
No Walls Gallery, Brighton ·
2015, *Dollhouse*, solo show, KK
Outlet, London

Selected Publications
2017, *Hattie Stewart's Doodlebomb
Sticker Book,* Laurence King, United
Kingdom · 2016, *Living With:
Hattie Stewart,* Roads Publishing,
United Kingdom

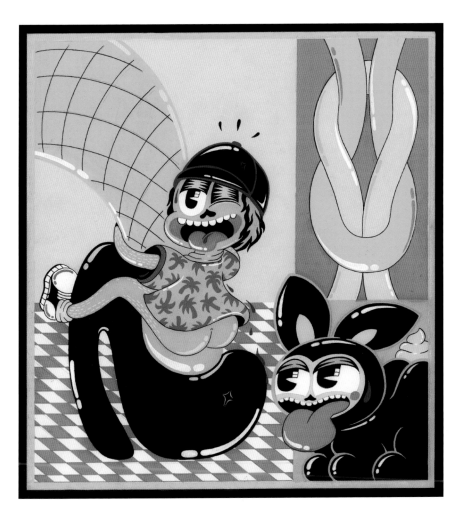

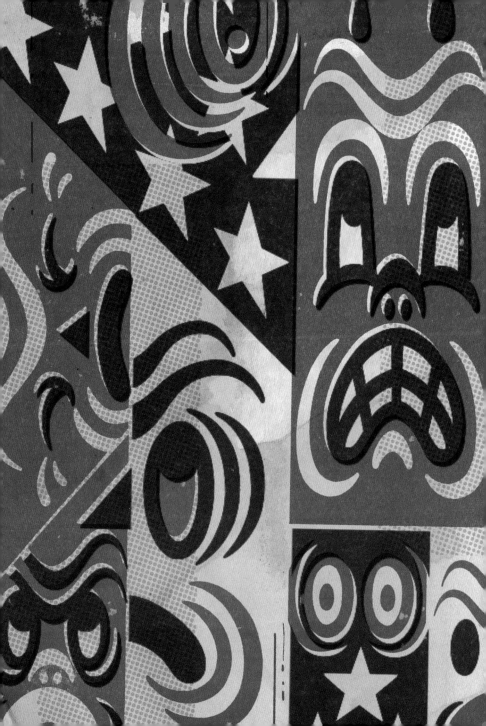

> "I work in a reductive way; it's kind of a safety net, like, 'Oh it's already kind of done, I'll just add a few things here and there.' It's intimidating otherwise."
>
> for *Cool Hunting*

GARY TAXALI

Through a hybrid style that mixes Depression-era comics and advertising graphics with Pop Art, celebrated Canadian artist and illustrator Gary Taxali has put his own unique stamp on contemporary visual culture. Taxali was born in 1968 in Chandigarh, India, and his family emigrated to Toronto when he was still a baby. Encouraged to draw from an early age, he enrolled in summer art classes before eventually studying illustration at the Ontario College of Art and Design (OCAD). Soon after graduating in 1991, he moved to New York and began working professionally and participating in group shows in the East Village. Upon his return to Canada a year later, his reputation was already spreading to the West Coast and in 2000, he had his first solo exhibition at the Anno Domini Gallery in San Jose. Throughout an illustrious career, Taxali has managed to bridge the gap between high art and pop culture. By reinterpreting graphic elements of the past, his work offers a fresh, satirical take on today's social issues. He works with pencil, ink, and silkscreen, sometimes employing found objects. Applying art to surfaces stems from his childhood habit of drawing on walls, headboards, desks, and chairs. It comes as no surprise that his work has migrated onto designer products. He has created silk pocket squares for Canadian menswear brand Harry Rosen and released a range of toys and stationery. Among his numerous exhibitions, Taxali has showcased his work at the Whitney Museum of American Art, MondoPOP Gallery, and the Andy Warhol Museum. His clients range from Gap to Nintendo, and the Royal Canadian Mint to Sony. Taxali is a professor in the design faculty at OCAD.

p. 528
GOP Paranoia, 2018
The Baffler, magazine;
mixed media; art director:
Lindsay Ballant

opposite
Wincy, 2015
Personal work, *Hotel There*,
solo show; mixed media

We Need to Talk, 2015
Personal work, *Jonathan
LeVine Gallery 10th Anniversary*,
group show; limited-edition
silkscreen print

Can We Stop, 2015
Personal work, *Hotel There*,
solo show; acrylic on Baltic birch

Selected Exhibitions
2019, *Society of Illustrators*, group
show, New York · 2017, *Winter
Show*, group show, Gallery Arts
Factory, Paris · 2016, *Unfamous*,
solo show, First Canadian Place
Gallery, Toronto · 2015, *Hotel There*,
solo show, The Jonathan LeVine
Gallery, New York · 2014, *Unforget
Me*, solo show, The Jonathan LeVine
Gallery, New York

Selected Publications:
2018, *Off the Wall. Art of the Absurd*,
Victionary, China · 2017, *Happiness
with a Caveat,* Chump, Canada ·
2011, *This is Illustration! American
Illustrators*, Monsa, Spain · 2011,
Mono Taxali, 27_9, Italy · 2011,
I Love You, Ok?, teNeus, Germany

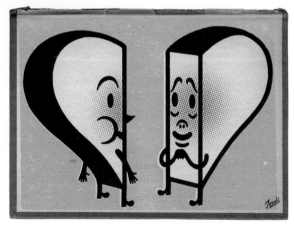

Benny's Celebrates 30 Years, 2018
Benny's Burritos, menu cover;
mixed media; art director:
Ken Sofer

One Love, 2016
The New Yorker, magazine;
mixed media; art director:
Deanna Donegan

opposite NO, 2018
Personal work; mixed media

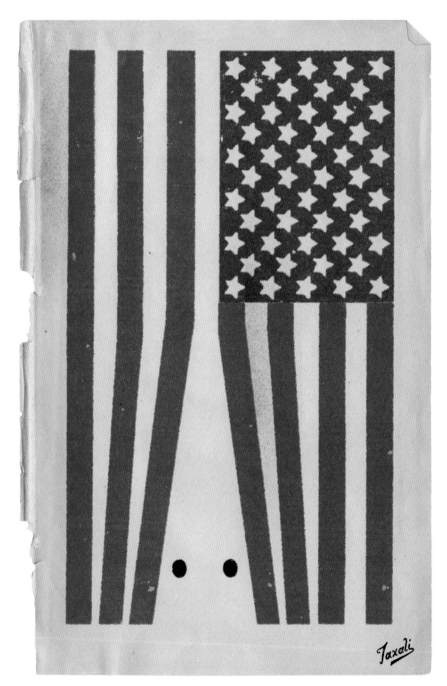

Taxali

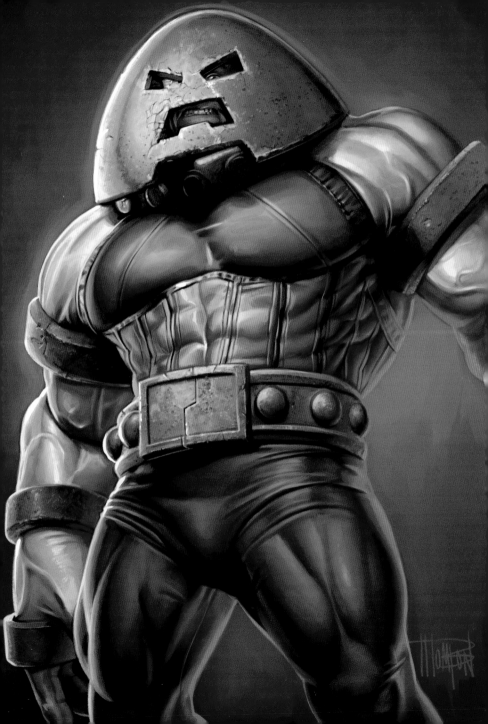

> "I spend a lot of time crafting each painting. I won't step away from it till I feel it's right. You are only as good as your last piece, that's just real."

MIKE THOMPSON

Mike Thompson is an Illustrator and digital sculptor based in Washington, D.C. As a child, he drew comic-book characters immortalized by heavyweight artists like Neal Adam and John Byrne—an early passion that would kindle his creative path. The discovery of Norman Rockwell would prove another major influence on his future style of realism. Born in Aschaffenburg, Germany, in 1968, Thompson started out as a designer and art director in the fashion sector, working for the likes of Marc Ecko, Nike, and Timberland, before going freelance. For over two decades, he has embraced new technology in his practice, expanding from traditional 2D painting to 3D illustration. His digital expertise coupled with an affinity with contemporary American culture—notably the celebration of black identity—has made him a go-to artist in the realms of editorial, package, promo, and 3D displays. Thompson has created video game covers for EA, High 5, Volition, and 2K Sports, and has illustrated a host of characters for Marvel, such as Guardians of the Galaxy and the Black Panther. He has also produced package art for G.I. Joe (Hasbro), and DC's Infinite Earths collection of toys by Mattel. His work has adorned editorials for a variety of music, entertainment, and sports magazines, including *XXL*, *Vibe*, and *Slam Presents Kicks*. In 2010, he created illustrations for a large-scale interactive fan wall for Verizon Wireless at the New Meadowlands Stadium in New Jersey. Thompson has also hosted webinars for Corel's "Painter Masters" series.

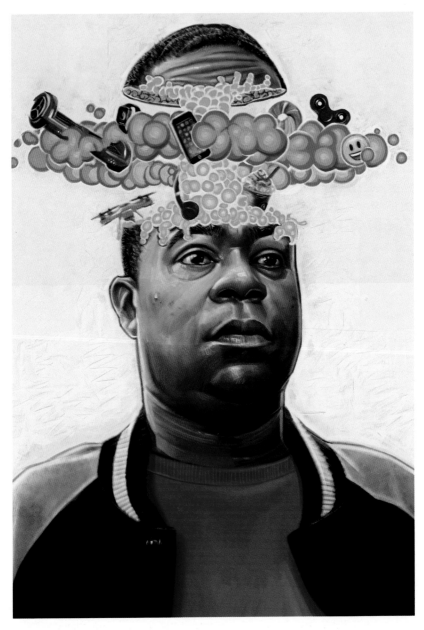

p. 534 Juggernaut, 2018
Upper Deck; digital

Tracy Morgan, 2018
TBS, Gravillis Inc; digital

opposite Hidden Figures, 2017
20th Century Fox,
Gravillis Inc; digital

Selected Exhibitions
2017, *Black History Exhibit*,
group show, Smithsonian Museum,
Washington, D.C. · 2011, *Hip Hop:
A Cultural Odyssey*, group show,
Grammy Museum, Los Angeles

Selected Publications
2016, *Los Angeles Times Magazine,*
Ross Levinsohn, USA · 2010,
Secrets of Corel Painter Experts,
Cengage Learning PTR, USA ·
2008, *GQ* magazine, Condé Nast,
USA · 2007, *Two Faced,* System
Design Ltd, Hong Kong · 2005,
Illustration Now!, TASCHEN,
Germany

opposite Cappie & Sheila, 2018
Nike; digital

Miles Brown & DJ D Sharp, 2018
Nike; digital

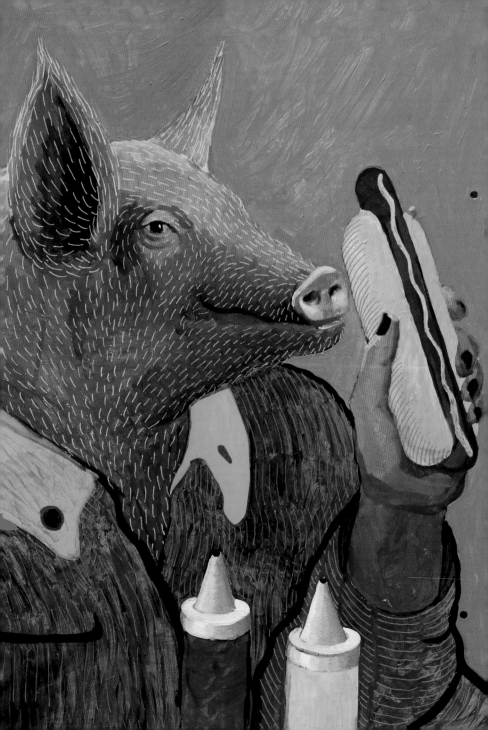

TRECO (DECO FARKAS)

André "Deco" Farkas (aka Treco) was born in São Paulo in 1985. Brought up around his renowned cinematographer father, Pedro Farkas, and Hungarian-born grandfather, photography pioneer Thomaz Farkas, visual creativity was in his blood from an early age. Whilst studying art at the Armando Alvares Penteado Foundation he quickly became disillusioned with the commercial art world and began his journey into street art, where he found his true artistic calling. Vibrant colors and wonderful hybrid figures with machine-like extensions define his cerebral style, while echoes of Hockney, Picasso, and de Chirico abound in his striking murals. The world of Farkas is a serendipitous journey into a surreal landscape. He has a natural disregard for intellectual analysis; his spontaneous approach flings open the doors of perception with no preconceived intent. He divides his time between painting at home on canvas and creating street murals—both distinctly separate approaches. Farkas' multidisciplinary practice includes animation projects and, in 2016, in collaboration with film directors Daniela Thomas and Fernando Meirelles, and French company Plasticiens Volants, he created four large-scale inflatable hands for the opening of the Rio Olympics, exploring universal hand gestures as cultural references.

Selected Exhibitions
2017, *Tropicality*, group show,
The Printspace Gallery, London ·
2014, *Esse Treco*, solo show, Galeria
Virgílio, São Paulo · 2013, *Recorte
Transversal*, group show, Galeria
Transversal, São Paulo

Selected Publications
2018, *Zupi 57,* Brazil · 2013,
Graffiti São Paulo, Ricardo Czapsky,
Brazil · 2011, *Nuevo Mundo.
Latin American Street Art,* Gestalten,
Germany

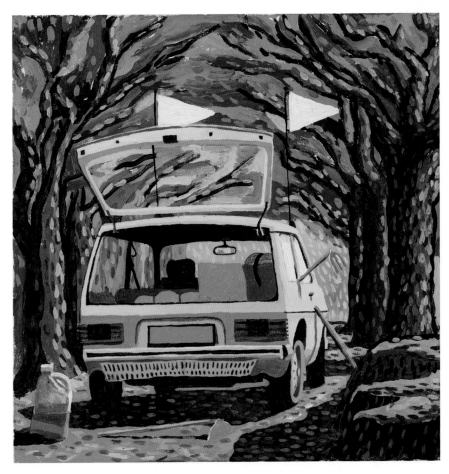

p. 540 Hungry Pig, 2018
Zona Central, newspaper; acrylic

opposite Brasília, 2018
Personal work; acrylic on canvas

Untitled, 2018
Personal work; acrylic on canvas

Philip K. Dick, 2016
Companhia das Letras, book cover;
acrylic on canvas, digital

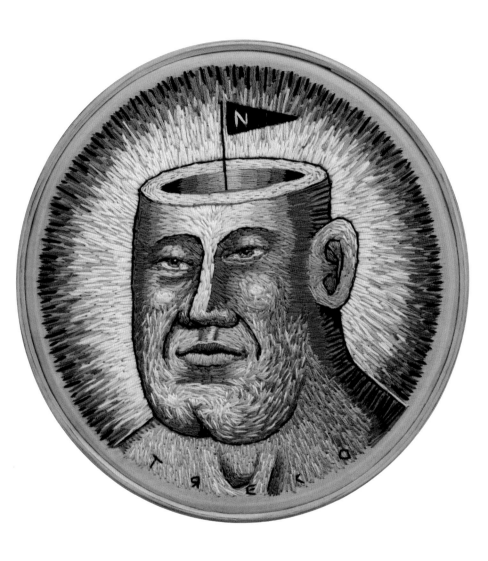

opposite top Imperatriz
Assassina, 2018
Jai Mahal e os Pacíficos da
Ilha, album cover; acrylic on
canvas, digital

opposite bottom
Pontes para Si, 2015
Pitanga em Pé de Amora,
album cover; pen on paper

Flaghead, 2018
Personal work, embroidery;
cotton shreds on cotton fabric

> "I start any new project by first gathering lots of beautiful imagery to help inspire me. I then grab a pencil and scribble down lots of ideas in my sketchbook, and once I have settled on an idea I develop it as much as possible." *for The Smuggler*

CHARLOTTE TROUNCE

The immediate appeal of Charlotte Trounce's work lies in her peculiar ability to translate visually her observations of people, objects, greenery, and architectural spaces. With economy of form, and a carefully selected palette (often dominated by pastel hues), Trounce creates painterly compositions—hand-rendered using either traditional or digital media—that perfectly suit her eclectic client briefs. Born in Tunbridge Wells, England, in 1988, she studied illustration at University College Falmouth on the Cornish coast, receiving her BA (Hons) in 2011. Trounce has since gone on to establish herself as a noted artist-illustrator and educator. She has illustrated various publications, from an activity book to accompany the Barbican exhibition *The World of Charles and Ray Eames* (2016), to *Panorama Pops: The British Museum* (2017), a three-dimensional expanding pocket guide celebrating the institution's famous collection of artefacts. The same year, the release of her delightful children's alphabet book *A to Zakka* coincided with an exhibition of objects and prints at Ground Floor Space, a dn&co gallery in London. In 2018, Trounce published *My Modern House*, a sourcebook for aspiring young architects. Her growing client list includes Art Fund, It's Nice That, *Financial Times*, Shiseido, and the Women's Prize for Fiction. Trounce has been an artist-in-residence at Seiunkan Farmer's Guest House in Komoro, Japan, and has led creative children's workshops at the Barbican in London. She lives and works in North London.

p. 546 The Trees
of San Francisco, 2018
Personal work, digital

opposite Paediatrics, 2018
One Medical, branding;
acrylic on paper, digital;
art direction: Moniker

Japan, 2018
Personal work; digital

I Love Dick, 2018
Personal work, book cover;
acrylic and crayon on paper, digital

Carrot, 2018
Shiseido, advertising;
acrylic on paper, digital;
art direction: Hiromi Shibuya

opposite top Ian Callum, 2015
Nest Supper Club, *Wallpaper** event,
live portrait drawing; acrylics on
paper; art direction: Anyways

opposite bottom Do We Need
Another Chair?, 2015
Fiera, magazine; acrylic and
crayon on paper, digital

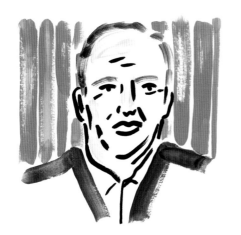

Selected Exhibitions
2017, *A to Zakka*, solo show,
Ground Floor Space, London

Selected Publications
2019, *Barbican Monthly Guide*,
Barbican, United Kingdom · 2018,
ES Magazine, The Evening Standard,
United Kingdom · 2016, *Artless:
Art & Illustration by Simple Means*,
Laurence King, United Kingdom ·
2014, *The Parisianer*, Little Brown,
United Kingdom · 2012, *Wrap
Magazine*, United Kingdom

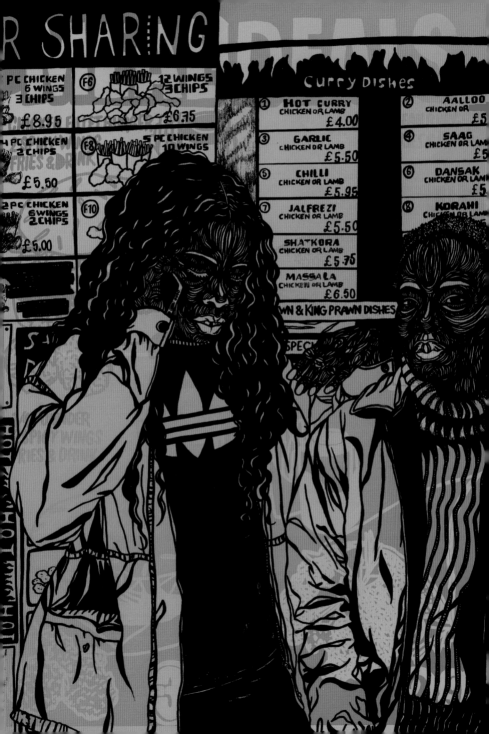

> "Be a self-starter; grab a couple
> of friends and make things happen.
> If you don't enjoy it, don't do it."
>
> for *The Albany*

OLIVIA TWIST

Hailing from East London (b. 1992), Olivia Mathurin-Essandoh (aka Olivia Twist) is an exemplar of the new generation of illustrators whose practice is informed by research-based approaches, community participation, and relational aesthetics. In her website statement, Twist cites her aims as being able to "provide her audience with 'the shock of the familiar' and encourage intergenerational discussion." Working with various media, including pen and ink, collage, print, and pencil, Twist contrasts the peripheral elements of everyday urban life—streets, walls, and entrances to apartment blocks—with subjects, notably black people, rendered in her distinctive style. After completing a BA in design for graphic communication at the University of the Arts London in 2015, Twist was accepted on the MA visual communication course at the Royal College of Art, which she completed in 2017. As a student and subsequent freelancer, her prolific output has been shown in over 70 exhibitions and events, including the Black British Girlhood Festival at the Centre for Mental Health (London) and Diaspora Britain (Birmingham), both in 2015. Twist was a British Council-funded artist in residence for ColabNowNow X at the Fak'ugesi African Digital Innovation Festival in Johannesburg in 2017. A proactive arts facilitator, Twist regularly gives talks and conducts art and creative writing workshops. In 2017, Twist won the Quentin Blake Narrative Drawing Prize.

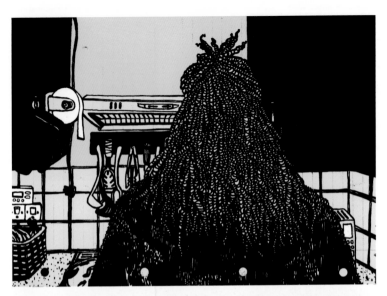

p. 552 3:45 – Spice Hut #2, 2017
Personal work; hand drawing

Redbean Stew, 2016
Varoom, magazine; digital
print on cotton drill

Move for *mi* to stretch
mi foot, 2017
Personal work; hand drawing

opposite Balcony Babes, 2018
ASOS, magazine; hand drawing

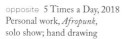
opposite 5 Times a Day, 2018
Personal work, *Afropunk*,
solo show; hand drawing

Second Floor, 2016
Personal work; hand drawing

Boss, 2016
Personal work; hand drawing;
permanent marker on lino tile

Selected Exhibitions

2018, *Reconstructing Practice*, group show, ArtCenter College of Design, Pasadena · 2018, *Don't Ask How We're Cousins*, solo show, Parkgate Road, London · 2017, *British Council*, group show, Faku'gesi African Digital Innovation Festival, Johannesburg · 2017, *3:45*, solo show, Wolverhampton Art Gallery, United Kingdom · 2015, *Acts of Looking, Africa Utopia*, group show, Southbank Centre, London

Selected Publications

2018, *Varoom,* Association of Illustrators, United Kingdom · 2018, *OOMK,* United Kingdom · 2018, *ASOS,* United Kingdom · 2018, *Yellow,* United Kingdom · 2017, *Galdem,* United Kingdom

opposite top Brothers, 2018
Royal College of Art, mural;
hand drawing

opposite bottom Telisha and Shahab, 2018
Royal College of Art, mural;
hand drawing

All Good, 2018
Print Social, illustration fair,
T-shirt design; screen print

"I love watching people on the street and observing the different ways they move about, look, and sound. Hours can go by as I imagine where they are going, what's in their luggage, and what their homes look like." for AI-AP

TOMI UM

Tomi Um's clean, wavy lines exude references to traditional Chinese art—and a self-confessed love of "curly noodles." Through meticulous execution, she is able to communicate a dense flow of graphic information in a clear and genial way—a talent that has seen her lauded with equal acclaim for both editorial and advertising work as well as her wonderfully conceived publications. Originally from Seoul, Haenim Um (b.1981) attended Parsons School of Design in New York, where she received her BFA in 2004. She returned home and briefly taught art but succumbed to the industry pull of New York. Um began developing her freelance illustration portfolio whilst working as a textile designer at Tom Cody Design—a practice that enhanced her skills in composition and coloring. Her landscapes and urban scenes are teeming with the hustle and bustle of everyday life. Um's style is also a result of her use of silkscreen, linocut, and scratchboard. Her personal projects are visual narratives that are filled with a wonderful array of Buddhist imagery and anthropomorphic characters. Notable works include her screenprinted comic series, *The Noodle Monk* (2008), her curated and illustrated issue of Italian art magazine *Un Sedicesimo* (2010)—printed as a single folded typographic sheet—and *Little Opera* (2011), a limited-edition silkscreened accordion book. She has illustrated *Billboard* magazine and Fab.com, and has been a regular contributor to the "The Ethicist" column of *The New York Times*. Um has been recognized in *Print* magazine's *New Visual Artists Annual* (2010), and as one of the recipients of the Art Directors Club Young Guns title (New York, 2011). She currently lives in Brooklyn.

p. 560 Hospital, 2018
Stern, magazine; digital

The Guggenheim is…, 2016
Guggenheim Museum, website;
digital

opposite Apartment, 2016
The Hub, And Partners,
poster and website; digital

pp. 564/565 Bedford Station, 2018
Personal work, print; digital

563

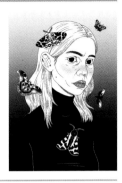

BERTA VALLO

For London-based illustrator Berta Vallo, observation is key to her creative approach. With a strong interest in human behavior and emotions, she addresses what she describes as "the notion of identity formation and female sexuality in relation to consumerist culture." She was born in Budapest, in 1995, where she grew up drawing and later studied world literature and media studies. She found herself learning traditional animation in the studio of Oscar-winning animator Ferenc Rófusz at the Art School of Buda. After two years she took up life drawing and began studying graphic design and painting. In 2014, she moved to London after being accepted on the BA graphic communication design course at Central St Martins, where she specialized in illustration in her second year. During this period she began working as a junior designer at the London studio of Icelandic artist Kristjana S. Williams, where she contributed visuals for art installations at the Rio Olympics. In 2016, Vallo presented her first solo exhibition at the Weöres Sándor Theater in Budapest. *Pixels* is a series of observational studies that showcase her practice of combining traditional analog media techniques with digital collaging. Precision lines and exaggerated features reveal behavioral glimpses through grotesque caricature and everyday scenes. Since graduating with honors in 2017, Vallo has produced an informational mural on London's food markets for Stansted Airport and has collaborated with British rapper Professor Green for the UK online support network The Book of Man.

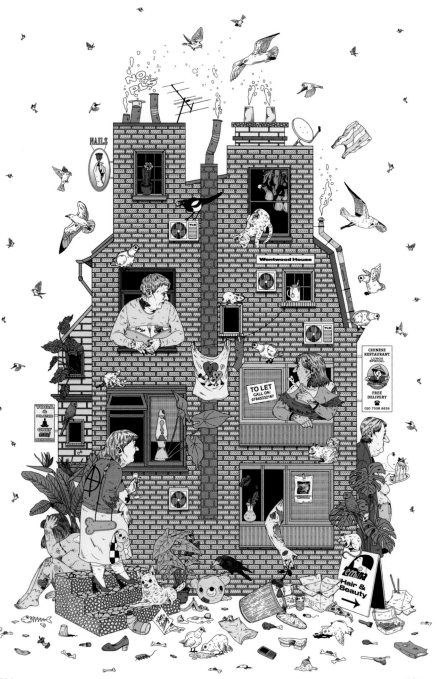

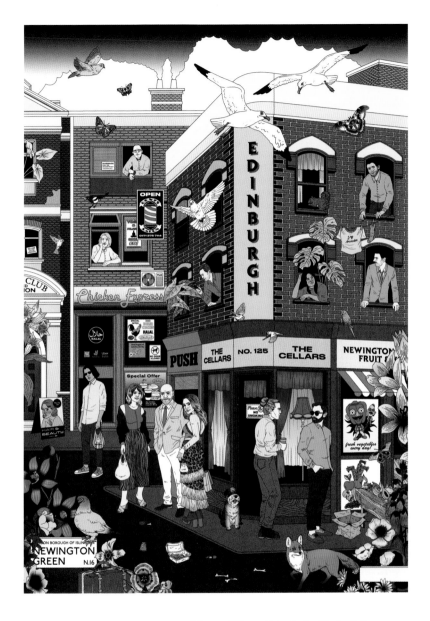

p. 566 Georgia Seeds, 2018
Personal work, print; digital;
inspired by Vanessa Winship's
photo series "Georgia Seeds
Carried by the Wind"

opposite 7 Wentwood House, 2018
Personal work, print; digital

Jordan Dingle, 2018,
private commision, print; digital

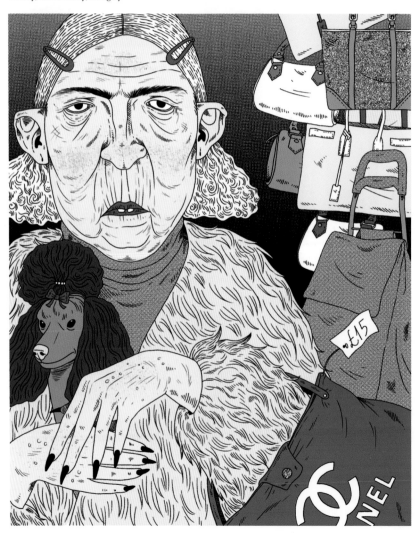

opposite Fake Bag, 2018
BBC website, *Vice* magazine; digital

Summers in Buda, 2018
Personal work, print; digital

Sweet Nothings, 2018
Personal work, print; digital; inspired
by Vanessa Winship's *Sweet Nothings*

> "Humor is important to me and drives a lot of my decision-making. If a drawing makes me smile or laugh out loud, it usually means I'm heading in the right direction."
>
> for *Communication Arts*

ARMANDO VEVE

Armando Veve's mind-boggling graphite and pen creations, depicting surreal constructions and weird inventions, are rendered with meticulous attention to detail and texture. References abound, from pointillism to vintage reference books, with hat doffs to the likes of Fritz Kahn and M.C. Escher. Such skill and imagination have brought the Philadelphia-based illustrator deserved attention through his work for major publications and a slew of awards to boot. Born in Lawrence, Massachusetts, in 1989, Veve attended the Rhode Island School of Design, where he began to find his voice studying editorial illustration under Chris Buzelli. After he graduated with honors in 2011, commissions soon began to flow. To date, he has contributed to *Condé Nast Traveler*, *MIT Technology Review*, *New Scientist*, and *Wired*, to name but a few. In 2017, he was awarded two Gold Medals from the Society of Illustrators and named an ADC Young Guns winner by the One Club for Creativity in New York. *Forbes* included him in the 2018 edition of its "30 under 30" list. Veve has also exhibited in art shows such as *1+() Global Network* at the Seoul Illustration Fair, *Go West!* at Vienna Design Week, and *The Shape of Things to Come* at Jonathan LeVine Projects in New York.

Selected Exhibitions
2018, *The Art of Armando Veve*,
solo show, Richard C. von Hess
Gallery, UArts, Philadelphia · 2018,
Art as Witness, group show, School
of Visual Arts, Chelsea Gallery,
New York · 2018, *Go West!*, group
show, Designforum Wien,
designaustria, Vienna · 2018,
Krem, group show, The Scarab Club,
Detroit · 2017, *Storybook Style*,
group show, Morris Museum,
New Jersey

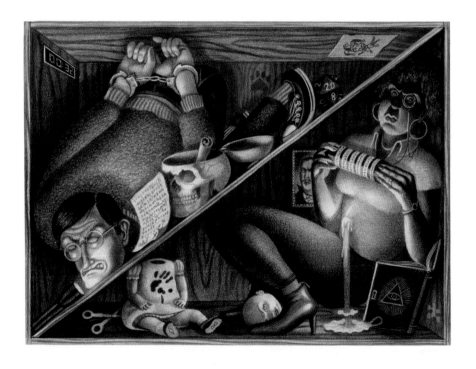

p. 572 Streamlining Data, 2018
Planadviser, magazine;
graphite, watercolor, digital

Escape Room, 2018
*The New York Times
Magazine*; graphite

opposite 10 Theses on Russia, 2017
Global Brief, magazine;
graphite, watercolor, digital

574

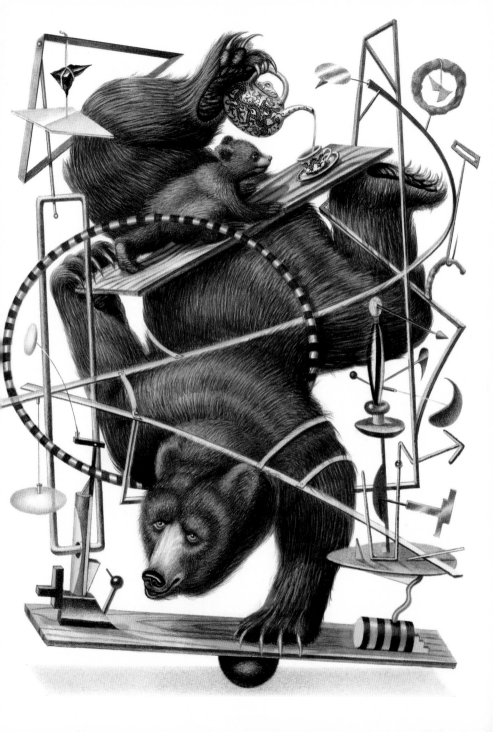

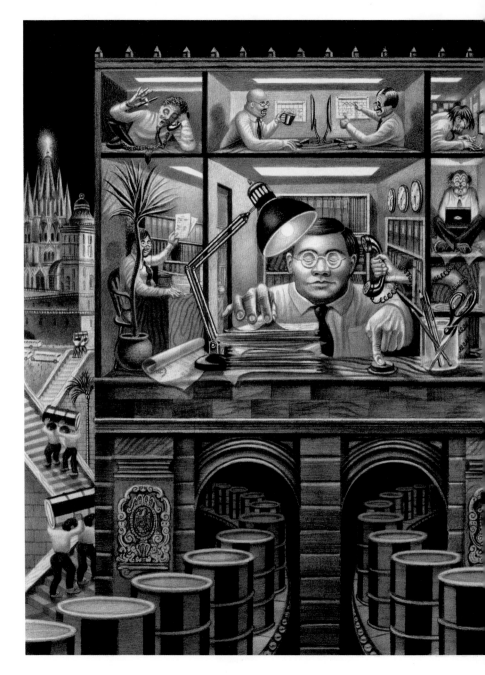

576

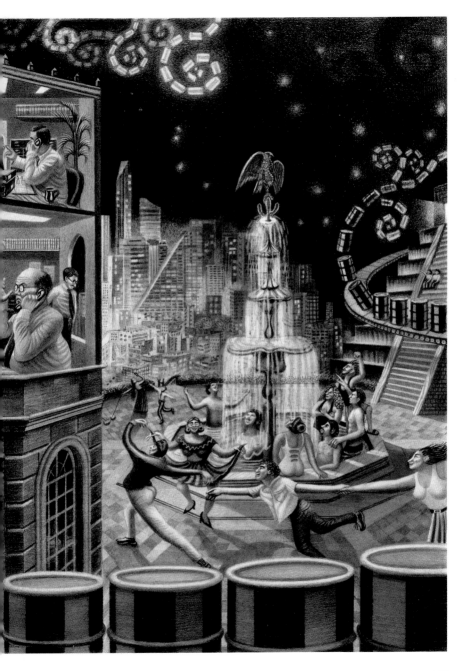

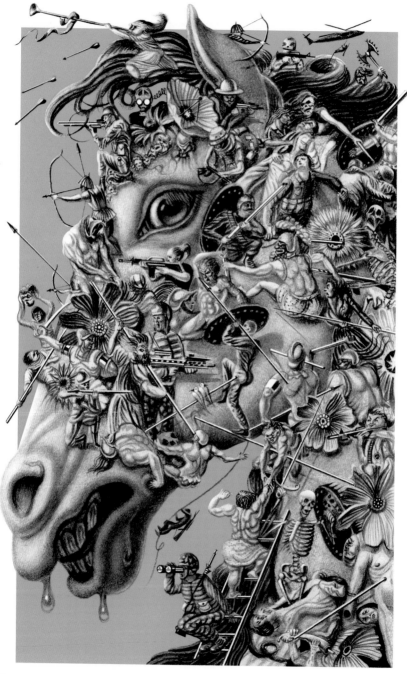

pp. 576/577
Hacienda Hedge, 2017
Bloomberg Markets, magazine;
graphite

opposite War Music, 2016
The New York Times Book Review,
newspaper supplement;
graphite, digital

Your Conscious
Unconscious, 2016
New Scientist, magazine;
graphite

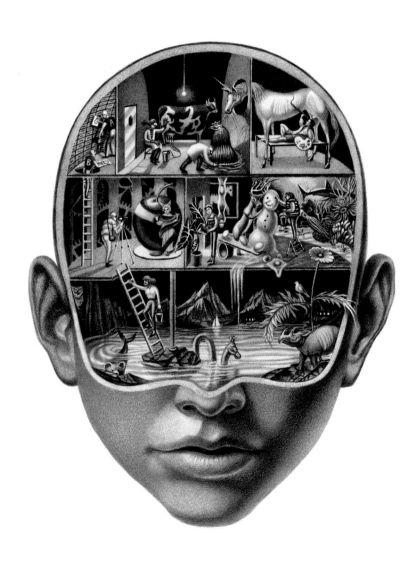

"I like skating, the 1970s, and astronauts."

STEFAN VOGTLÄNDER

Stefan Vogtländer is a freelance illustrator and art director based in Berlin. Working with silkscreen printing and digital tools, he reduces landscapes and compositions to minimal line, color, and shadow. A notable example is *Travelgram* (2017), a personal series of illustrations inspired by the travel photographs commonly posted on Instagram. Using images taken during a road trip in the summer of 2017, he charted a journey across Switzerland and down through Italy. The body of work also formed his first exhibition at ILLU18 in Cologne. Born in Marl in 1987, whilst studying at the Academy for Communication Design (Cologne), Vogtländer worked at a printing shop, where he was able to experiment with different techniques, papers, and binding—explorations he translates in his digital work. He also began freelancing in editorial design, which gained him a Junior Art Directors Club award in the print media category for his thesis. Since graduating in 2014, Vogtländer has worked as an art director and graphic designer for various agencies, including BBDO and Hirschen. He lists his inspirations as ranging from Edward Hopper and early graphic designers like Edward McKnight Kauffer and A.M. Cassandre to mid-century modern design, vintage video games, and skateboarding. Among his commissions to date, he has illustrated campaigns for Düsseldorf's Schauspielhaus theater, the German Skateboard Championships, and Wrigley's gum.

Selected Exhibitions
2018, *ILLU18*, group show,
Michael Horbach Stiftung,
Cologne · 2018, *Parks*, solo show,
Gloria Café, Cologne · 2017,
ADC Festival, group show,
Kampnagel, Hamburg · 2016,
Skatespots, solo show, Pivot,
Cologne · 2014, *ADC Festival*,
group show, Oberhafenquartier,
Hamburg

Selected Publications
2017, *Art Directors Club Annual*,
Edel, Germany · 2014, *Art Directors
Club Annual*, Avedition, Germany

p. 580 Lago Maggiore, 2018
Personal work, poster; digital

Alexander Platz, 2018
Personal work, poster; digital

opposite Alex's Yard, 2017
Personal work, poster; digital

582

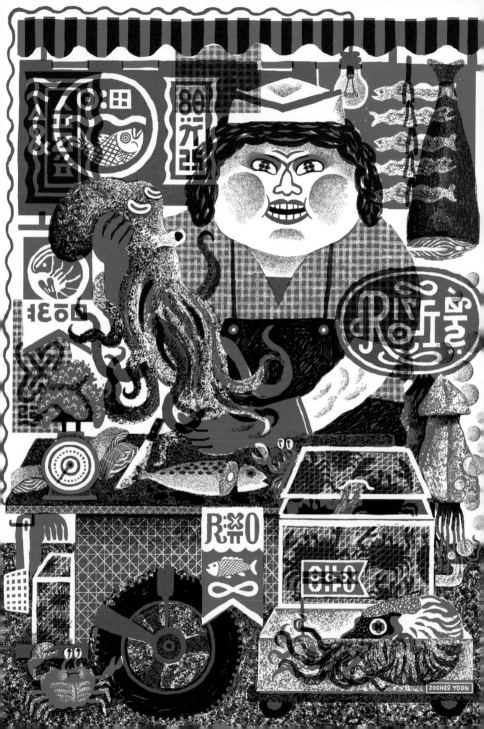

> "I find people-watching endlessly fascinating and I get a lot of inspiration from just observing people on the streets, especially in cities and in public transportation where all sorts of people gather."
>
> for *Inky Goodness*

JOOHEE YOON

JooHee Yoon uses traditional printmaking techniques to produce beautiful illustrations. Born in Seoul, in 1989, she grew up traveling and spending time on the West Coast of the United States. In 2011, whilst studying at Rhode Island School of Design, she won a student scholarship competition run by the Society of Illustrators—by whom she would later be awarded a Gold Medal. Her inspirations range from observations of everyday life to the natural world, medieval art, and European posters of the early 1900s. When tackling client briefs her approach is to problem-solve and create "parallel metaphors" that make the visual component to the narrative accessible, whilst adding a conceptual dimension. Yoon is fascinated by printing processes, in particular early-20th-century reproduction methods that employed limited colors which, when overlapped, produce secondary shades. This is a technique she uses to great effect in works such as her first book aimed at younger readers. *Beastly Verse* (2015) is a selection of 16 poems about animals—both real and imaginary—by such classic writers as William Blake, D.H. Lawrence, and Ogden Nash. By using elements of the physical structure of the book, such as fold-out pages, she brings the creature-filled verses to life with a rhythmic sense of motion and play. Her subsequent interpretation of James Thurber's 1956 fable, *The Tiger Who Would Be King*, was named a *New York Times* Book Review "Best Illustrated Children's Book of 2015." Yoon has produced work for such prominent clients as *Die Zeit*, MailChimp, Fortnum & Mason, and *The New Yorker*. She regularly gives talks and workshops, and has taught screenprinting and illustration at her alma mater. Having lived in various cities throughout the United States and Germany, Yoon travels frequently, and works in what she describes as a "transitory state."

Selected Exhibitions
2018, *The Art of JooHee Yoon*, solo show, Richard C. von Hess Gallery, UArts, Philadelphia · 2018, *Ilustrarte*, group show, Centre for Contemporary Culture, Castelo Branco, Portugal · 2017, *New Prints 2017 Summer*, group show, International Print Center New York · 2016, *Visual Taipei*, group show, Songshan Cultural & Creative Park, Taipei · 2016, *Bologna Illustrators Exhibition*, group show, Bologna Book Fair

Selected Publications
2018, *30 under 30, Forbes* magazine, USA · 2016, *Communication Arts,* USA · 2016, *American Illustration,* USA · 2015, *Best Illustrated Picture Books, The New York Times*, USA · 2015, *Society of Illustrators,* USA

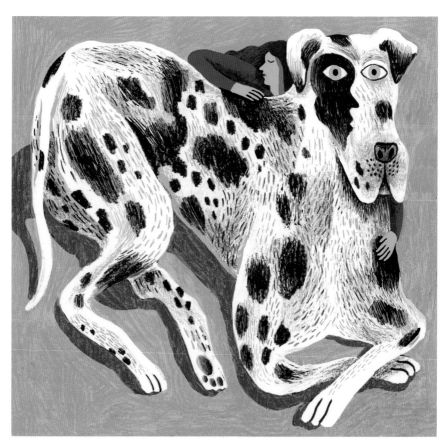

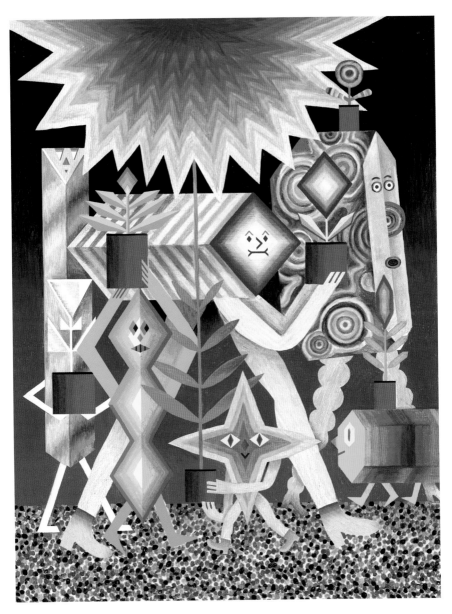

p. 584 Fishmonger, 2017
Personal work, limited-edition
print; screen printing

The Friend, 2018
New York Times Book Review,
newspaper supplement; hand
drawing, digital; art direction:
Matt Dorfman

Best of the Best, 2018
Planadviser, magazine;
hand drawing, digital;
art direction: SooJin Buzelli

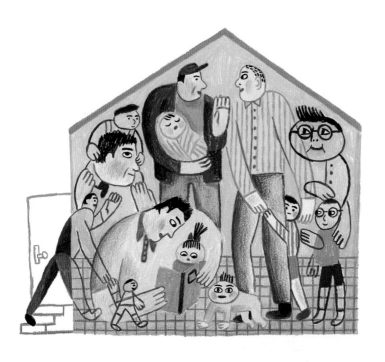

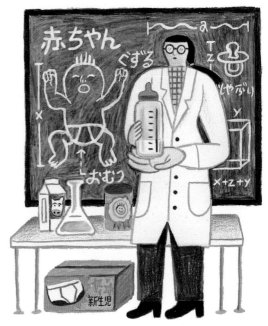

Ikumen, 2018
Topic, online publication;
colored pencil

Baby school, 2018
Topic, online publication;
colored pencil

opposite Decomposers, 2018
The New York Times, newspaper;
hand drawing, computer;
art direction: Nathan Huang

> "My inspiration comes from the great artists of the past mixed with psychedelic night visions and some pop songs. I like to play with shapes and lines and make them do a little dance before creating the final piece."

OLIMPIA ZAGNOLI

Born in Reggio Emilia, Italy, in 1984, to photographer and artist parents, Olimpia Zagnoli absorbed visual references from an early age. She has referred to her kindergarten as her most profound creative influence. At the age of six she moved to Milan, where she would later study at the European Institute of Design. In 2008, New York beckoned and Zagnoli's bright, colorful vision soon splashed onto the editorials of *The New York Times* and *The New Yorker*, migrating to the city's subway system and the Guggenheim Museum. Drawing inspiration from childhood memories of Italy in the 1980s—from psychedelic animated TV commercials to soda can logos, coupled with a diverse set of influences ranging from Bruno Munari to Kermit the Frog—Zagnoli has created a fizzy-pop universe of brightly colored flat shapes. Based in Milan, she sketches quickly, and doodles on her iPhone before bringing her concepts to life on tablet and computer. Her portfolio has expanded to books, stamps, and art installations. Together with her father she has designed and launched Clodomiro, an offbeat range of apparel and cookery wares. Constantly experimenting, Zagnoli has ventured into art installation, mobiles, stickers, video, and light art. Her nostalgic worlds have featured in solo exhibitions, such as *Parco Zagnoli* (2014) at Ninasagt Galerie in Düsseldorf, and *Cuore di Panna* (2018) at HVW8 in Los Angeles.

p. 590 Prada, Spring/
Summer 2018
Textile and fashion
accessories; digital

opposite Untitled, 2018
Dueostudio, rug; digital,
hand-knitted wool and silk

How to Eat Spaghetti Like
a Lady, 2017
Antonio Colombo Gallery,
print; digital

Oz Fever, 2018
Marella, textile and fashion
accessories; digital

Summer in the City, 2018
BASE Milano, poster; digital

opposite Rock Stars, 2015
Bang & Olufsen, magazine; digital

Selected Exhibitions
2018, *Cuore di Panna*, solo show,
HVW8 Gallery, Los Angeles ·
2017, *How to Eat Spaghetti Like a
Lady*, solo show, Antonio Colombo
Gallery, Milan · 2015, *Cinetica
Zagnoli Elettrica*, solo show, Galleria
121+, Milan · 2014, *Parco Zagnoli*,
solo show, Ninasagt, Düsseldorf ·
2014, *Welcome to OZ!*, solo show,
Yoyogi Art Gallery, Tokyo

Selected Publications
2018, *The Illustration Idea Book,*
Laurence King Publishing, USA ·
2016, *W. Women in Design,* Triennale
Design Museum, Italy · 2016, *In
The Company of Women,* Artisan,
USA · 2016, *Una Storia Americana,*
Corraini Edizione, Italy · 2013, *It's
Nice That Annual,* United Kingdom

Prada, Spring/Summer 2018
Textile and fashion accessories;
digital

opposite Black and White, 2016
Guggenheim Museum,
website; digital

ISADORA ZEFERINO

Isadora Zeferino is a freelance illustrator and visual development artist from Rio de Janeiro. Born in 1993, she initially studied biology, but later realized it was probably because she enjoyed drawing cell structures so much. Eventually, she attended classes on the product design and visual communication course at the Industrial Design School of the Rio de Janeiro State University. Zeferino weaves through her work a colorful style that harks back to European folklore and children's book illustration. She shares her thoughts and images on a daily basis, delighting her tens of thousands of social media followers. Disney fan art illustrations are posted alongside mermaids and the very occasional attack of sinister irony. Just for fun, Zeferino takes up 24-hour illustration challenges, such as "Inktober," or reinterprets classic book covers like Douglas Adams' *Hitchhiker's Guide to the Galaxy*, Aldous Huxley's *Brave New World*, and J.K. Rowling's *Harry Potter and the Philosopher's Stone*. Her clients include the Association of Public Defenders of Rio de Janeiro and Brazilian concert crowdfunding company Queremos. Zeferino is currently developing concepts for books.

p. 598 A Gossip All Your Friends
Should Hear, 2018
Personal work; digital

opposite A Stroll around
the Block, 2018
Personal work; digital

Mercado de Artesanias
de la Ciudadela, Mexico City,
2018; digital

Knowledge Blooms, 2018
Personal work; digital

ACKNOWLEDGMENTS

I have now worked in partnership with Steve Heller on over ten books, one way or another: sometimes as a consultant and others as a proactive co-editor. This man's knowledge is insurmountable, and so is his generosity in sharing it. I would like also to thank my other partner for over 14 years, the always impeccable Daniel Siciliano Bretas, who has managed many of the publications I edit. I have also to thank Chris Mizsak for researching and writing about each of the illustrators in this book. It is not a showcase in classic terms, and therefore the profiles demanded both persistence and wit, and he has done an accurate and tireless job. When it comes to editors, we also had the supreme work of Gill Paul, who revised and edited the texts. To make everything look good throughout, we counted on Jens Müller designing the book and Daniela Asmuth taking care of the pre-press. We also had the honor of having the cover and front matter illustrated by Christoph Niemann, who proposed many new solutions for the challenges we faced during the course of producing the book. Many thanks to all of you.

The soul of this book is the work done by each artist featured here. And by being here, they also represent many more artists who could have been. Their collaboration and proactive involvement is fundamental to make a book like this relevant. I would like to thank all the illustrators, and extend that to the studio staff who helped us put this book together. They are the true heroes, and have certainly swum against many currents, and against many odds thrived in a world that doesn't fail to stun us daily with overwhelming visual experiences. They have raised the bars, and the book is here to crown it.

Last but not least I would like to thank all TASCHEN staff, and everyone in my department who has been involved in the book, from production to marketing. Developing a new book with a new concept demands the involvement of many people, and our guys have never failed to give this book their full support.

Julius Wiedemann

Savoring Summer,
by Kadir Nelson, 2018
The New Yorker, magazine cover;
oil on linen; art director:
Françoise Mouly

100 Illustrators

The Package Design Book

Logo Design. Global Brands

D&AD. The Copy Book

Modern Art

Bookworm's delight: never bore, always excite!

TASCHEN
Bibliotheca Universalis

Design of the 20th Century

1000 Chairs

1000 Lights

Industrial Design A–Z

Bauhaus

1000 Record Covers

20th Century Photography

A History of Photography

Photographers A–Z

Eugène Atget. Paris

Photo Icons

New Deal Photography

The Dog in Photography

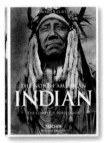

Curtis. The North American Indian

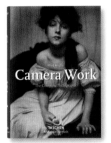

Stieglitz. Camera Work

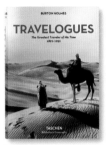

Burton Holmes. Travelogues

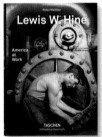

Lewis W. Hine

Film Noir

Horror Cinema

100 All-Time Favorite Movies

The Stanley Kubrick Archives

20th Century Fashion

Fashion History

1000 Tattoos

Tiki Pop

YOU CAN FIND TASCHEN STORES IN

Berlin
Schlüterstr. 39

Beverly Hills
354 N. Beverly Drive

Brussels
Place du Grand Sablon /
Grote Zavel 35

Cologne
Neumarkt 3

Hollywood
Farmers Market,
6333 W. 3rd Street, CT-10

Hong Kong
Shop 01-G02 Tai Kwun,
10 Hollywood Road,
Central

London
12 Duke of York Square

Madrid
Calle del Barquillo, 30

Miami
1117 Lincoln Rd.

"If browsing is
considered an art form,
the TASCHEN store
is a masterpiece."
—*Dwell*

Milan
Via Meravigli 17

Paris
2 rue de Buci

IMPRINT

© 2023 TASCHEN GMBH
HOHENZOLLERNRING 53
D-50672 KÖLN
WWW.TASCHEN.COM

To stay informed about TASCHEN and our
upcoming titles, please subscribe to our free
magazine at www.taschen.com/magazine, follow
us on Instagram and Facebook, or e-mail your
questions to contact@taschen.com.

**EACH AND EVERY TASCHEN BOOK
PLANTS A SEED!**
TASCHEN is a carbon neutral publisher.
Each year, we offset our annual carbon emissions
with carbon credits at the Instituto Terra, a
reforestation program in Minas Gerais, Brazil,
founded by Lélia and Sebastião Salgado.
To find out more about this ecological partnership,
please check: www.taschen.com/zerocarbon
**INSPIRATION: UNLIMITED.
CARBON FOOTPRINT: ZERO.**

**PRINTED IN SLOVENIA
ISBN 978-3-8365-9256-7**

ORIGINAL EDITION
© 2019 TASCHEN GmbH

EDITOR
Julius Wiedemann

DESIGN OF ORIGINAL EDITION
Jens Müller, www.studiovista.de, Düsseldorf

**ILLUSTRATIONS
COVER & INTRODUCTION**
Christoph Niemann, Berlin

GERMAN TRANSLATION
Andrea Wiethoff for Delivering iBooks
& Design, Barcelona

FRENCH TRANSLATION
Valérie Lavoyer for Delivering iBooks
& Design, Barcelona

p. 461 Young, Gifted and Black by Jamia Wilson
and Andrea Pippins, published by Wide Eyed
Editions copyright © 2018. Reproduced by
permission of Wide Eyed Editions, an imprint of
The Quarto Group